DAVID BLACKWOOD

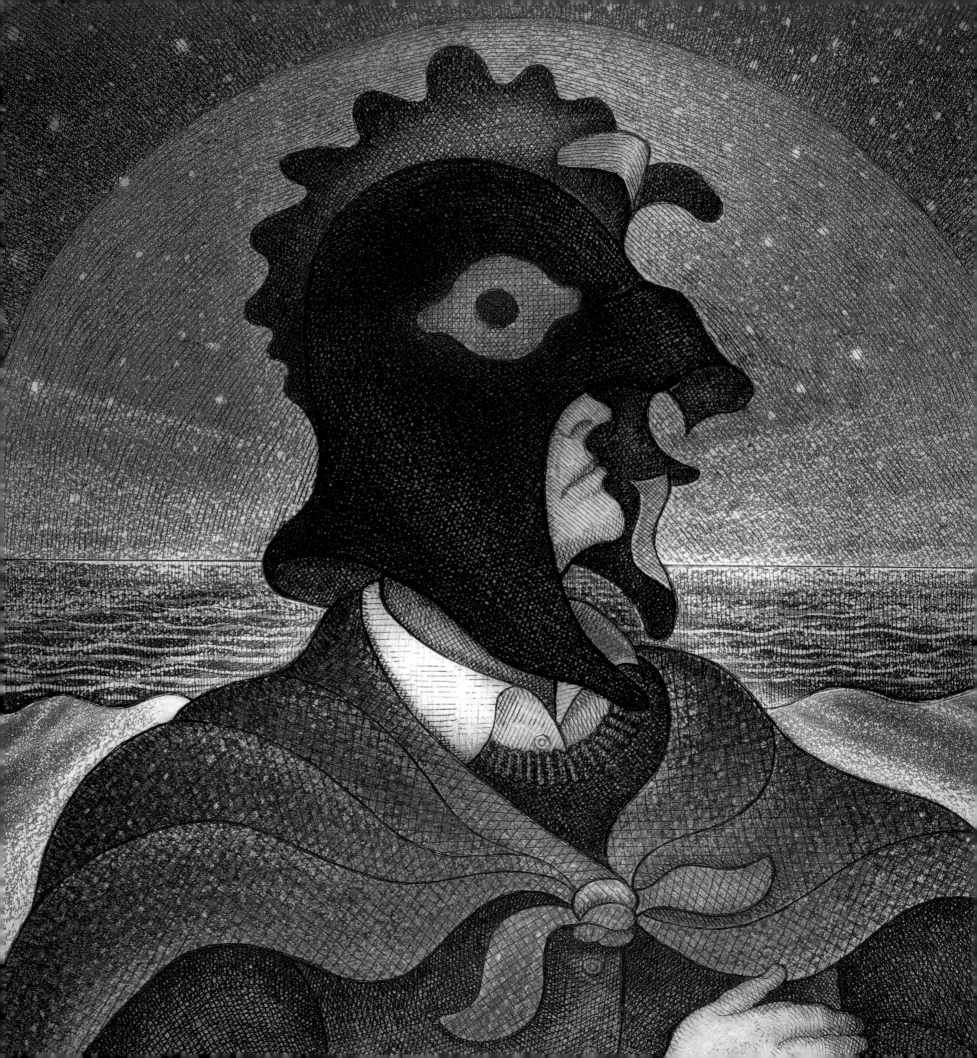

WILLIAM GOUGH · WITH AN APPRECIATION BY ANNIE PROULX

DAVID BLACKWOOD

MASTER PRINTMAKER

Douglas & McIntyre

VANCOUVER/TORONTO

01 02 03 04 05 5 4 3 2 1

Douglas & McIntyre Ltd.
2323 Quebec Street, Suite 201
Vancouver, British Columbia
Canada V5T 4S7

National Library of Canada Cataloguing in Publication Data
Blackwood, David.
 David Blackwood.

ISBN 1-55054-872-7

 1. Blackwood, David. 2. Newfoundland—In art.
I. Gough, William. II. Proulx, Annie. III. Title.
NE2013.5B63A4 2001 769.92 C2001-910355-7

Originated in Canada by Douglas & McIntyre and
published in the United States of America by Firefly Books.

Cover and text design by Peter Cocking
Photographs of David Blackwood's work by W. Edward Hunt
Dimensions for prints are given in centimetres,
with height preceding width.
Map by Stuart Daniel/Starshell Maps
Front cover: Detail from *Brian and Martin Winsor*
by David Blackwood; complete image appears on pp. 38–39
Back cover: Detail from *Fallen Mummer on Brookfield Marsh*
by David Blackwood; complete image appears on pp. 90–91
Frontispiece: Detail from *Study for Great Mummer*
by David Blackwood; complete image appears on p. 164
Printed and bound in Hong Kong by C&C Offset

We gratefully acknowledge the financial support of the
Canada Council for the Arts, the British Columbia Ministry of
Tourism, Small Business and Culture, and the Government
of Canada through the Book Publishing Industry Development
Program (BPIDP) for our publishing activities.

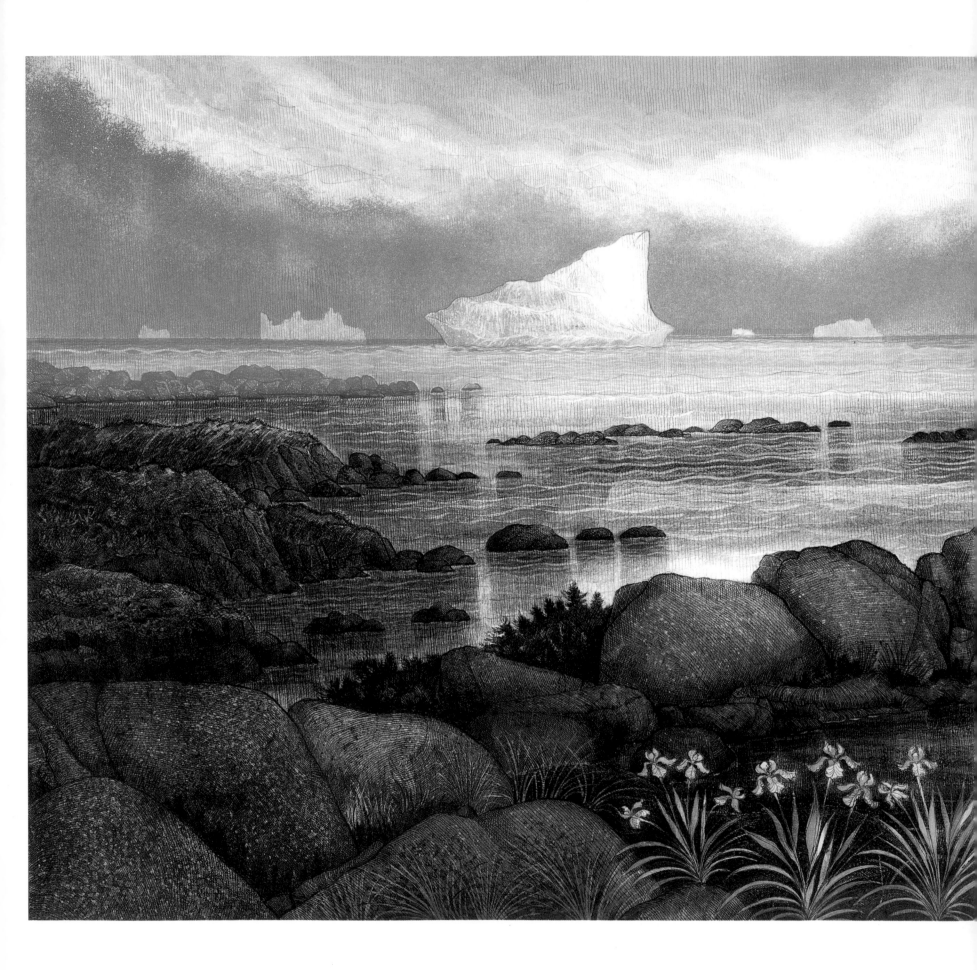

CONTENTS

June Visit Home
1999 · 50 × 80 cm

ACKNOWLEDGEMENTS

I wish to acknowledge gratefully the support and friendship of Doris Pascal, Dr. John Tuzo Wilson, Adrian and Lily Bonar, John de Visser, Emma Butler, Dr. Katharine Lochnan, E.M. (Yeti) Agnew, Fred Hagan, Casandra and John Alikakos, Edgar Blackwood, Nancy Hazelgrove, W. Edward Hunt, Bill Gough, E. Annie Proulx, and my mother, Molly Glover Blackwood, and my father, the late Captain Edward Bishop Blackwood.
DAVID BLACKWOOD

I wish to thank Captain Edward Blackwood, Mrs. Molly Blackwood, Edgar Blackwood, Miss Alice Lacey, Edgar Glover, Rev. Naboth Winsor, Mrs. Mildred Winsor, Captain Carl Barbour, Mrs. Dorothy Barbour, John de Visser, Edward Hunt, Anita Bonar Blackwood, the Eccleston Family, Joe and Hope Partington, John Ryan and Irene Phelps, Jim Osborne and Dan Curtis, Dr. Jessica Motherwell McFarlane, George Payerle, Madeleine DesMarais, Debbie Papadakis, Teal Maedel, Sax Franciso, and my mother, Dr. Ruby Gough.
WILLIAM GOUGH

March: Wesleyville
from Bennett's
High Island
1976 · 50 × 80 cm

viii

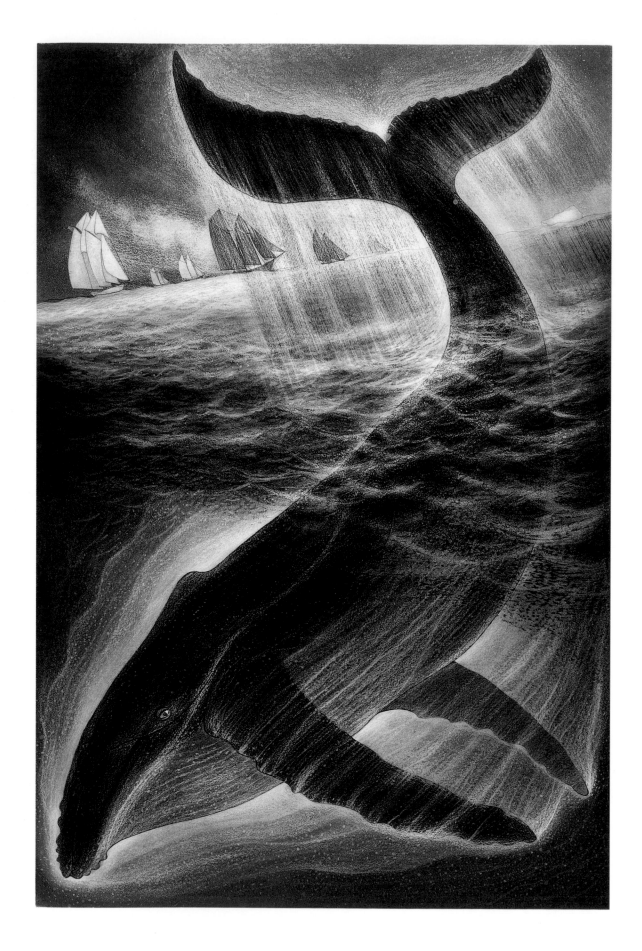

Wesleyville Fleet
in the Labrador Sea
1995 · 90 × 60 cm

NEWFOUNDLAND AS ATLANTIS

THE GHOSTLY WORLD of marine Newfoundland that emerges from under David Blackwood's hand no longer exists in real time. The traditional hard-won livings from boats, cod, seal, and ice, tinctured with isolation and a burning will to endure, have disappeared in recent years with the failure of the cod stock and the closure of foreign markets for sealskins. These centuries-old occupations have been replaced by tourism, roadside jam stands, and a seasonal shift to the mainland for wage work. With frightening rapidity the old skills of boat building, net-making, fog-bound navigation through long familiarity with local water, the abilities to read weather and people are fading as the last generation to practise the accumulated knowledge of centuries goes into the earth. The sea of change washes remorselessly over Newfoundland, drowning everything—fish flakes, seal sculps, abandoned houses, hand-worked mats, the ancient berry-picking trails. The Rock goes under the slosh of global culture, yet David Blackwood, in his glass-bottomed boat of memory, gazes down through the deepening water as one might look at drowned Atlantis, and sees the outport world that existed in his childhood.

Sometimes a great artist appears just at the point of historical shift and catches the essence of a region and time, as the Altamira Master, Bruegel's paintings of medieval peasants, George Grosz's bitter depictions of post–World War I Germany. In a curious way a cultural era ready to tumble into the abyss of the past comes to belong to the artist who caught it before it fell. As the marvellously rich speech of the place is preserved in *The Dictionary of Newfoundland English,* the Newfoundland of boats and cod, of mummers and sealers, the brilliant flags, the hoarse voices of foghorns, ice aloof and jagged, the mug-ups and kitchen times, the coffin in the boat have become inseparable from the name of David Blackwood.

ANNIE PROULX
March 23, 2001

INTRODUCTION

STANDING IN HIS STUDIO in Port Hope, Ontario, David Blackwood is considering a small, hand-carved horse, something made in his native Newfoundland before he was born. As he turns the horse over and over in his hands, it's as if he can see with his fingers. "In New York, in the Metropolitan Museum of Art, there is a little bronze horse that follows the same lines as this one," he says. He leans back, tilts his head to view the little carved horse from another angle. "See? See the connection? And the man back home in Wesleyville who made this didn't have any great classical ideas about sculpting. For him he was simply chasing a shape. He had a natural instinct about how the horse was to look—and that instinct is really prehistoric."

Somewhere in Blackwood's thoughts about the horse is a connection to the print he's working on at the moment, and he turns his attention to this work in progress. Silently he stands back from it, walks around, moves in closer to the print, sits, tilts his head, and looks carefully at one corner. Then he simply gazes.

In an age that seems unable to bear silence, at a time when big cities are installing fast-walk lanes on sidewalks, and configurations of pixels on Internet-linked monitors leap and shift in an eye-blink, David Blackwood knows how to sit still; he can do as the *Tao-te Ching* suggests, and watch the water settle. The expression on his face is one that, as a fellow Newfoundlander, I've seen many times before— on the faces of fishermen mending nets, women as they

quilted, boys as they made stilts, uncles as they carved the first whistles of springtime, aunts as they knitted and told stories. It is a look of considered creation, where each thing that's done in the present trails the glory of all that's been created before.

David Blackwood and I have talked many times about the role this period of consideration plays in the development of his work. "It's not calculated or planned or thought out," he says. "I'll come in here and spend thirty minutes looking, not rationalizing but *feeling* the light and the feeling I want. It's a mystery how I do it, so I feel my way along and it happens." There's a pause. "Sometimes."

After he adds the "sometimes," he laughs, in a way that reminds me of his late father, Captain Edward Blackwood. It's the laugh of a skipper who understands that, no matter how clear a course may be, there's always the chance of an unexpected gale. The sudden lifting of a fog bank, the quick parting of thick curtains of mist, the surprise of a beam of light cutting into the ocean as the days get shorter: all of these belong to the world of "sometimes." David Blackwood's vision descends from generations of people who could glance towards the ocean and see an approaching storm where others might notice only a slight shifting of colour. The hands that draw and sketch and coax magical lines from metal plates are simply putting to new use skills that his ancestors used to turn planks into the smooth lines of a ship's hull. And the spirit that drives his art is powered

by older spirits that have, again and again, asked for answers to the questions "Why are we on earth, and what are we to do here?"

Blackwood continues to gaze at his work as the sun pours through the window. He is completely engrossed, and I remember a Newfoundland fisherman I once observed gazing in the same way at the ocean. I asked the man if he ever tired of the sea, ever grew weary of what he did. I wanted to know how each morning was for him.

The fisherman looked out over the rolling billows and thought a long time before giving his considered answer.

"The sea? Why, my son, 'tis as good as your breakfast."

Watching David Blackwood lost in his work, I understand that he approaches his art as if it were the ocean—endless, deep and infinitely variable. It is here that Blackwood has set his nets, and his nets come up filled with light and stories.

David Blackwood, 1999
photo: John de Visser

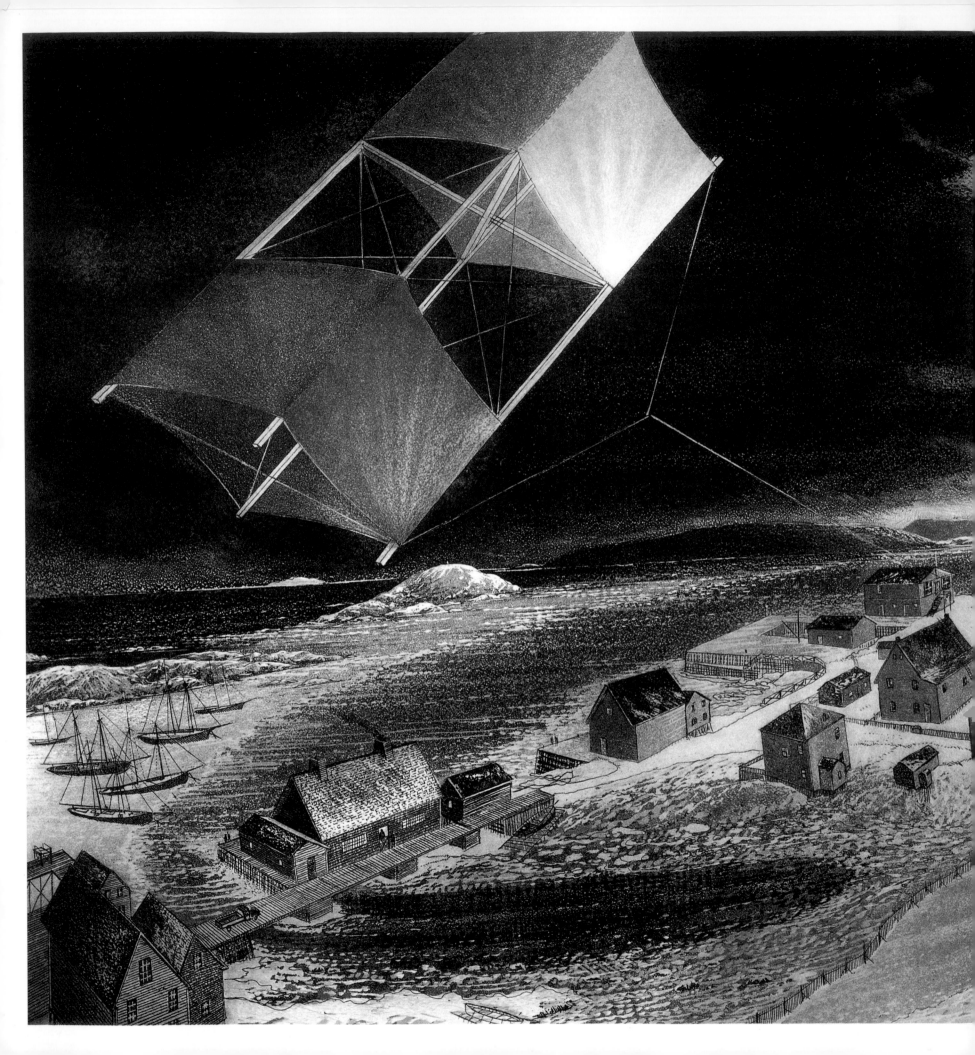

Uncle Cluny's Kite
over Wesleyville
1989 · detail

THE PLACE

WE STAND TO FLY

A KITE

1

Captain Ned
Bishop Home in
Wesleyville
1976 · 50 × 80 cm

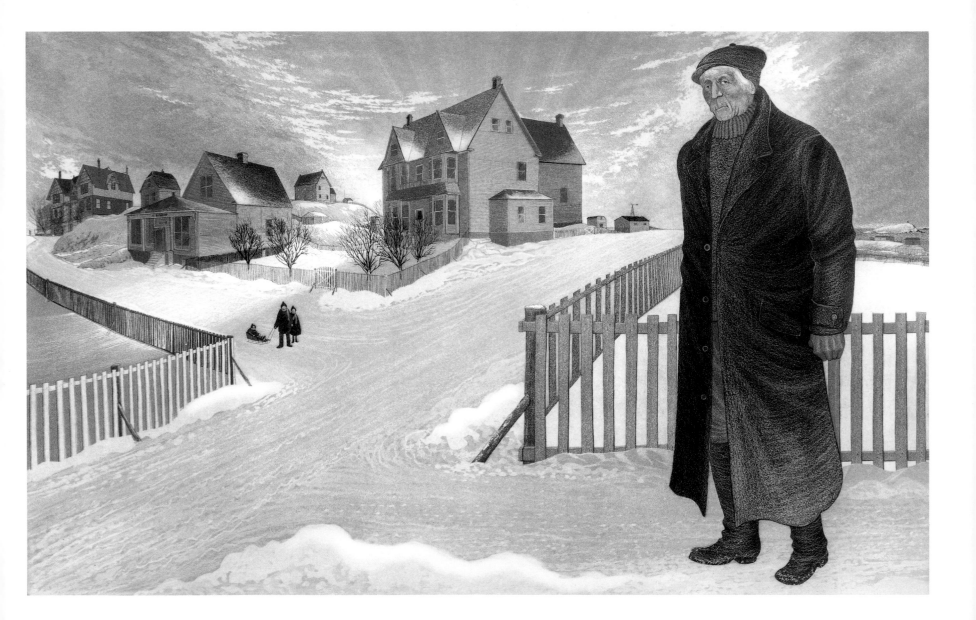

Hᴏᴡ ʜɪɢʜ ᴀ ᴋɪᴛᴇ ᴍᴀʏ ꜰʟʏ depends on the place where you stand, and on the winds that blow to help you. The first kites in Wesleyville, where David Blackwood comes from, were made of brown paper torn keen and true from the grocer's roll to be wrapped around all manner of things. At home, showing stains of salt beef or wax rubbings of cheddar cheese, impregnated with scents of pickle juice or spices, the brown paper was carefully taken off the parcels and then folded into a diamond shape. Thin strips of wood were cross-strapped and placed on the diamond, more strips of wood were laid along the diamond's sides, and, finally, the brown paper was folded over the outer wood and glued there with a paste made from flour and water. Once the paste was dry there was the slap of paint on paper, and the tying on of a tail fashioned of glorious rags or folded pages from mail-order catalogues. Then young David Blackwood and the other children would run outside, past the grownups who dreamed of long-ago days when they had flown their own kites. Old men might stop the youngsters to inspect their kites, make suggestions, offer advice, and then, their own bones too salted by sea and rheumatism to move easily, let the kites lift them through imagination to the skies.

What goes into a kite tells much about the people who make it. In Wesleyville, kites were not made sloppily; this was a place where the shoddy was not welcome. If shutters were not attached perfectly to windows, the winds that screech along the Newfoundland coastline could rip them away. If work on ships was not done with care, those ships might founder. A poorly mended hull, improper caulking, a sail that was mended incorrectly: all of these could mean death. And so, even children were taught how to find the proper form for everything. They were taught to go with the grain instead of against it and to observe the way wood twisted itself before trying to turn it. Learn to make a kite of true balance, learn to fly a kite the right way, and all else flows from that simple knowledge.

It's easy to imagine young David Blackwood making his kites—waiting for the paste to dry, then carefully studying the sky before releasing the precious kite into the power of the wind. And then smiling as the gusts tested the well-balanced tail, the heft of the kite itself. He would tilt his head back to see how colours flowed like the spill of a rainbow or in shades as subtle as the slow progress of lichen on Precambrian rock.

There is control over materials and form in this creation, but then comes the moment when the kite flyer must surrender the kite to winds that can never be fully predicted, that live in realms far beyond human control.

The sky shifts, and I see myself standing next to David Blackwood. Time and space shift again, and the childhood kites turn into etchings. Leaning against walls, propped to catch the light, they seem to float in the room.

"The best work happens when you don't have control," insists David Blackwood. We are talking in his studio in Port Hope. The house where he lives with his wife and business manager, Anita, is neat, the garden immaculately arranged. The studio itself is spotless, and even the sun is cut into squares before it lays patterns across the floor.

Blackwood sits tilted back on a chair, his beard trimmed, his sweater smooth, hands folded as secure and strong as a Methodist church steeple. But his eyes are like melting ice, full of dark dreams that hold surprises. Underneath the gathered lines of his brilliant etchings, beneath the precise shading, inside the copper plates and the sharp-as-vinegar smell of nitric acid running to bite metal, behind the fresh paper waiting for the pressure of ink, everything is chance, fluke, a shift in the wind that angles a kite towards unexpected courses.

It was sixty years ago that David Blackwood began his own true course. Back in 1941, Newfoundland was still a country. It had few roads, little electricity, and more in common with the years behind than the years ahead. Wesleyville, located on the northern shores of Bonavista Bay, was secure in a faith based on God and the Fisheries, with an equal devotion to both. There was no tradition of art in Wesleyville; there'd never been a full-time artist in the place. There were neither art galleries nor print shops, and the focus of education was on matters less frivolous than art. Despite all this—or perhaps because of it—David Blackwood could have chosen no better place to be born. He arrived on November 7, 1941, two nights after Bonfire Night's brief blaze against oncoming winter. The Second World War already seemed as though it would never end. For those men still at home, the growing winter storms meant that fishing was ending for the year, and it was time to make repairs, mend nets, and plan for the annual seal hunt.

Wesleyville had bred captains and skippers—men whose names were legend throughout Newfoundland and the entire seafaring world for their exploits—but no artists. To make a painting would have been a remarkable event,

to draw for pleasure a highly unusual activity. There was, of course, the sketching of plans for boat-building, but that was the exception. Besides, drawings weren't really necessary when it came to a vessel. Those were the days when a boat-builder could hold the design of the finest schooner in his head. Some of the older men could walk through the forest and pick out the perfect tree: the one that, beneath its branches and bark, deep inside its stem and trunk, held the perfect keel. That kind of skill was expected, but not the skill of an artist. When the midwife held David Blackwood aloft to see his mother, Molly, and later to meet his father, Edward, home from the sea, no one dreamed that this little boy would grow up to be a master printmaker, an internationally admired shaper of art.

Blackwood was born into a family of seafaring men. His grandfather, Captain A. L. Blackwood, was a strong man destined to command vessels. David's father, Captain Edward Blackwood, often took his young son for voyages on the family schooner, the *Flora S. Nickerson*. David would lean over the gunwales and stare into the water that sprayed in a driftwood bleach over the bow. He'd watch gulls tip like a compass needle towards the sea, and he'd smell the familiar mix of salt and canvas. The path of the wheel and the net, the wind in the billow and snap of a canvas sail all seemed destined to be part of his trade. Wesleyville was the ideal place for that trade. It was a town of people who lived by and for the ocean.

Miss Alice Lacey, a former teacher of David Blackwood's, remembered the way the harbour was in its prime. "The young people growing up today don't know anything about it. There was a time here, if you sat down and looked out at the motorboats going, and up here along what we call 'the reach,' there were as many as sixty-four schooners. And in the spring when they were getting ready and all had their sails up, you could go right up the reach, jumping from one deck to another. People were proud of it."

A place of startling storms, of bare light—sun rays staggering across a raging sky—it also offered the gift of a

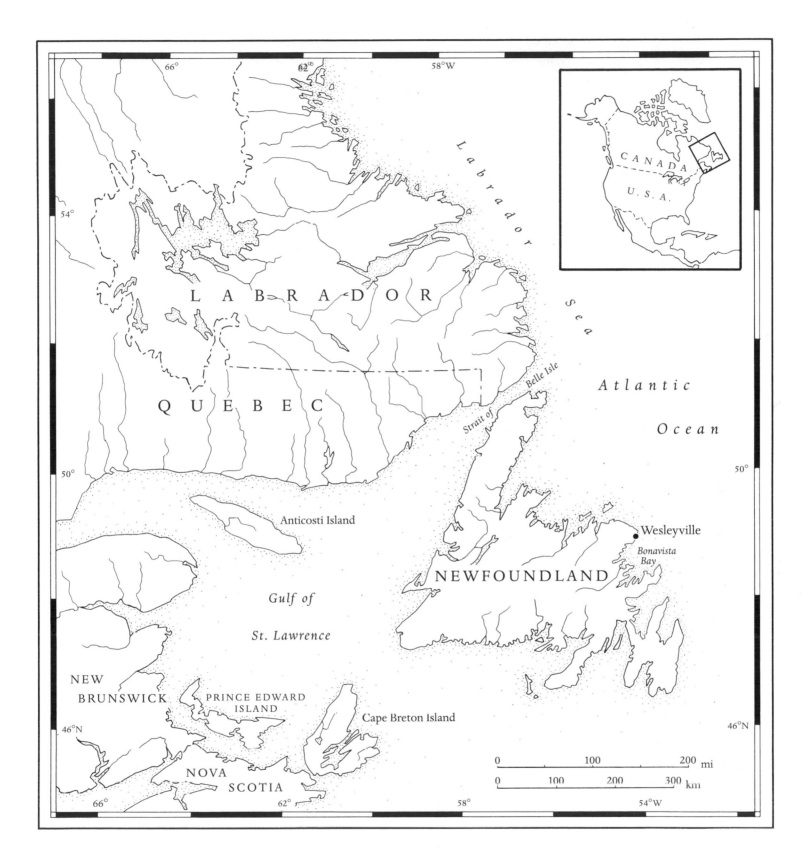

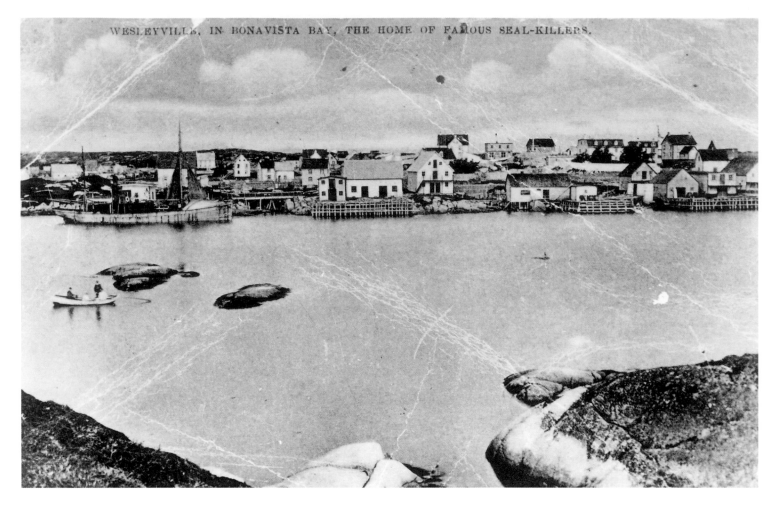

WESLEYVILLE, IN BONAVISTA BAY, THE HOME OF FAMOUS SEAL-KILLERS.

Postcard view of Wesleyville, "home of famous seal-killers," 1907

winter's night. David Blackwood says, "The region is very flat and barren. The dominating features are the sea and the sky. In winter you feel this even more, all shades of grey and black and white. That's the big influence on my work."

Another influence was the sheer fragility of life between the rock and the sea. Sometimes death would arrive as sudden as a squall, bringing a body home from a voyage to a solemn line of mourners moving towards the vessel. Men with grim faces handed down the body. Sometimes a man would return home from sea to find that, while he was away, death had come calling on someone he loved.

Because death was always at hand, life was lived with intensity. Every action was important, every gesture counted.

The stories that the older people told were repeated again and again. Each man and woman carried, like kindling for a fire, stories for the night. Every person, building, and boat had a history. It was a world where the shape, the heft, the rub of every object was noticed. Older skippers could look at the way a knot was tied, the way a gaff-handle was carved, and tell who had made it. Instead of toys coming from far-off factories, playthings were made for a specific youngster or created by the children themselves. The kites were just one of a multitude of toys made by people in the town.

In a David Blackwood print, every object also has its own life and history. The sweater worn by Uncle Sam Kelloway was knitted for him by his wife, Lizzie, and made according

to a pattern that was passed on to her by her mother. The wool had been carded, oiled, and spun by Aunt Mary Fifield. Sometimes, as a boy, David Blackwood would help Aunt Mary do the carding, rubbing his hands together to help her form the rawlings, or lamb's-tails, as they're sometimes called.

The details of this world, the way a created object could stand for and tell us all about its owner, lend power to Blackwood's print *Uncle Sam Kelloway, 1876–1971*. Blackwood tells us about Uncle Sam through the pattern on his cuffs, or mitts. The traditional design of diamonds with little arrow shapes echoes the diamond shapes of windows in some of Wesleyville's homes; similar patterns are painted on fishing-shed doors to keep the Devil away. The spread of the mitts' fingers indicates the way nets must be handled; the worn wood of the cutting table is vital, letting us know this was a time when fish were plentiful. The arrangement of the mitts tells us about the person who placed them there moments ago. The scuff marks scraped across the table, the glow around the edge, are particular and driven by an inner light. Without ever having seen Uncle Sam, we know about him and his life.

Everyone was a novel, everyone was a painting. Older men were called "Uncle," no matter what the blood relationship, and older women were all called "Aunt." It didn't matter how bloodlines flowed: the world flowed everyone into the same ocean, where they were all related. Every person in a town was seen as being responsible for every other person. The larger world, when this belief was extended, became a place where there were always aunts and uncles, where everyone mattered. This was the Newfoundland that David Blackwood was born into—this country where riches weren't heaped up for moth and corruption. The true richness of this place lay in the lives of the people. The proof of the creation of humankind rested in what men and women made, and in the words they spoke of each other. In Wesleyville, an unpretentious civilization was courted; lives were judged by actions,

and words and creation blended. David Blackwood lived in a world where everyone was trained to *see*.

The nearness of death and storm, the pressure of standing at the edge of land and ocean, also brought darkness and shadow. It isn't only in the strengths of a community that we look to see how art is formed. Shadows etch more lines than sunshine erases.

David Blackwood was the son of a new marriage. His father's first wife had died of appendicitis, leaving Captain Blackwood alone with five children. He returned to life on the sea, and it was while he was hove-to off Bragg's Island that he first saw Molly Glover and fell in love with her. She was standing by the ocean, her long black hair glinting in the sun, and he decided that he wanted her to be his wife. Molly Glover was eighteen.

Any marriage in which a young woman becomes an instant mother of five children requires a lot of energy and adjustment. Unfortunately for Molly Glover, she also acquired an instant mother-in-law. Mrs. A. L. Blackwood was a woman of great power, so strong-willed that when she was late for church on Sunday morning, the clergyman wouldn't dare start without her. And she was always late! She ruled the large family house absolutely. There was no speaking at the dinner table, no jokes, no singing. There was always a proper way to do things.

For Mrs. Blackwood, her first daughter-in-law, Allison Roberts, had been perfection itself. Before she met Captain Blackwood, Allison had managed a big household. Her own mother was bedridden, and she had looked after her and also cooked meals for the men who worked for her father.

When she married Edward and moved into the Blackwood house, Allison had taken over right away. She looked after all the meals and even lugged buckets of water into the house without asking for help. She used to warm Mrs. Blackwood's coat for her before the old lady went outside into the cold.

And then Allison died, some said worn out from work and children. When Molly, as a young bride, came to the

Blackwood house, she found she never could live up to the demands made of her. She tried her best but was ignored. Old Mrs. Blackwood taught the previous children to disregard Molly and to call her, and her alone, "Mom." The house echoed with commands for Molly, and large though it was, the walls hemmed her in. Perhaps she hoped the birth of her new little boy would help her to be accepted by her mother-in-law.

But in a society where the stern patriarch, Captain Albert Blackwood, was supposed to be at the tiller, in charge of and under God's guidance for the family, the actual power lay in the strong matriarchal presence of Mrs. Blackwood. And whatever young Molly Glover from Bragg's Island did, it was never enough. She of the warm and tuneful voice, she of the long cascade of hair, was not welcome. Molly's stories, her music, her love of the way the world looked and whirled like a spin-top, were held high for little David. For him, and then for the other children as they arrived, she spun her secret yarns. But the secrets she shared with them became more and more fragile over time, and her anger, at first turned inwards, began slowly to turn outwards.

David Blackwood remembers heading for Bragg's Island one time on what was to be a family excursion. There were David and his brother, Edgar, two little boys in the prow of the boat, and their mother, her hair now bound tight to her head. When they arrived at the island, Molly discovered they would have to stay somewhere other than her family home. Her parents had other visitors, and they had taken over Molly's familiar childhood room. Blackwood recalls, "The wind was coming up, and I can remember that my grandfather was really upset, and we got back in the boat and left. I can remember she was in the front of the boat yelling. Oh, the language coming out of her, the anger—vitriol."

Back home, as calm as calm could be, Molly picked up a broom and went up the stairs to the top of the house. On her way down, she danced past window after window,

lashing out with the broomstick, breaking out each pane of glass, shattering all the windows systematically. Shattering her prison.

David Blackwood didn't know the reasons then; he only knew the results. He was learning that there are other kinds of storms besides the ones at sea. What became vital was the ability to chart a course, to sketch a map, to unroll a chart that showed the way home, even for troubled Molly Glover. Like the ocean when the wind has ceased, Molly Glover found calm in later life. In a small house of their own, she and her husband Captain Blackwood were at rest, having at last found their own safe passage. In outport life, Molly was never condemned. People understood the way the wind had been at her, the way the cold had snapped her will, the way she needed a safe port in which to rest.

David Blackwood would find his own way to face the storms. As a boy, he began to spend more time with his grandparents, more time dreaming, more time listening to stories—tales of bravery, chronicles of errors that had led to great wrongs. All the stories told around the stoves on winter evenings, and around stageheads on summer days, were of everyday people, but all came back to the same theme— how to lead a good life, and what to do in time of trouble. David learned to lean on the words, to feel them as real, and he learned to watch for telltale signs: the way the forgetting of a tortoiseshell comb can forecast greater trouble, the way a smile may mask a wounded heart.

The making of an artist is more than the training of hands; it's the training of the eye, the ear, the listening heart. The way people in his community were supposed to live became an all-consuming passion for David. He learned the ways of his ancestors. But his hands were learning also— learning to create.

In an age when there were no "arts and crafts" aimed at children, David found his own. "At three," his father recalled, "with scissors and cardboard he cut great spiralling shapes, made snowflakes, birds, animals," recreating the world in cutout. Discovering crayons, David made the world shimmer

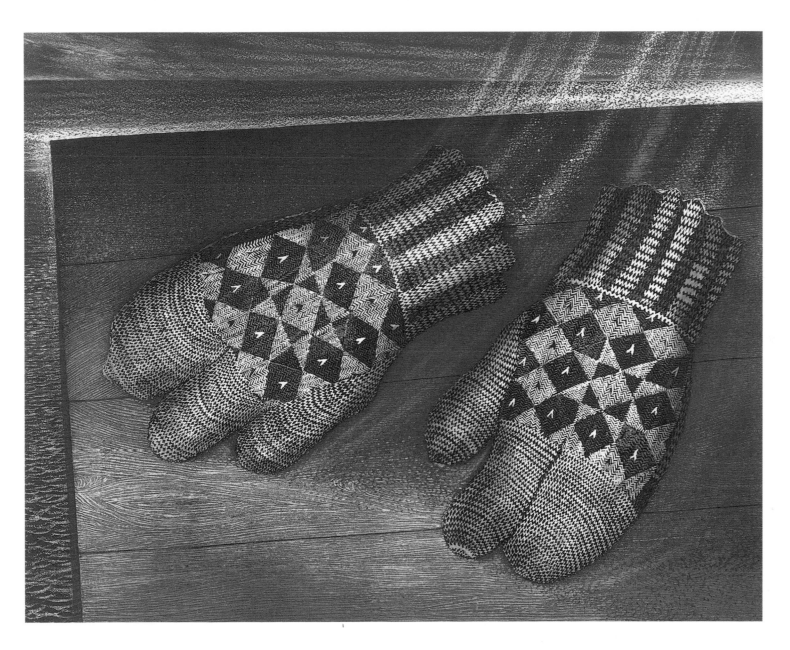

Uncle Sam Kelloway,
1876–1971
1983 · 40 × 50 cm

9

David Blackwood,
Wesleyville,
May 1956

upon a page. He carved, drew, sketched, and built—all on his own. By the time he began school, his teachers remember, his sketches were already perfect. And then one Christmas Mrs. Gertie Hann gave young David a set of watercolours. She'd noticed his skill, and though there wasn't much money in those days, she bought a special tin of paints and then smiled in delight as she saw what he could do with this new treasure. Every time she saw him, for years after, she'd say, "Now, my son, don't give up your painting!"

As he grew older, David began to liberate his mother's sheets from the clothesline in order to tear them in sections and paint on them. His father, looking out the window to see another sheet gone, would curse the neighbours' goat, which he believed was eating the sheets. David would wait a proper length of time, then steal another bedsheet. He wanted to see what paint looked like on fabric. Preparing the "canvas" himself, he'd use, instead of gesso, a coating of white house paint. He painted at every available moment; in the early morning, and within the gentle light of lamps placed in corners against the night. He talked his father into letting him use an old family store for a studio, and, to ward off the cold, David dragged in a pot-bellied stove, painting while winter trembled against the window. He turned at once in his work to the landscape of the place where he lived, to the ships that sailed from there, and most of all, with an alert eye, to the people of Wesleyville. He captured the way a sharp nose can cut the chill air, the way a furrowed brow may contain ridges of the land; he sketched rapidly the bowsprit-like jut of a stubborn jaw.

In the front windows of the store where he painted, David displayed his paintings, usually three at a time, to the townspeople who had inspired them. Sometimes the work caused smiles; many times there was a shock of recognition at seeing anew someone so familiar that family and friends had stopped looking at them. Once in a while his paintings made someone angry. Very angry.

Many Newfoundlanders are intensely private people, and this was the case for the subject of one of David's favourite paintings. David had worked all through one winter to capture the spirit of a local character, a confirmed bachelor known for his temper who made it clear that he did not want to be "sketched." However, David couldn't help himself; his eyes, his heart, and his hands compelled him to do it. While other boys distracted the subject with idle conversation, David's pencil moved rapidly, capturing the fierce eyes, the dense eyebrows, and the jut of the jaw. And then one day he was finished. The painting was complete—well, almost complete. It still needed to be seen. And so, it joined two other paintings in the display window.

The new painting caused a sensation. It certainly impressed the brother of the subject, a man with an equally famous temper. When David came home from school, he learned that the man's brother was on his way to destroy the painting. The young artist had a choice: he could either respect his elders as he'd been taught, or . . . he could do something else.

Grabbing the familiar 12-gauge from the rack in the Blackwood kitchen, he raced over to the store. Setting the gun aside, he removed the painting from the window, slipped it out of its frame, and hid it. Then he took a chair and, facing the locked door, placed the 12-gauge on his lap and waited. He didn't have to wait long. The brother arrived in a fury, slamming his body against the door when David wouldn't open it. As David recalls, "The brother banged three times on the door. He had the reputation of being a strong man—and sure enough one mighty kick sent the door off its hinges and the latch flying across the room."

"Where's the painting?" demanded the brother, and then he noticed that the artist was armed. The gun was unloaded, but the man didn't know that. The teenage David slowed his breathing, made his voice steady, and said, simply, "One more step and I'm going to let you have it with the gun!"

Tough or not, angry or not, the man turned as white as the prepared bedsheet canvases that were all around the makeshift studio. Threatening to call the local RCMP, he stormed back out over the door he'd just kicked in. David

waited, but no RCMP came, so he put the door back on its hinges. His painting was safe, and he was an artist. Locking the door behind him, he walked out into Wesleyville. His eyes saw everything, and there was only one puzzle: what to paint next.

David painted every day—even on the Sabbath. His Sunday painting was certainly not a regular part of Methodist life. Wesleyville was a Methodist town, a place of practised religion, of belief put into action. Whenever riches accumulated in the community—and there was a time, between economic crashes, when they did—those riches were regarded as visible signs of God's bounty received. The Jubilee Methodist Church, begun in 1907 and dedicated on January 20, 1912, stood immense and firm. As David Blackwood recalls, "It used to be at one time a very classical view. You'd see a profile of Wesleyville— and there would be those two very tall spires of the church, and the community was grouped around those spires. A little to the right of it you had the spire of the church hall, and then most of the houses, of course, were small in comparison. Except, on another elevation, the Winsor house stood out like a castle, surrounded by smaller houses and fences."

Fences, lanes, and dirt roads in Wesleyville followed natural boundaries, the outlines of what people called their "places." A "place" included a house, the outbuildings, and the property lines. All traced their way back to the church, which stood secure—a visible sign of the way the Lord had blessed Wesleyville. That is, until the early morning of Wednesday, July 15, 1942.

The Reverend J. T. Clarke, who'd been unlucky enough to begin his pastorate only four days earlier, is quoted in Reverend Naboth Winsor's book *By Their Works* describing it this way: "Shortly before 4 a.m. . . . an outcry was raised, 'The Church is on fire!' Mr. Nathan Winsor called the minister who as soon as possible rang the bell. The North West end of the church was on fire on the outside, and soon the metal ceiling over the rostrum was melted and pieces of

blazing embers were falling on the seats and rostrum. By 6 a.m. the roof and walls had fallen and only the smoking and blazing ruins remained."

And more than a building had vanished. For many people the fire was a sign that something was wrong in Wesleyville, and older people swear to this day that the year 1942 marked a change in the community. Among people in other communities up and down the shore, there was talk that God was demonstrating displeasure about the church having been constructed for the wrong reasons, in order to show off rather than to praise the Lord.

For David Blackwood, the burning of the Jubilee Methodist Church became a symbol; it represented the beginning of the end for the civilization that had produced the building. In those days people's faith was so strong that nobody had bothered to install a lightning rod; for God to strike a church would be unthinkable. It was, however, a lightning bolt that did the job, shivering one main spire of the church, burning its way down the ship's mast that was the spire's centre. The fire ate beneath the zinc plates that curved around the wood and burst into the sanctuary itself, spilling flames down the walls. People ran from their houses at the sounding of the warning bell. Women and children dragged pews outside. They rescued the pulpit, but then the church collapsed in on itself, the thick slate roof crashing through the rich oak floorboards.

The church itself had burned, but the faith behind it was not so easily extinguished. It was a faith, according to the belief of the time, that continued because of unseen witnesses.

Mildred Winsor commented, "I often heard my father say, 'You know we're surrounded by a great cloud of witnesses. If we could pull aside a veil, there is only a thin veil separating us from those who have gone before.'"

Those clouds of witnesses are very present in David Blackwood's work. How else to explain the light?

Wesleyville is flat rock next to ocean, and the light there is frequently seen to glow at the horizon, appearing to

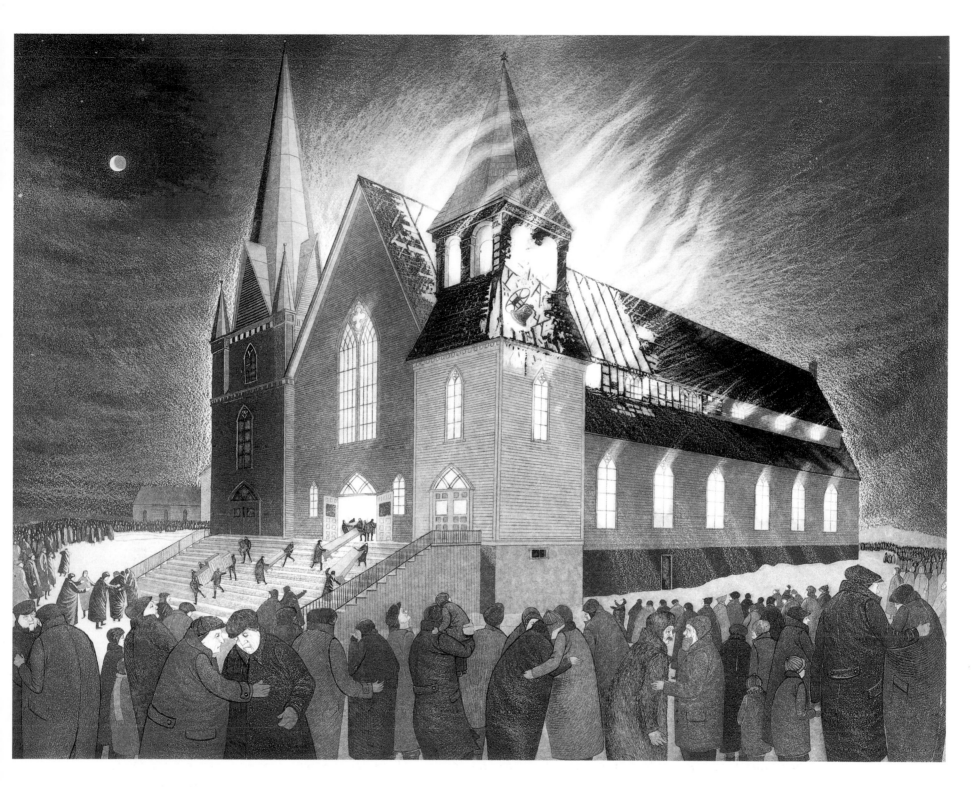

**Wesleyville: Burning of
the Methodist Church**

1976 · 55 × 72 cm

overleaf:

Man Warning Two Boys

1982 · 50 × 80 cm

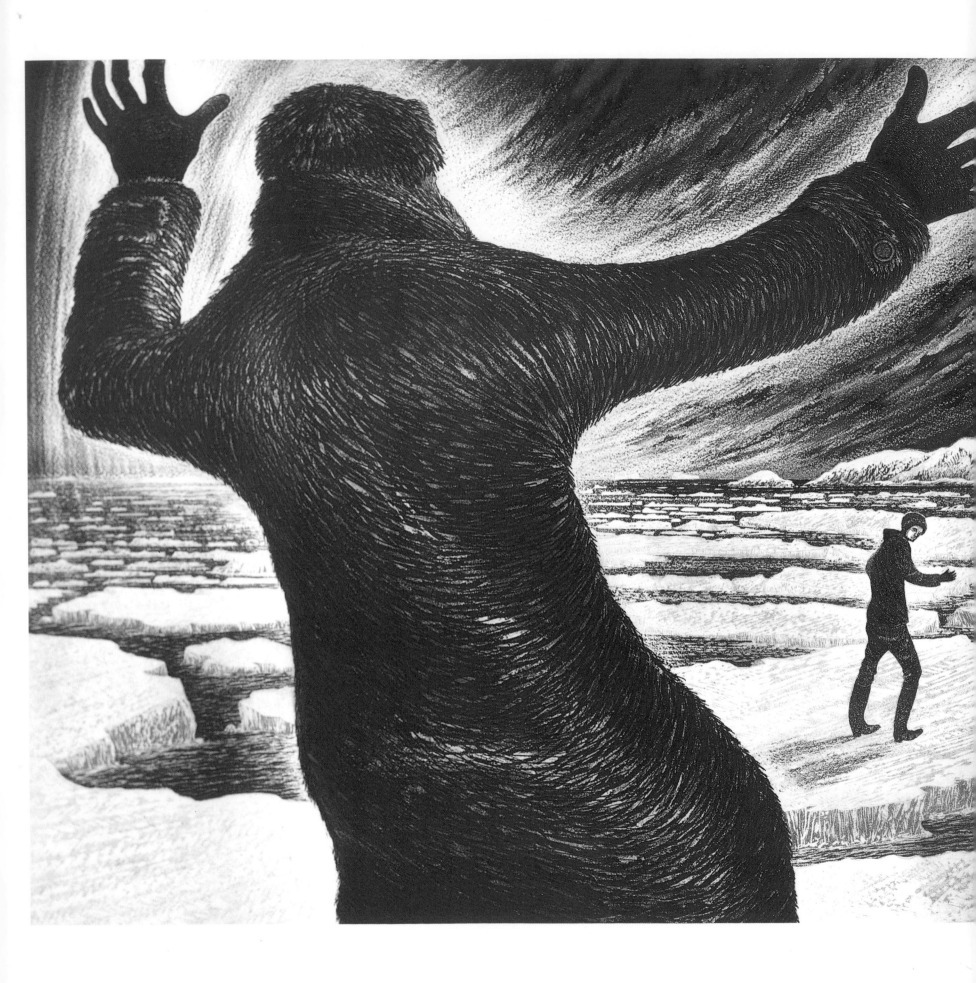

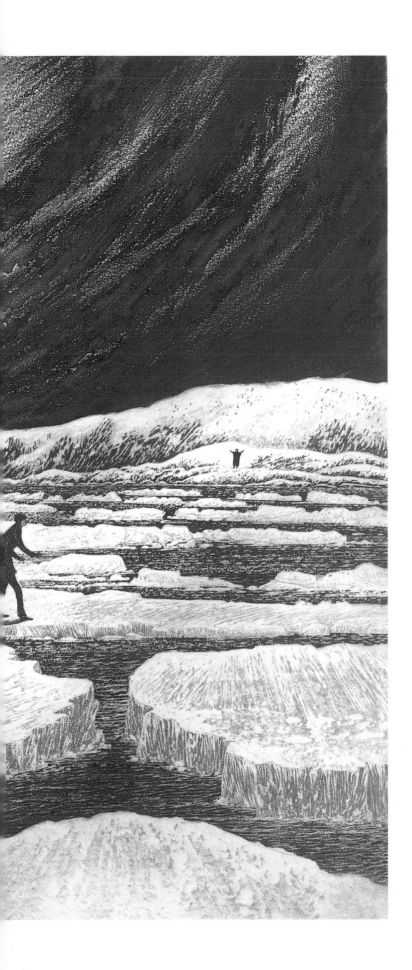

spread in a circular manner. But that doesn't explain fully the source of the light in Blackwood's work. "In many cases the light is coming from within," Blackwood says. "People naturally ask, 'Where is it coming from? Sunshine? Where?' Well, in many cases the light is, for example, inside the iceberg coming out, and the light is inside the person, coming from the person, emanating from the hand, sometimes the glove . . . but from within."

The spiritual is always near; it is the bedrock of the light. "I did a piece about a lantern," Blackwood says, "and the lantern itself occupies all the space. Now this is a specific lantern that belonged to a specific man, Lewis Lacey. That lantern and the work of doing it have a tremendous meaning for me, because I knew the man who owned the light. The print becomes a piece about maturity, about aging, and about death—the audience, of course, won't know Lewis, but they will know what that represents.

"I've got a very strong belief that people who've gone before are watching, observing. And they're in a position to help you as well—I think they watch, and in a positive way."

There was once a large house in Wesleyville. It was the house where David's father was born, where David himself was born. Over the years the house faded, cracked, buckled, and split under the power of the elements. Finally it was taken down, and David had to watch that being done. He didn't have enough money to repair it; there was no way to prevent its death. But he still has a recurring dream about it. In this dream, he says, "I see myself in there and actually preventing the demolition. Men come at the house with hammers and crowbars, but I stop them. They can't destroy the house. Then I work at the restoration. I put on a new roof, cedar shingles, replace the windows, and nail on new planks. Then I paint it. Finally I stand there inside the house again, and I look out the window."

Spires may burn, boards may shift to ash, grass may cover footings—but light will live and find an eye.

For Wesleyville, the eye is David Blackwood's.

Loss of the
Flora Nickerson
1993 · 80 × 50 cm

facing page:
Uncle Sam
Kelloway's Place
1999 · 40 × 50 cm

overleaf:
Wesleyville:
Cyril's Kite over
Blackwood's Hill
1996 · 37.5 × 90 cm

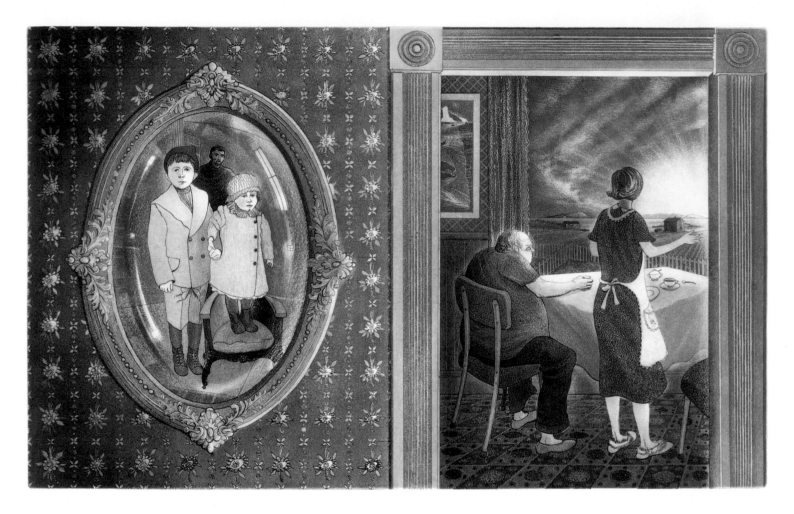

Edward and Molly

1989 · 50 × 80 cm

facing page:
Master Mariner

1994 · 50 × 40 cm

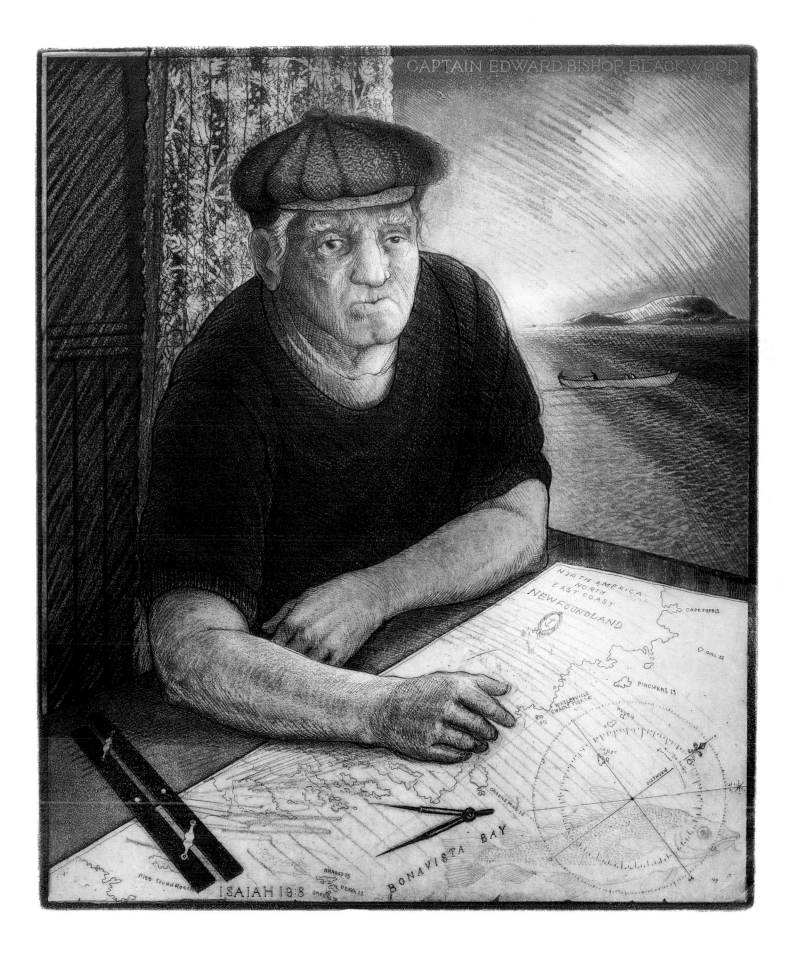

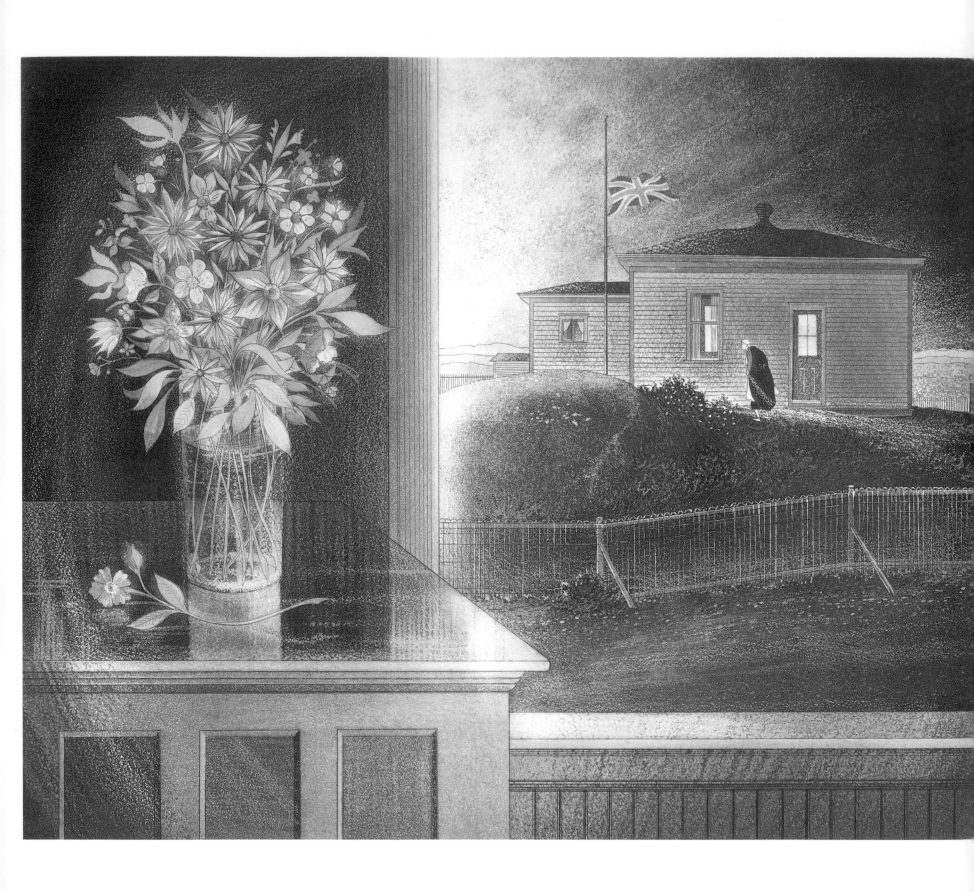

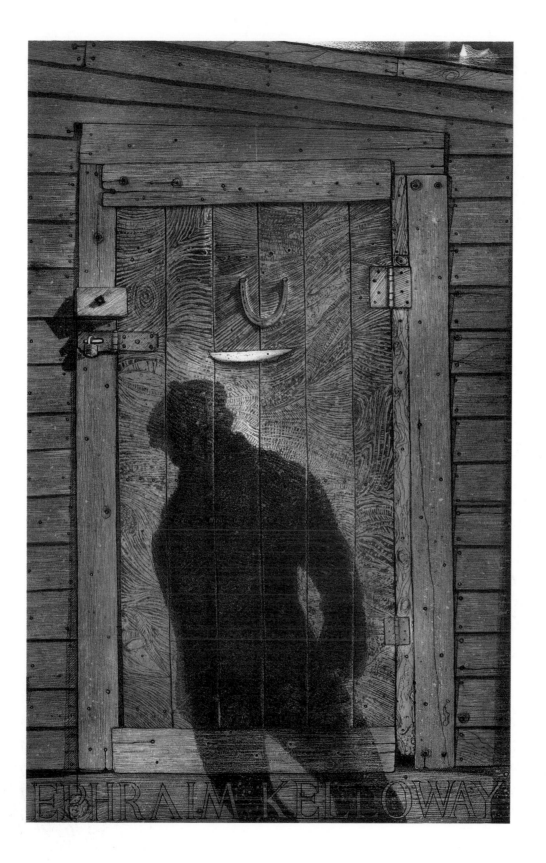

Passing Shadow

1990 · 80 × 50 cm

facing page:
Aunt Gerti
Hann Home in
Wesleyville

1987 · 40 × 50 cm

Ephraim
Kelloway's Door
1982 · 80 × 50 cm

right:
Wesleyville:
March Iceraft
1981 · 50 × 80 cm

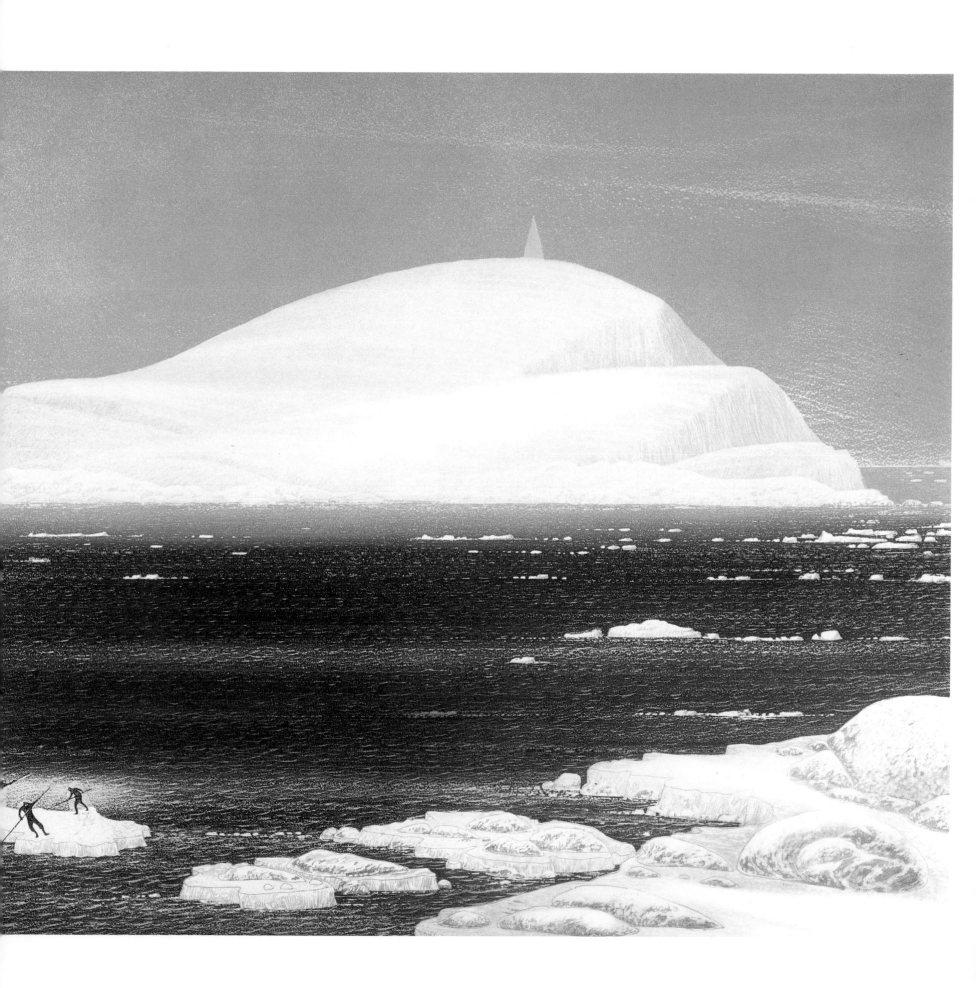

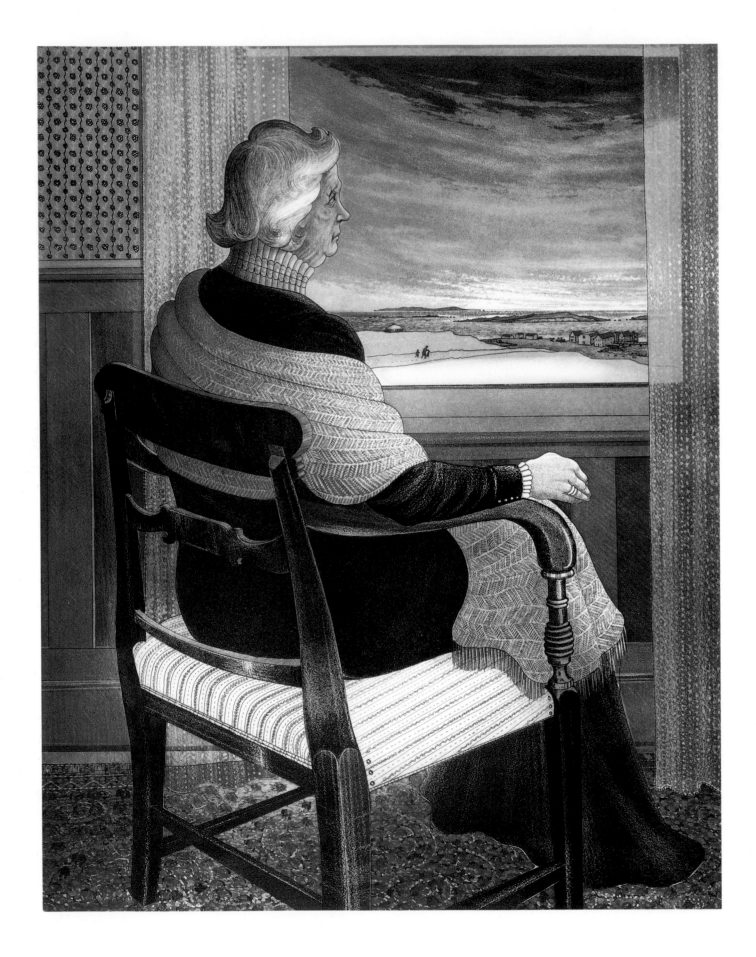

facing page:
Mrs. Captain B.
Home in Wesleyville
1979 · 72 × 55 cm

Wesleyville: Night
Passage Bennett's
High Island
1981 · 50 × 80 cm

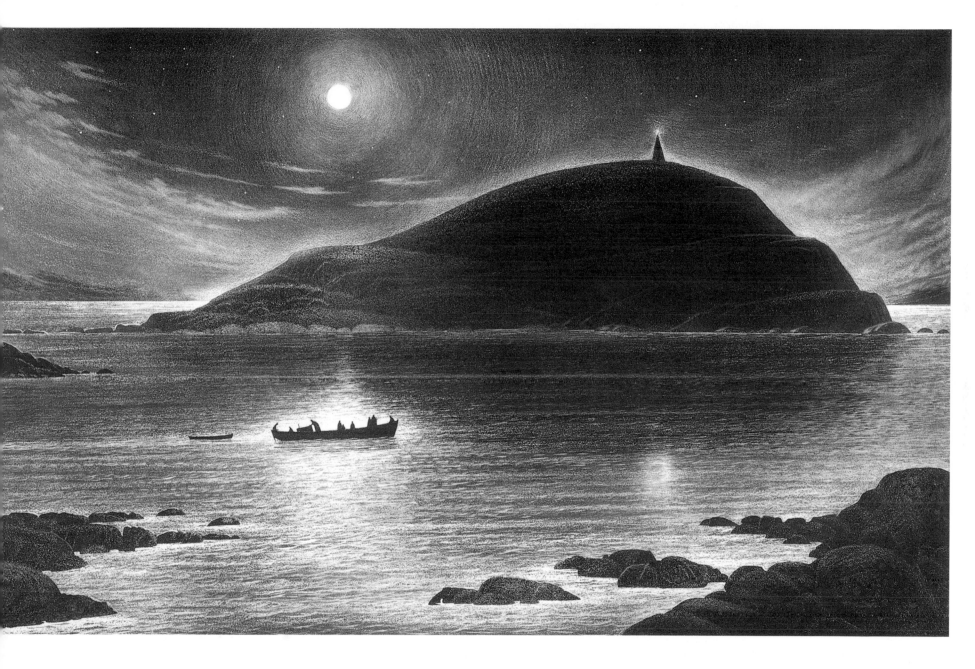

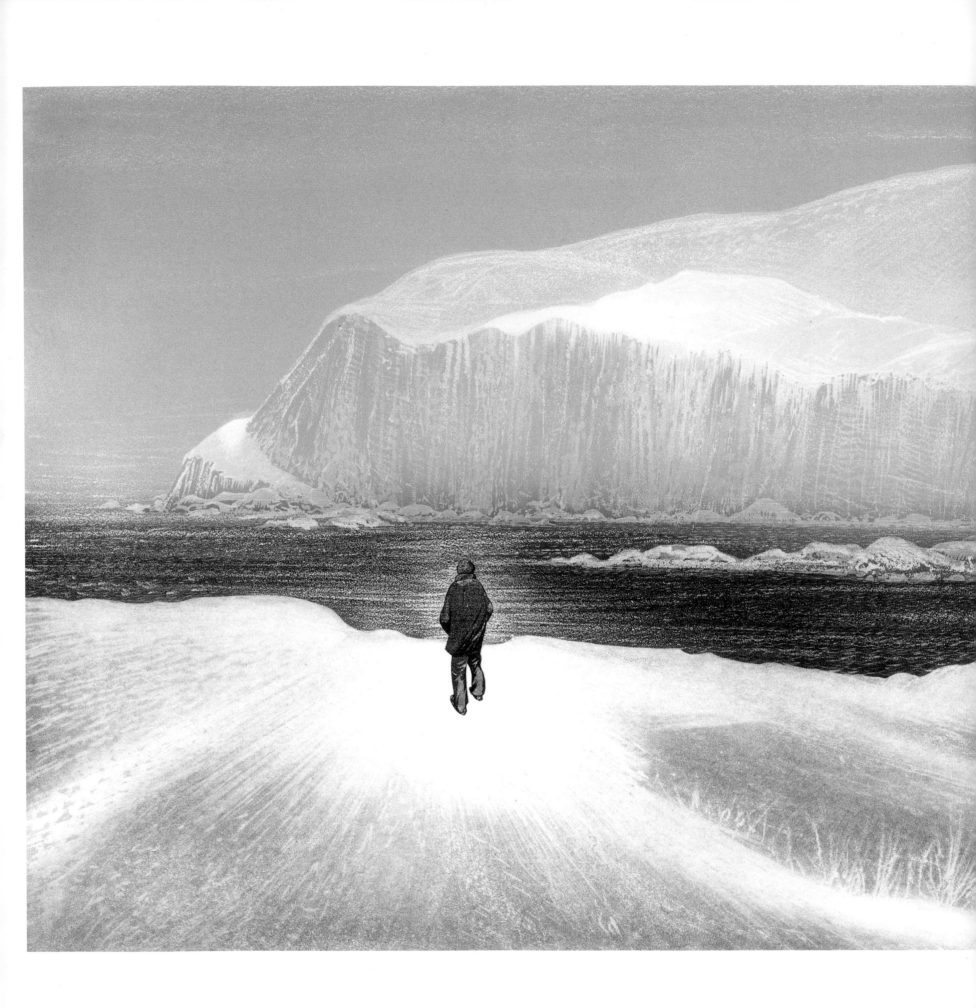

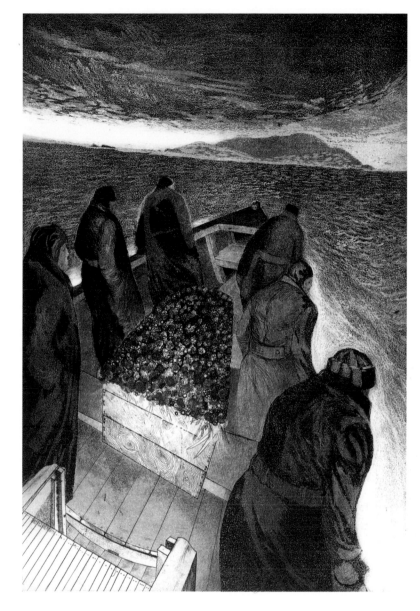

Island Funeral
1967 · 75 × 50 cm

left:
January Visit Home
1975 · 50 × 80 cm

Gift

1994 · 22.5 × 30 cm

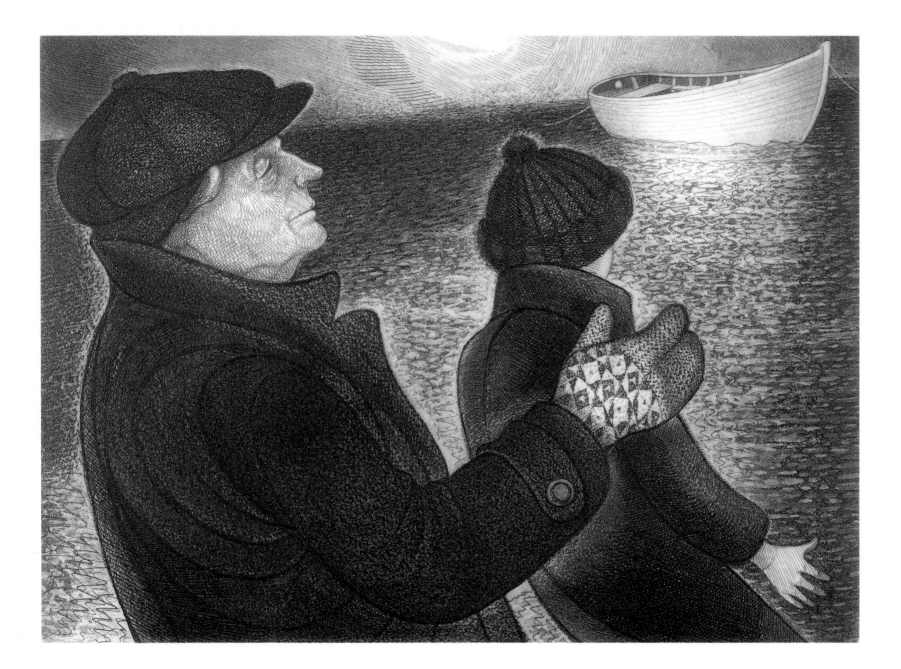

The Burning of
William Fifield's Forge
1974 · 50 × 80 cm

overleaf:
Hauling Job
Sturge's House
1979 · 32.5 × 80 cm

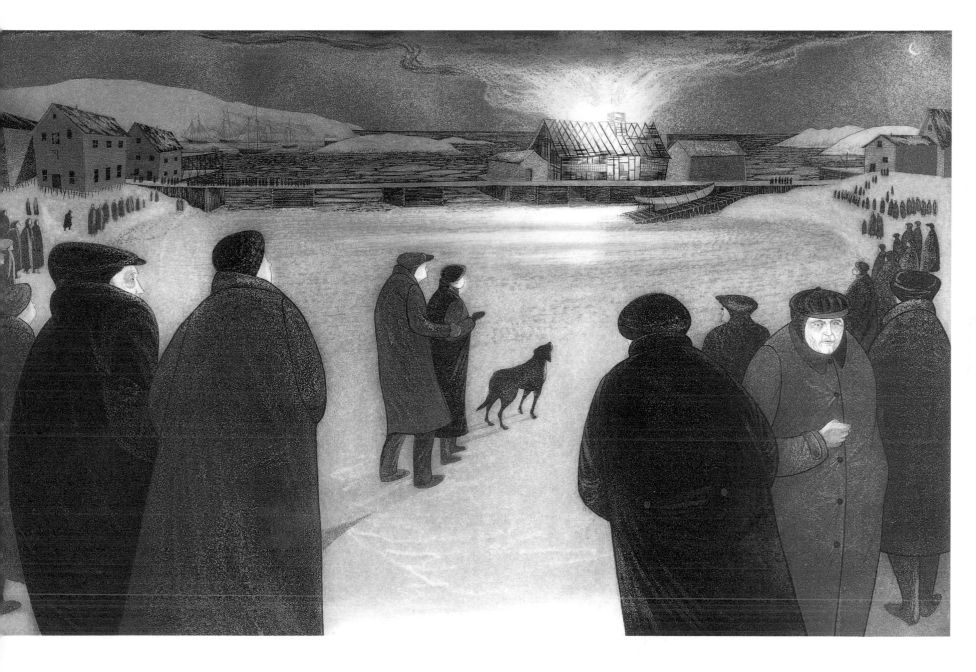

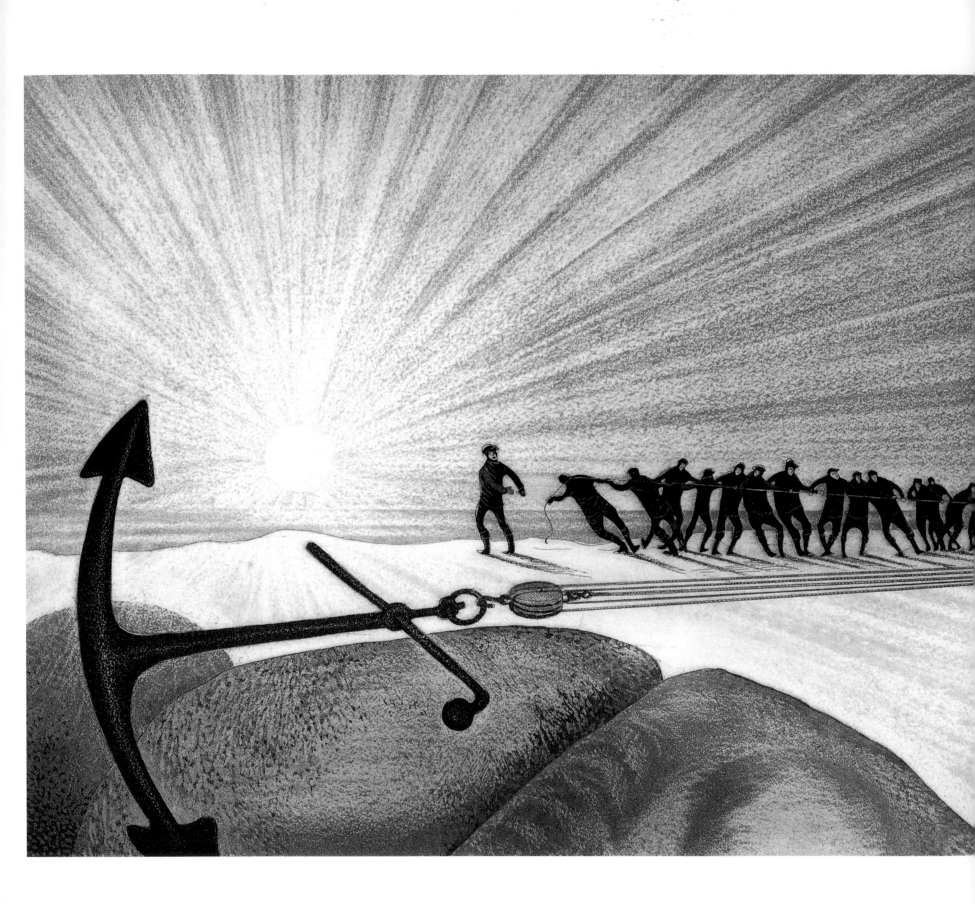

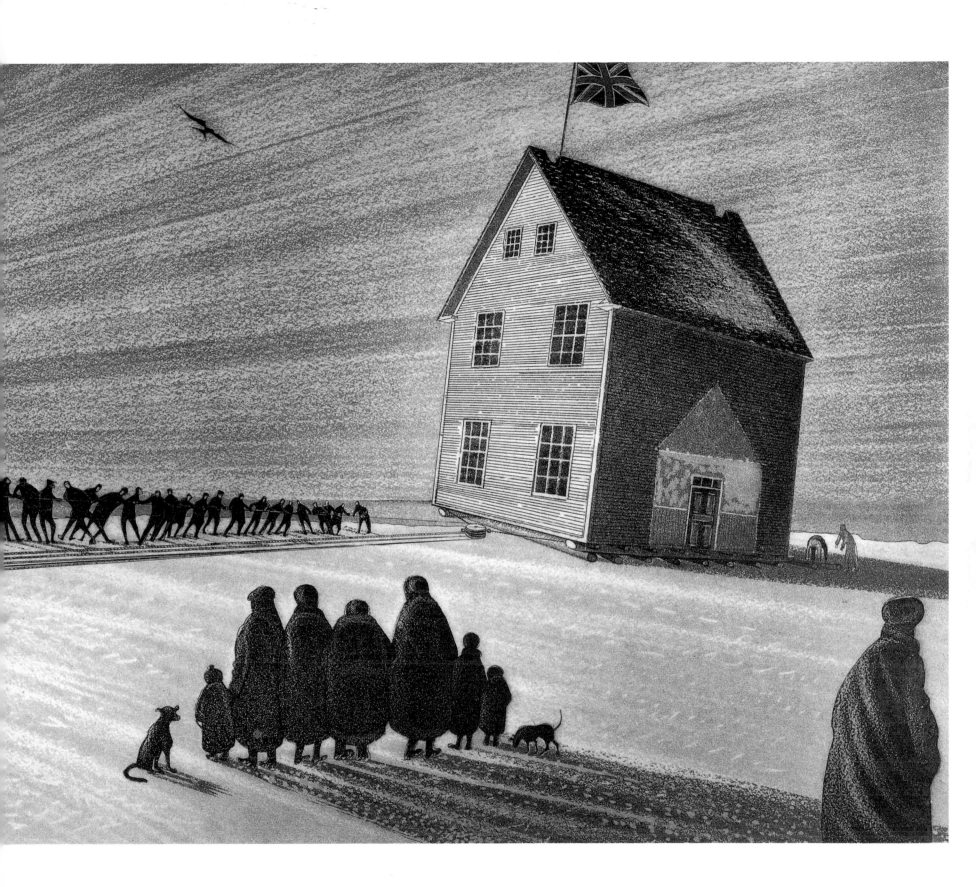

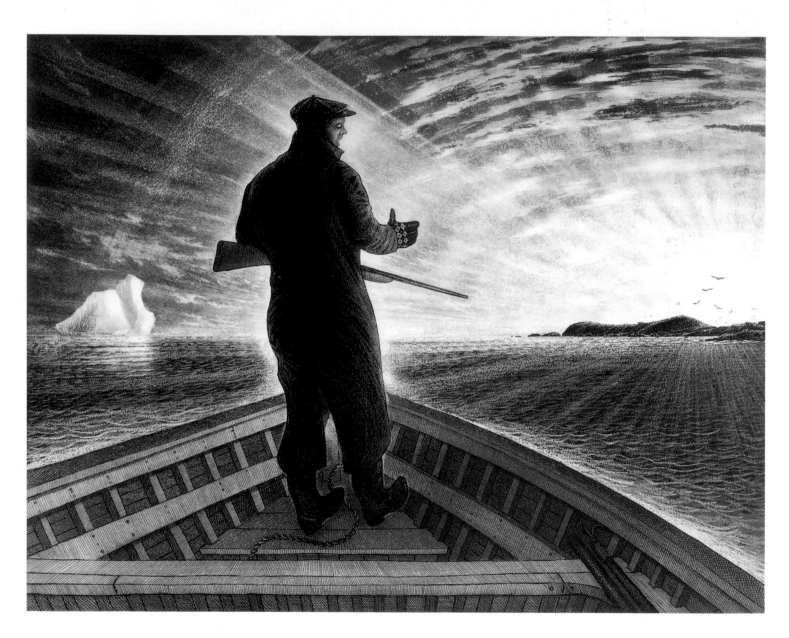

Cape Freels

1984 · 55 × 78 cm

facing page:

**For Ishmael Tiller:
The Ledgy Rocks**

1975 · 90 × 60 cm

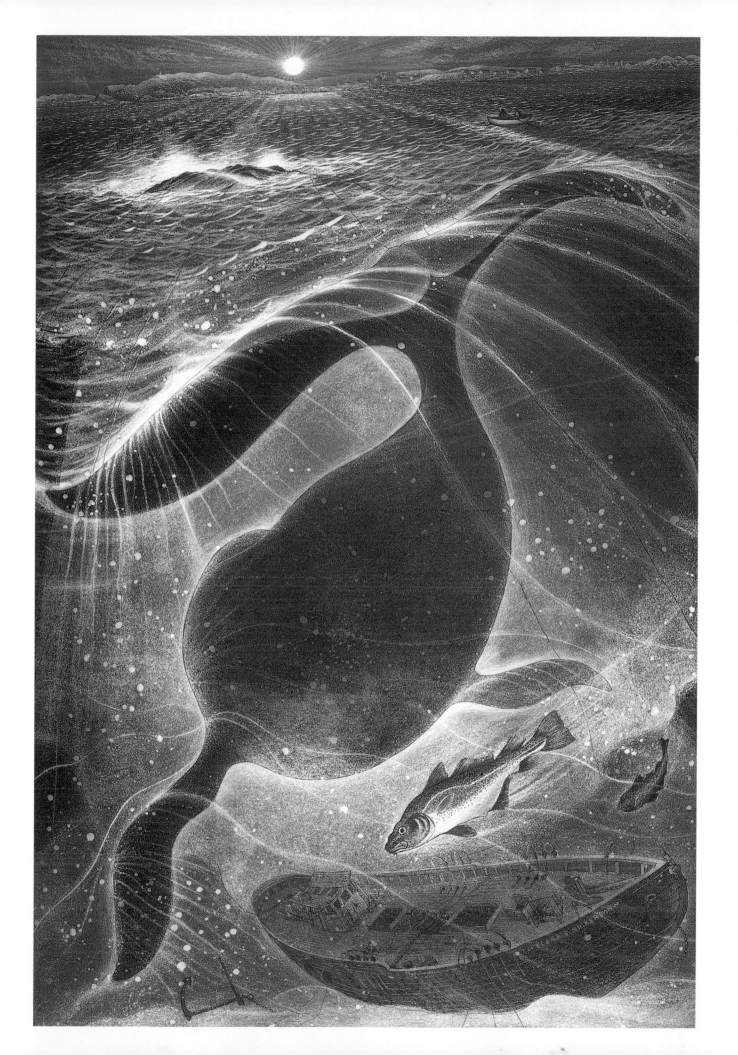

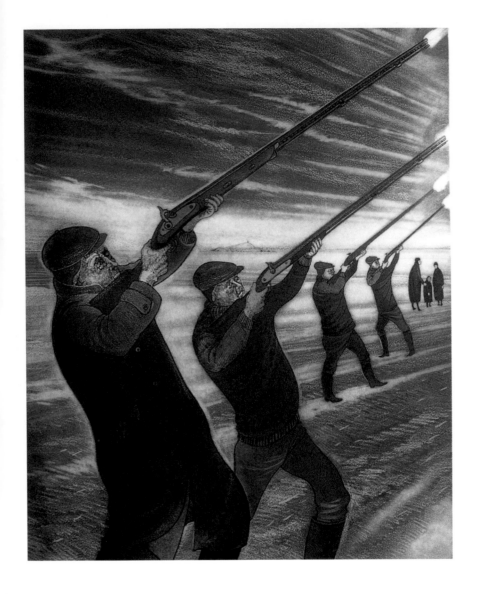

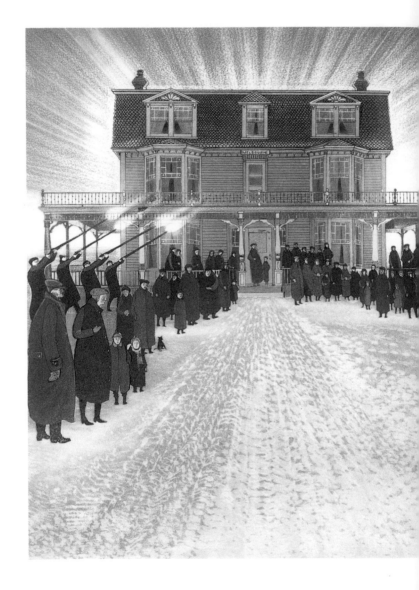

36

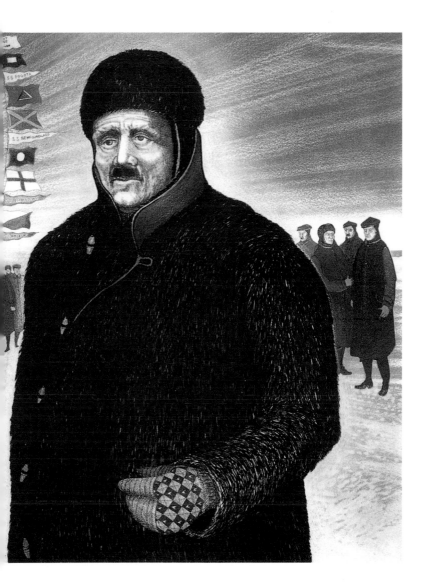

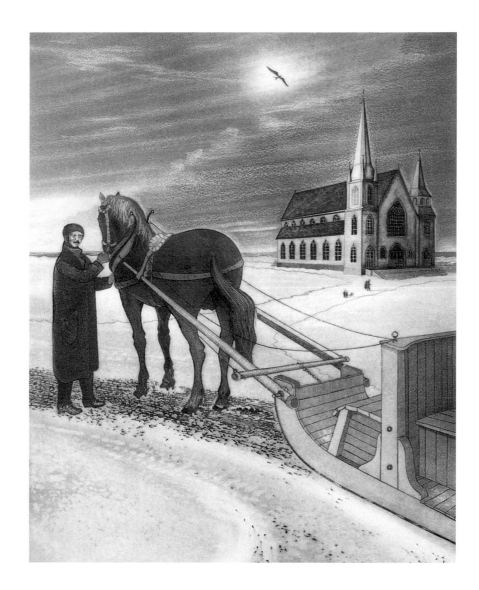

Captain Jess Home
from the Icefields
1979 · 50 × 160 cm

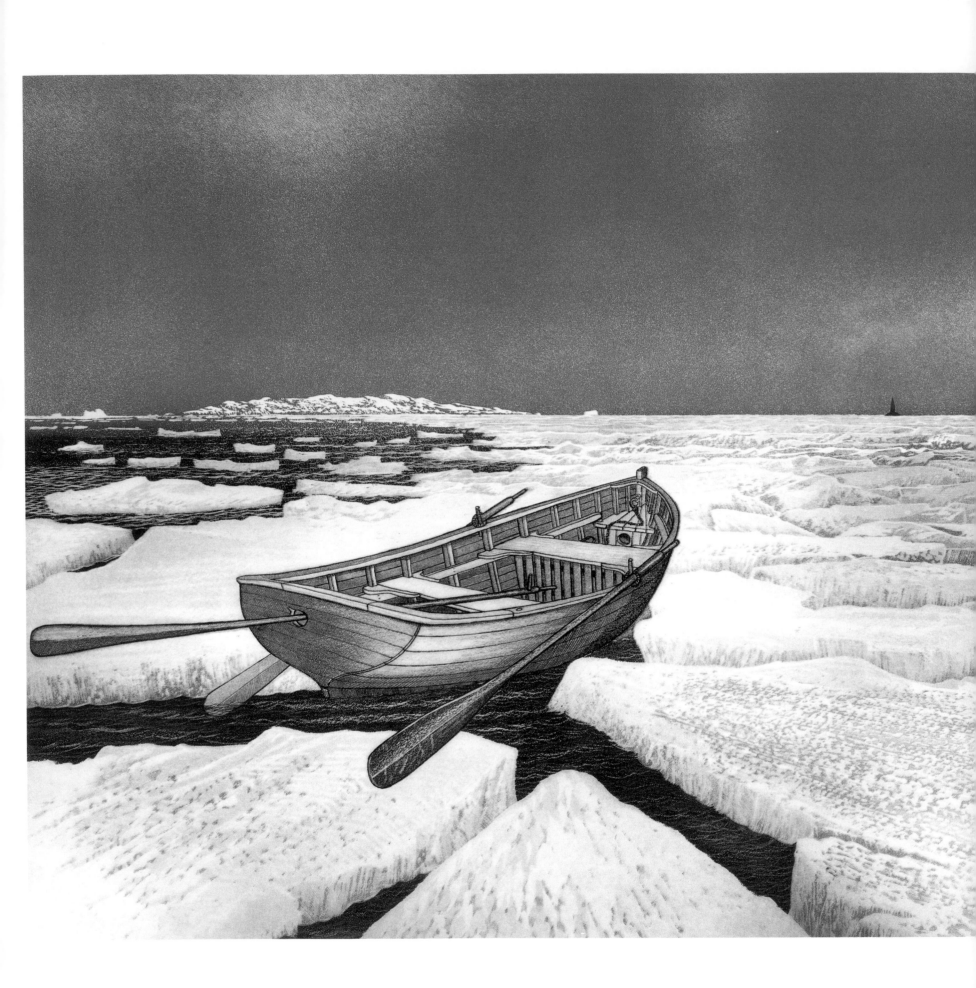

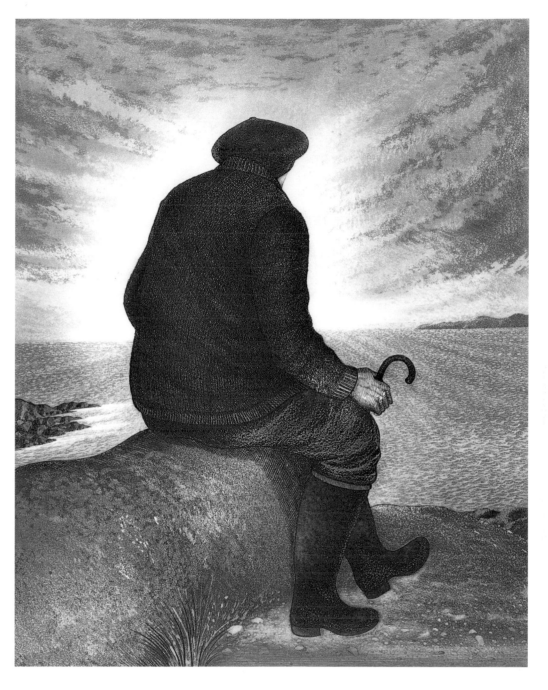

Captain Peter
Carter Home on
Greenspond

1978 · 40 × 50 cm

left:
Brian and
Martin Winsor

1979 · 50 × 80 cm

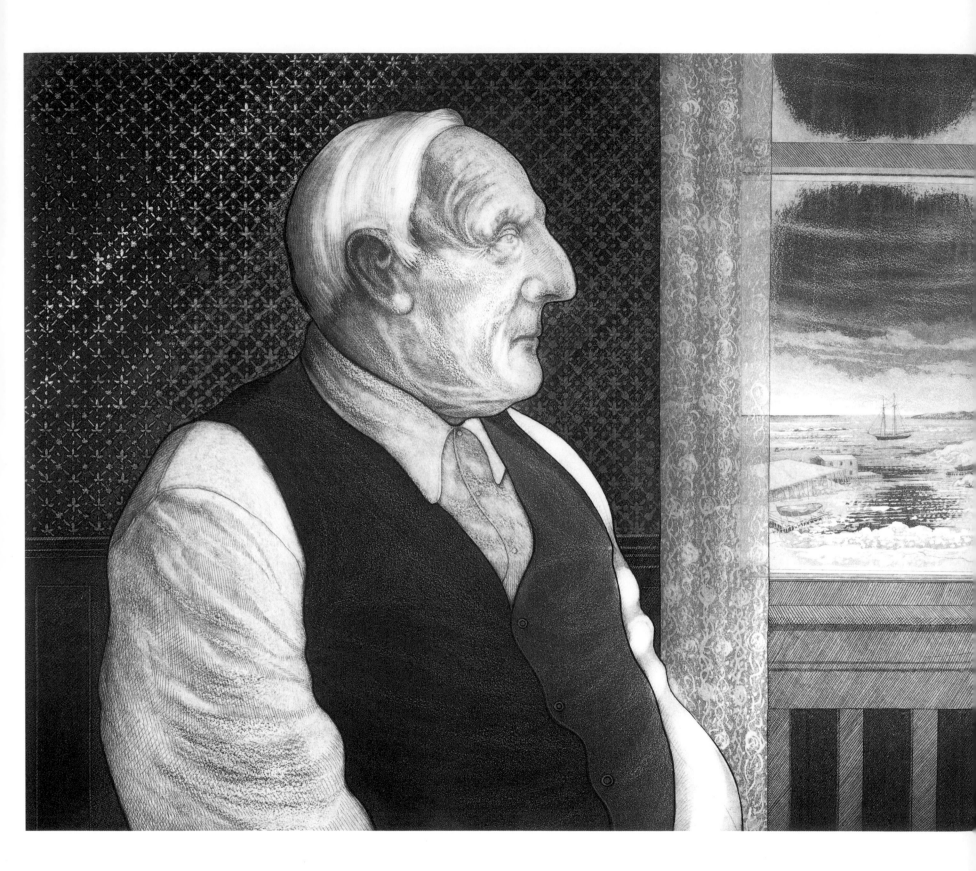

facing page:
Skipper Bax Ford
Home in Wesleyville
1979 · 40 × 50 cm

Wesleyville:
Seabird Hunters
Crossing the Reach
1981 · 50 × 80 cm

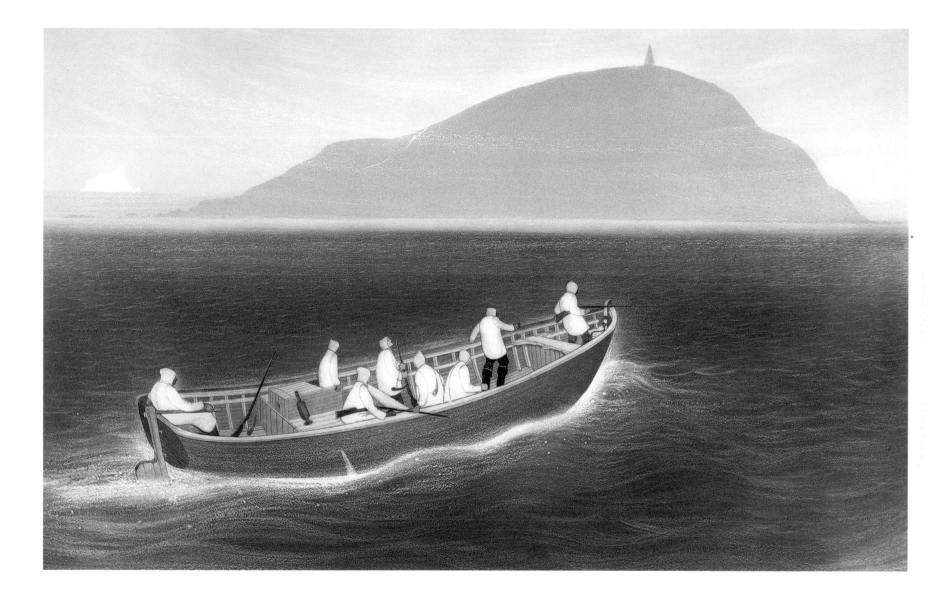

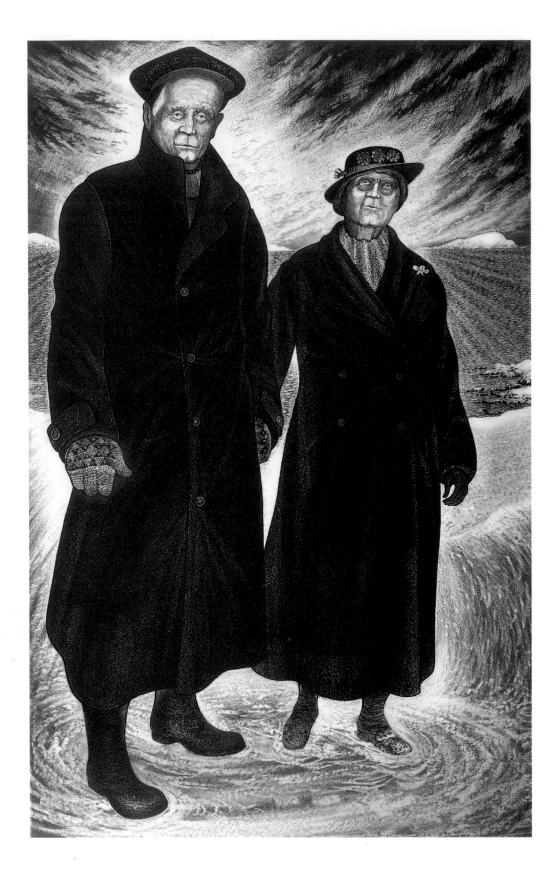

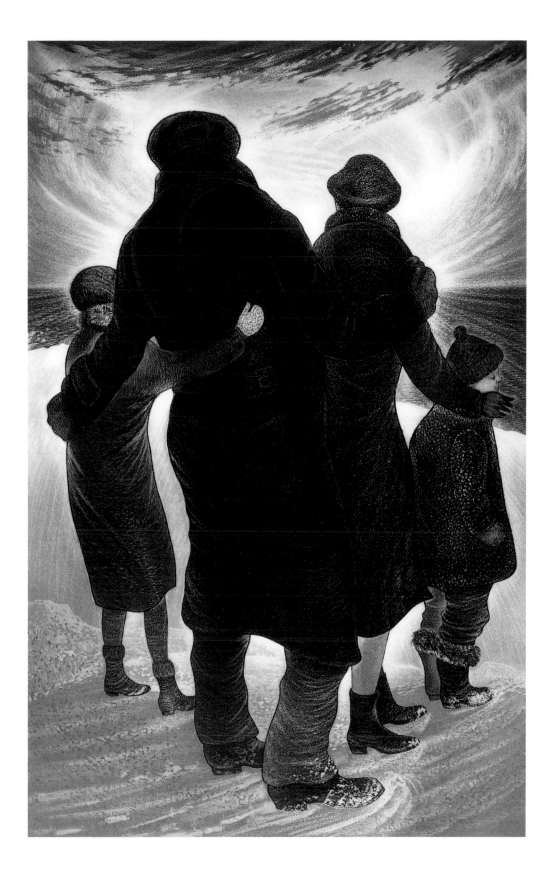

The Family
1982 · 80 × 50 cm

facing page:
Captain Alb and
Aunt Nance Home
in Wesleyville
1982 · 80 × 50 cm

overleaf, p. 44, top:
March Kite
1986 · 37.5 × 90 cm

overleaf, p. 44, bottom:
March Ice Offshore:
Eric Bishop's Kite
1986 · 37.5 × 90 cm

overleaf, p. 45:
The Seabird Hunter
1978 · 50 × 80 cm

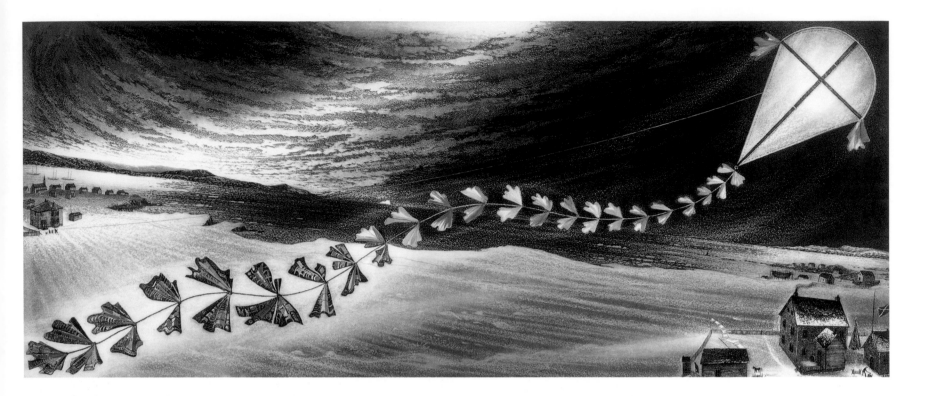

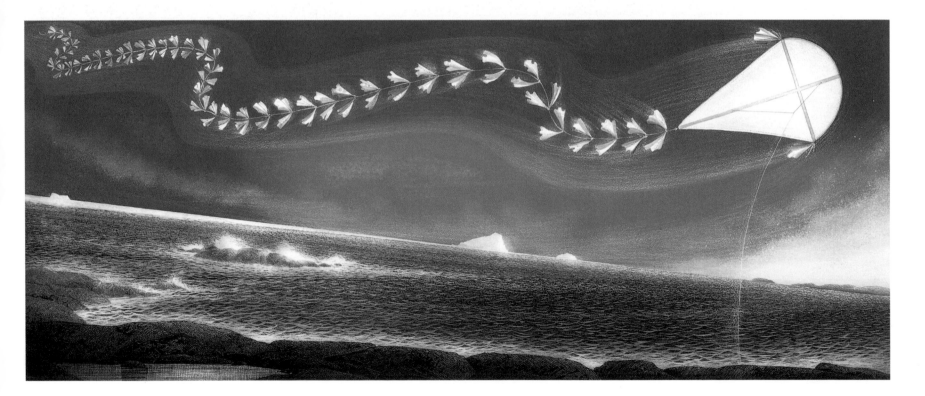

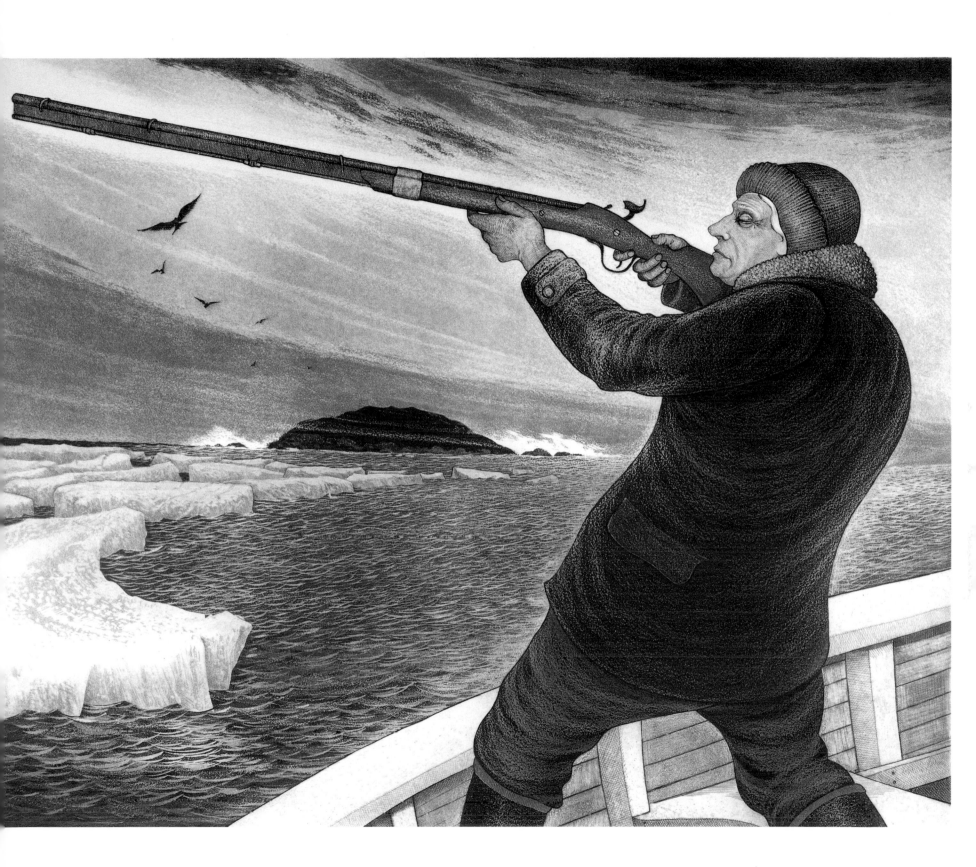

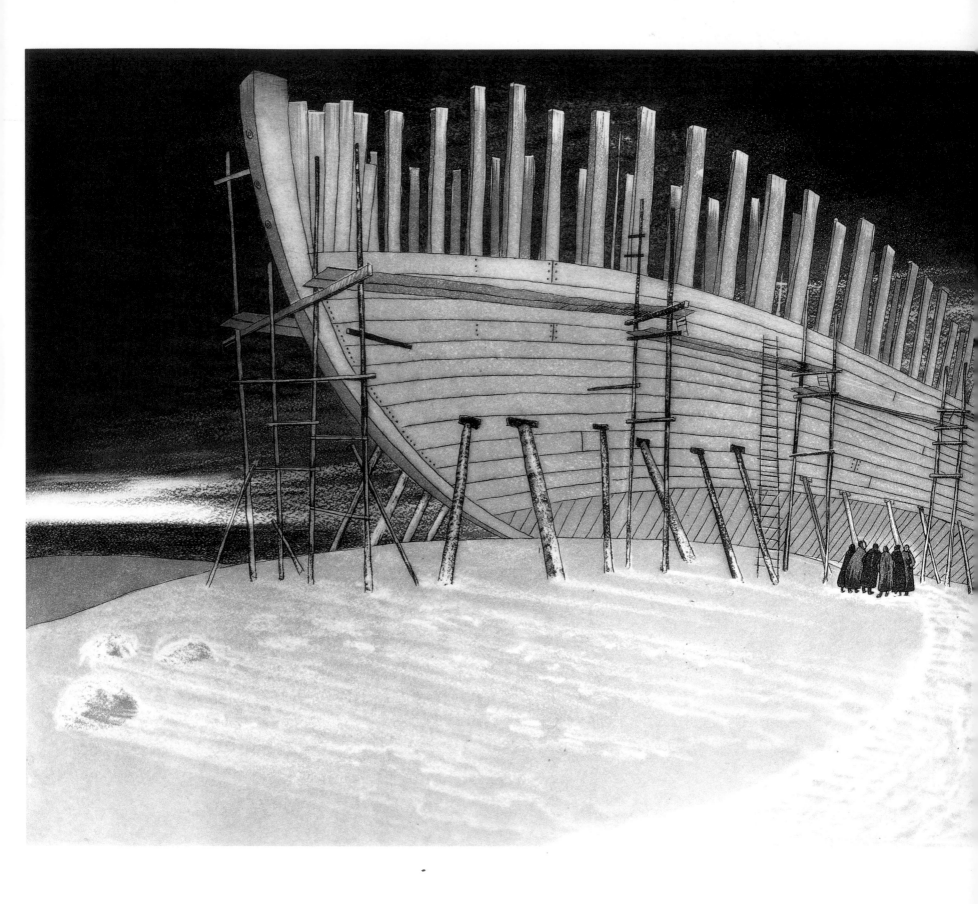

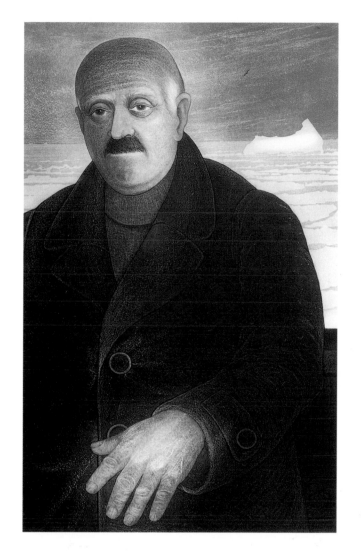

Captain Jesse
Winsor Home in
Wesleyville
1975 · 120 × 50 cm

facing page:
The *Prince
Andrew* under
Construction
1973 · 50 × 80 cm

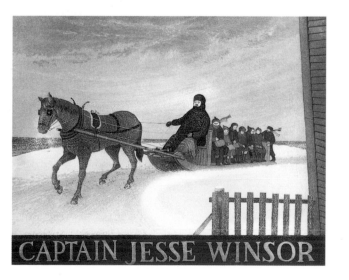

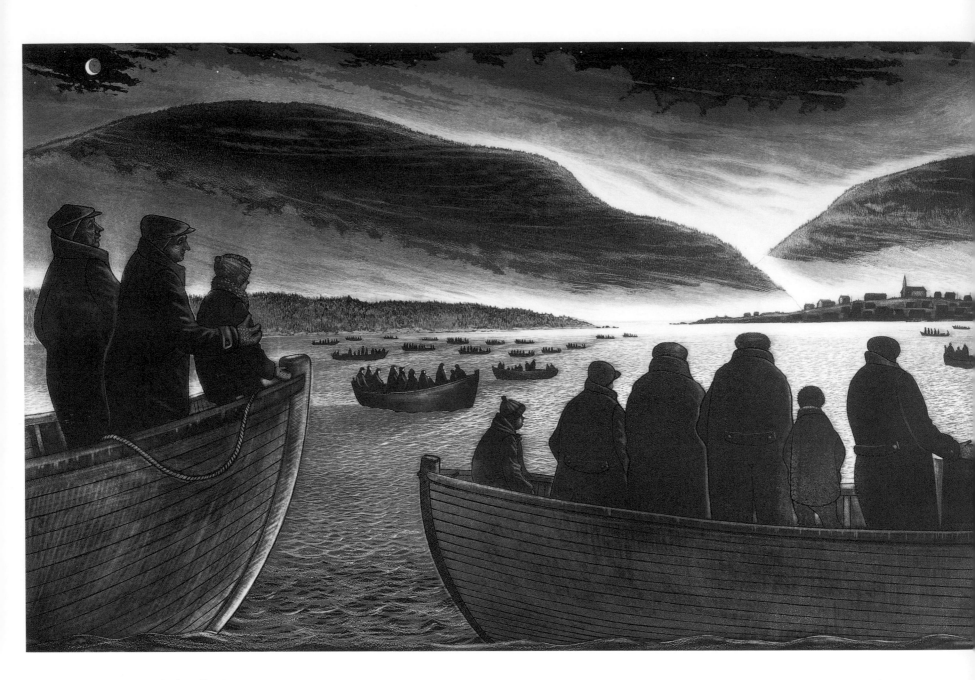

Fire in Indian Bay

1979 · 50 × 80 cm

Our Darling Man,
Mr. Coaker
1984 · 50 × 80 cm

overleaf:
Wesleyville:
Seabird Hunters
Returning Home
1991 · 37.5 × 90 cm

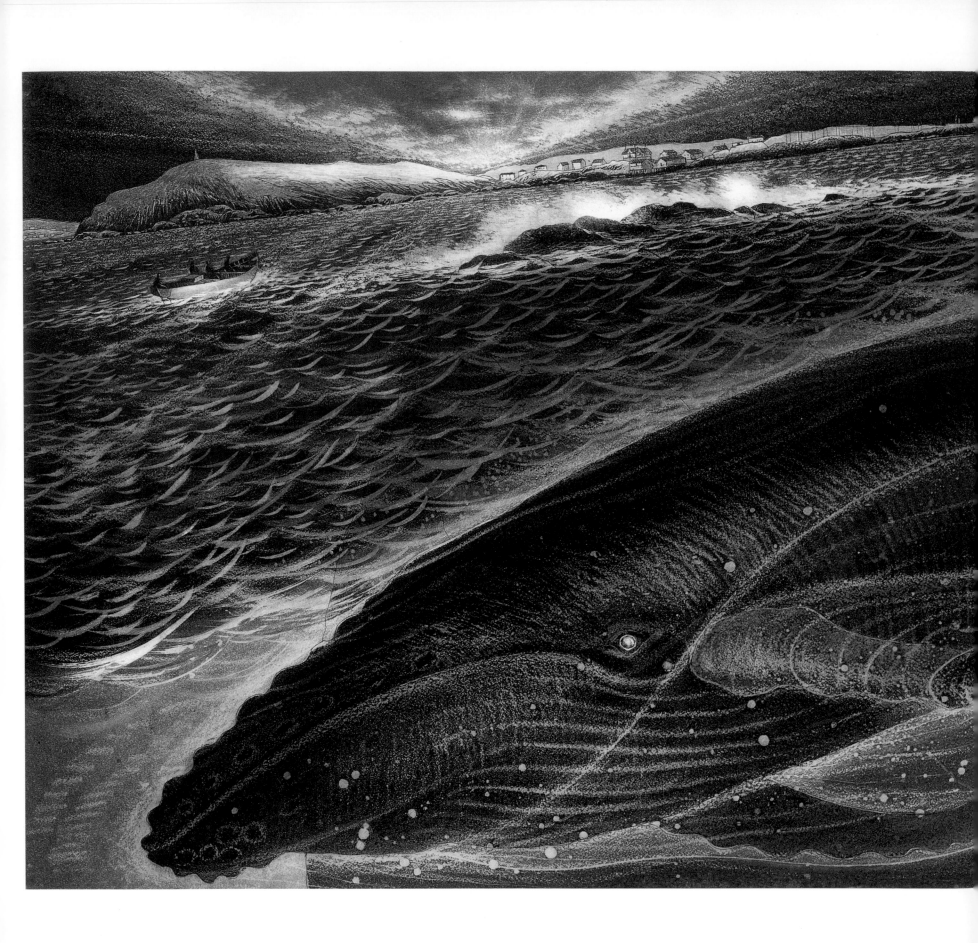

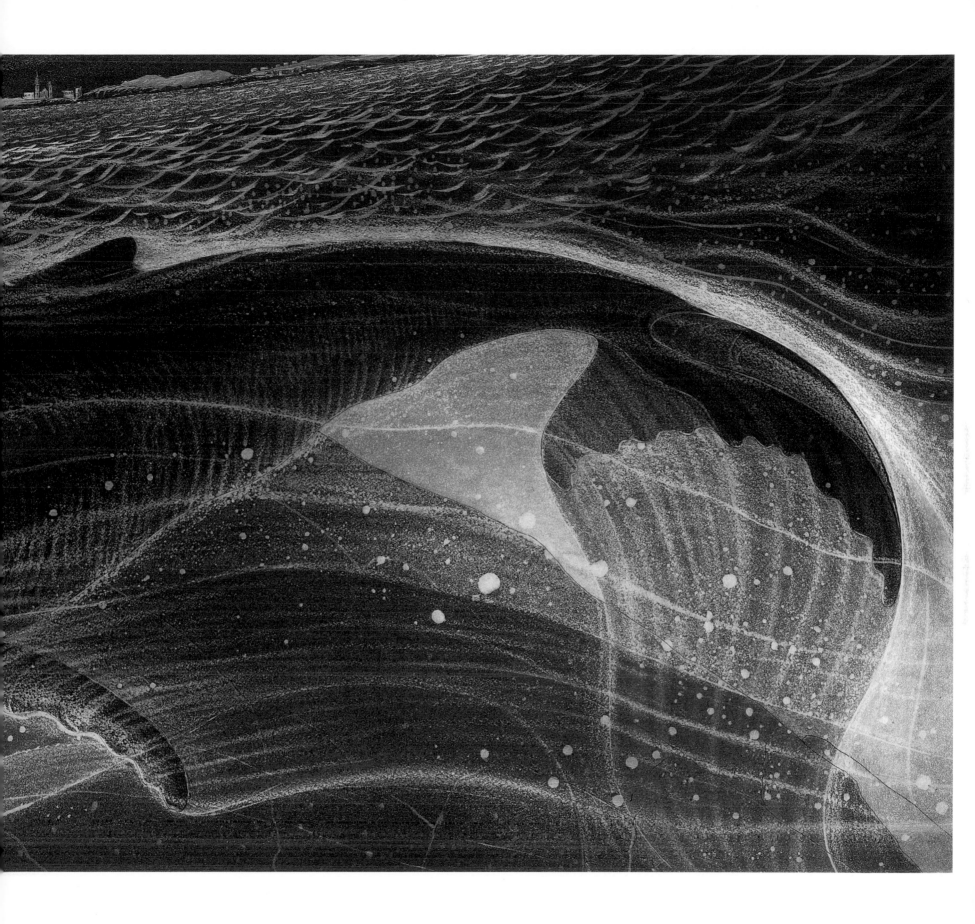

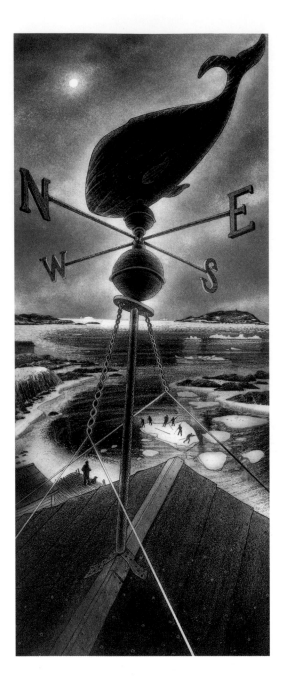

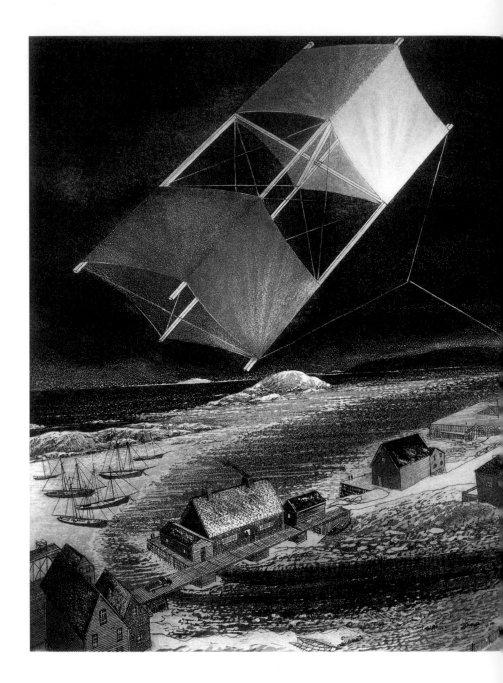

left:

Studio Weathervane:
Wesleyville
1989 · 90 × 37.5 cm

Uncle Cluny's Kite
over Wesleyville
1989 · 37.5 × 90 cm

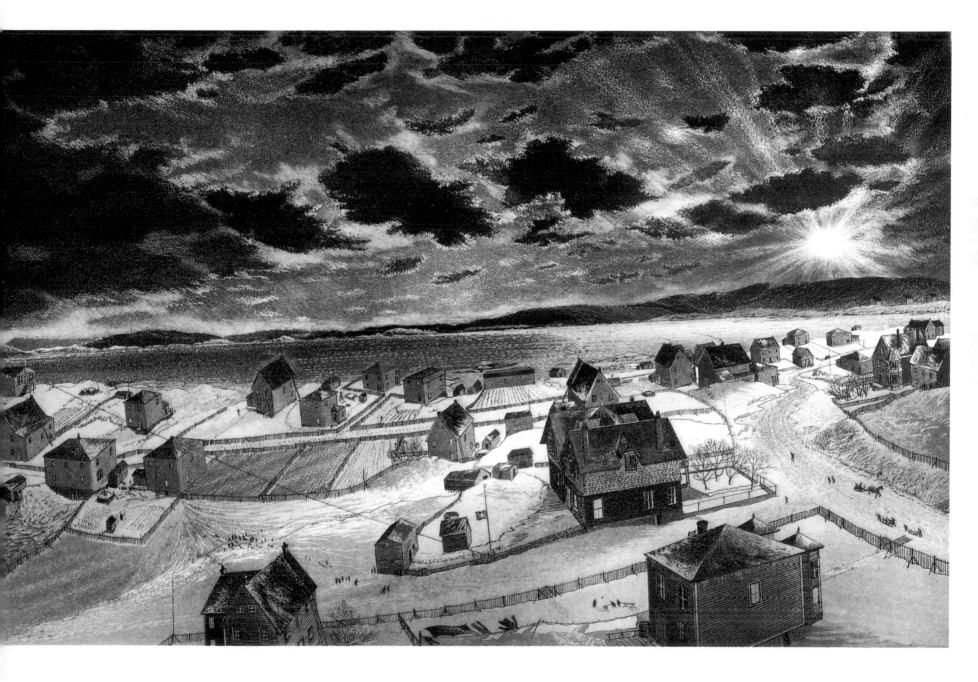

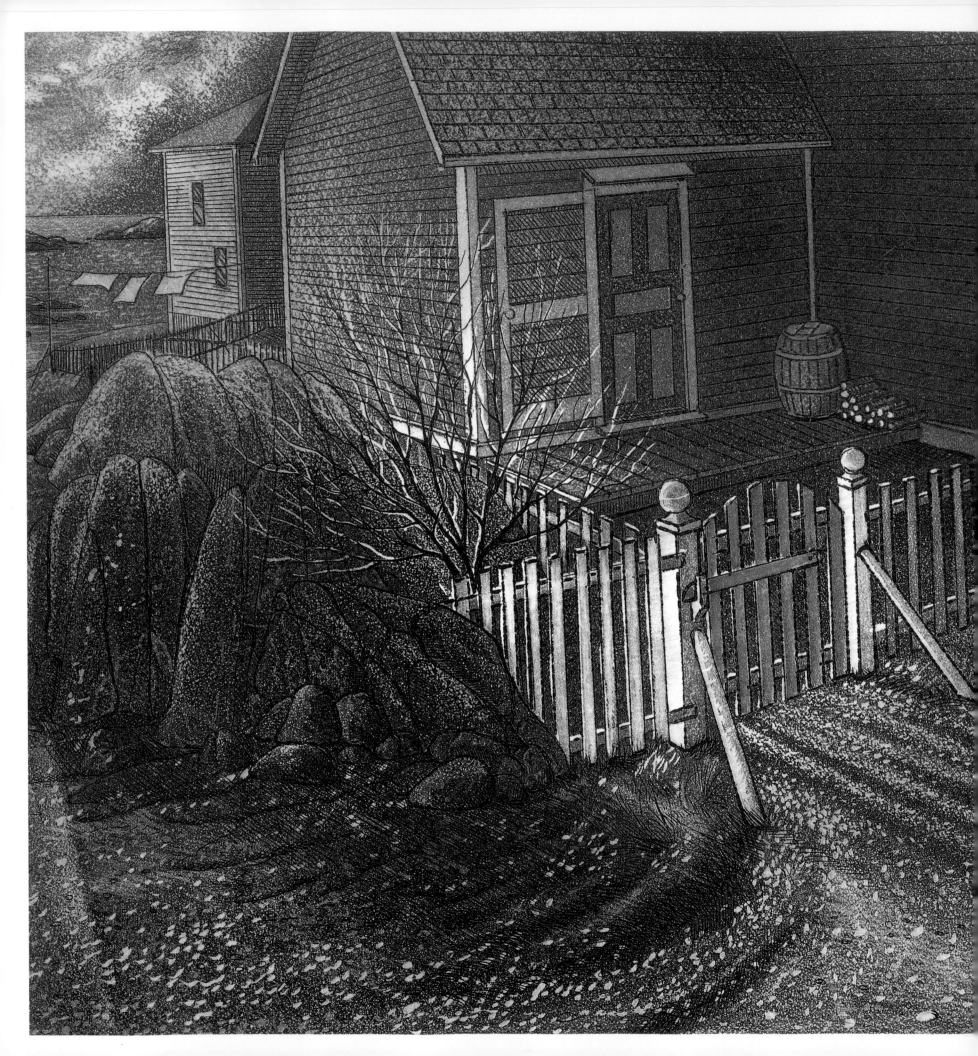

ONE SMALL

ISLAND

Haven

1994 · 50 × 80 cm

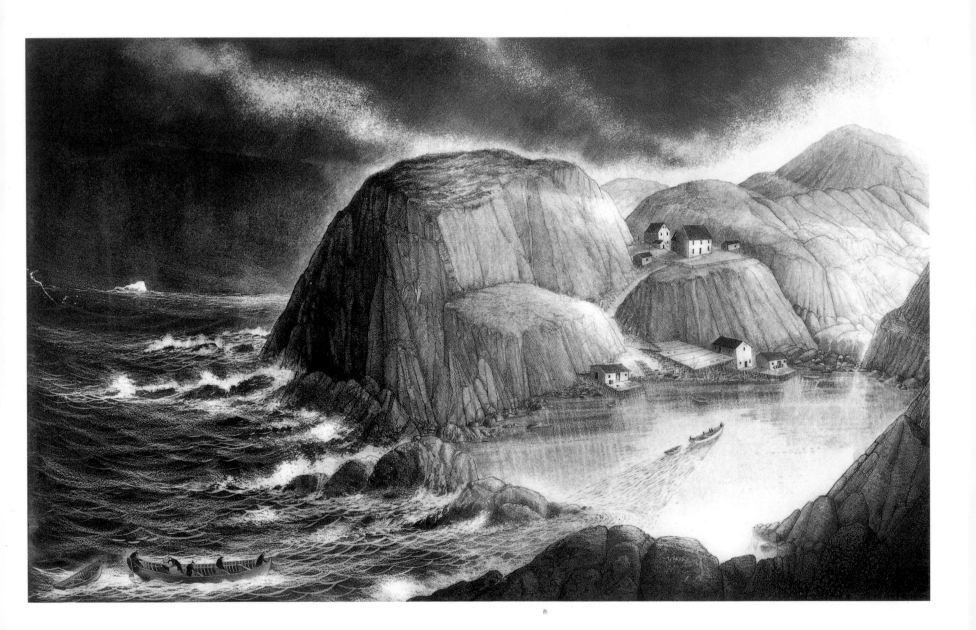

Each area of the world has its own quality of light. There is no confusing the sky that roils over Rome with the salty sky of Normandy; neither is it possible to mistake the clouds or the glow inside the light-filled wind that whistles and keens through the sky of Bonavista North for any other place on earth.

Schools and television news train us to see the world as a place of boundaries and borders. But for the child, the explorer, the alchemist, and the artist there is only, ever, a geography particular to the land itself. And for a child there is always a magical place outside all boundaries and borders. For David Blackwood that place is one small island, the home of his grandparents Glover, just a short distance from Wesleyville.

Settled around the turn of the century, Bragg's Island is a little over a mile in length and about half a mile wide. The people who arrived soon began the process of naming every part of the little island. Soon it wasn't just "Bragg's Island"—you could say you'd been to Little Bait Cove, Bragg's Point, Lane's Harbour, or Gilliam's Harbour, or had gone a little offshore to Jack Barr's Island. Instead of pointing to an empty piece of land, you'd show people the new house of Uncle Absalom—sparkling, freshly painted with ochre and oil, against the sea. There, a stone's throw away, was the house of Aunt Mag Feltham. It was always painted ruby-red with white trim, and it had a shingle roof and curious, diamond-shaped windows. One window let light into the pantry, another allowed sunshine through the upstairs hallway. Uncle Elias Feltham would look out one of the diamonds and, on a clear day, see the sun itself shattered into diamonds by the ocean. On stormy days, the edge of the island would shiver the waves into foam that licked the rocks and slid along the catwalk. Bragg's Island houses began to smell of high tide; paint held rimy roughness, steps were salt-lick bright. Echoing around and around were the crash of waves, the mew of gulls, the creak of boats at their moorings, and the shouts of children as they called to each other while catching conners in the shallows along the shore. In the air was the smell of fir, new-split, and of fish with sun-curled tails. Youngsters would peel off small yellow-white pieces of the cod that resembled tough salted canvas, chewing while they looked out to sea. The barking pots where twine soaked gave off quick scents that lingered on nets and calloused hands; the smell of ochre and oil mixed with fresh-baked bread and salt-beef dinners.

At night there was prayer and, afterwards, sleep that breathed the rhythm of slow waves.

Sundays, familiar hymns could be heard to echo along the shores, and when visitors from Popplestone Island, Green Island, and Wesleyville were going home, their hymns too would drift back to Bragg's Island. As the boats pulled farther away, the singing would stir the water's edge until all became one hymn. Deep in feather beds, rolled into sleep, sometimes a warm rock with you against the cold, the music lingered.

This was a place that seemed to be forever. Men and women lived with the sea, and when they died they were buried by the sea, salt joining tombstones to the ocean.

For David Blackwood, Bragg's Island was, in many ways, his grandmother Alfreda Glover. Strong, warm, and—despite harsh and bitter weather—always welcoming. For the artist, Gram Glover personifies much of what was grand and glorious about Newfoundland civilization.

Blackwood's grandfather, David Glover, built the Glover house the year before he married Alfreda. That was the custom then: when a man became engaged, he'd begin to build the family house. He and his wife-to-be would spend hours talking about their home: the direction it would face; the colour it should be; how best to build it to keep the storms at bay. For paint, David's grandparents chose a rich viridian green, with yellow trim to sharpen the house against the sky. They planned a big back kitchen where a man could take off his fishing gear and wash away the scales before entering the main house.

When their home was ready, the couple were married. The greening house became their honeymoon, became the marriage bed, became the space where eventually David Blackwood's mother, Molly, could stand on tiptoe to see the lantern that, on a pole, shone light to warn of rocks and shoals. It was there that Molly would comb her long black hair and look out to sea, wondering what the ocean would bring her. It was on Bragg's Island that David Blackwood, the first son of Molly, would reach for the strong, warm arms of Gram Glover, and she would whirl him to the sky. Nighttimes, in the kitchen, she'd tell him stories of his own mother as a child, before the troubles came upon her, before the warning light pulsed red against the rocks. The lamplight would pour warm along Gram's face and spill over her knitting fingers, and David would watch and listen. Later he would creep out of bed in the darkness to see the moon pull caplin spawn through the waters.

This was Bragg's Island forever, he thought. On Bragg's Island then, no Newfoundlander had yet heard of "resettle-ment"—the bureaucratic vision of outport people living neatly in "growth centres." It was a dream of the province's premier, Joey Smallwood, to stop the raggedness, the sheer disorder of people living wherever they chose to love and make their homes. No one on Bragg's Island had dreamed the dream of resettlement. But, as a young man, Blackwood's grandfather had encountered Joey Smallwood. Talk of confederation was everywhere at the time; David Glover was opposed to it, Alfreda in favour. One day while Glover and some other men were digging a well, he glanced over to see that his wife was standing watching them, a stranger at her side. The short, painfully thin man in the black suit and the trademark bow tie was identifiable at once as Joey Small-wood. But Blackwood's grandfather didn't pay much attention to the unwelcome arrival. It wasn't until his wife approached and told her husband that Smallwood would like a "chat" that Glover glanced over again. Then, instead of going over for a chat, David Glover looked back into the well that he and the other men were digging. Loud enough for Smallwood to hear, he replied, "We're doing something important here, and I don't have time to waste on politicians."

The Smallwood government found it irritating, as the twentieth century marched on, to see a people who clung to land that was "inconveniently" located. Once upon a time, doctors had been expected to brave the storms, fight the seas in all weather to help people on Bragg's Island; now it was decided that was the wrong way to run things. People were to be moved to places where there were government services, instead of having the services come to them. Neat rows of figures in sharp columns on white paper laid the foundation for the plan. Men in shirts and ties schemed deep into the night inside their brick buildings, fluorescent tubes lighting their pale faces.

Once resettlement was underway, the politicians came up with many reasons for people to move. "We can't get you teachers, doctors, plumbers, electricity, or television here," they said. "Come to us, and we'll give you what you're missing."

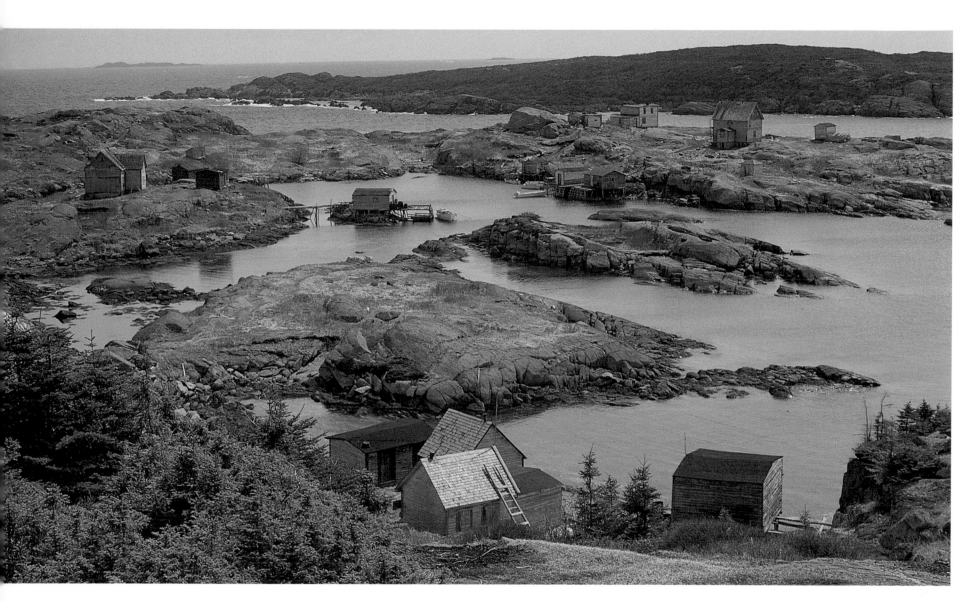

View of Bragg's Island, 1968

No one had ever heard of such a thing as resettlement when young David sat in the front of a motorboat on his way to Bragg's Island, waiting for the first sighting of the warning light. "Then one night," recalls Blackwood, "Gram Glover had a dream. I can remember her coming down to the kitchen that morning. 'Well, well, well,' she said. 'I had a funny dream last night, that we all had to pack up and leave this place. That we had to pack up and everything was torn to pieces, like there was another war coming. The whole place was in a shambles. There must be another war coming!'

"When the time came for them to be resettled, they didn't shift the house, you know; they took it down. And my grandfather locked himself in his shed and wouldn't come out. So his own son started to take the house down; piece by piece, he took apart the house."

As each board was pulled screaming from the wedding house, the house of the marriage bed, the birthing bed,

the kitchen with the warm stove, the windows that had always seen the sea, Blackwood's grandfather stayed locked inside his shed.

David Glover lived for years after that week, in a house in a growth centre. He sat and looked at the wall. The pole that had held the warning light was broken, the lantern gone, and an old man turned his back to the outside world in a house he hadn't built.

If he had known that someday people would start to move back to the island, that there would be families who make the place a summer home and some who think to live there year round, David Glover might have stood and walked and found a boat, then pulled straight and true, hands huge upon the oars, angled as a gull heading back home towards Bragg's Island.

As it turns out, there was one crucial factor the bureau-crats didn't consider. There is something stronger than brick buildings, more powerful than columns of figures and forms filled out in triplicate. The bureaucrats dismissed Bragg's Island, if they thought of it at all. But their calcu-lations hadn't included the boy who would gather the stories, the sounds, the sights, the memories of all who had lived on that one small island. Patiently, with great care, David Blackwood would reconstruct the world of his child-hood on paper, drawing out the faces of those he loved, their eyes as they seek out our gaze, their hands as they reach towards us.

Gram Glover Home
on Bragg's Island
1976 · 55 × 72 cm

overleaf:
Uncle Eli Glover
Moving
1982 · 27.5 × 85 cm

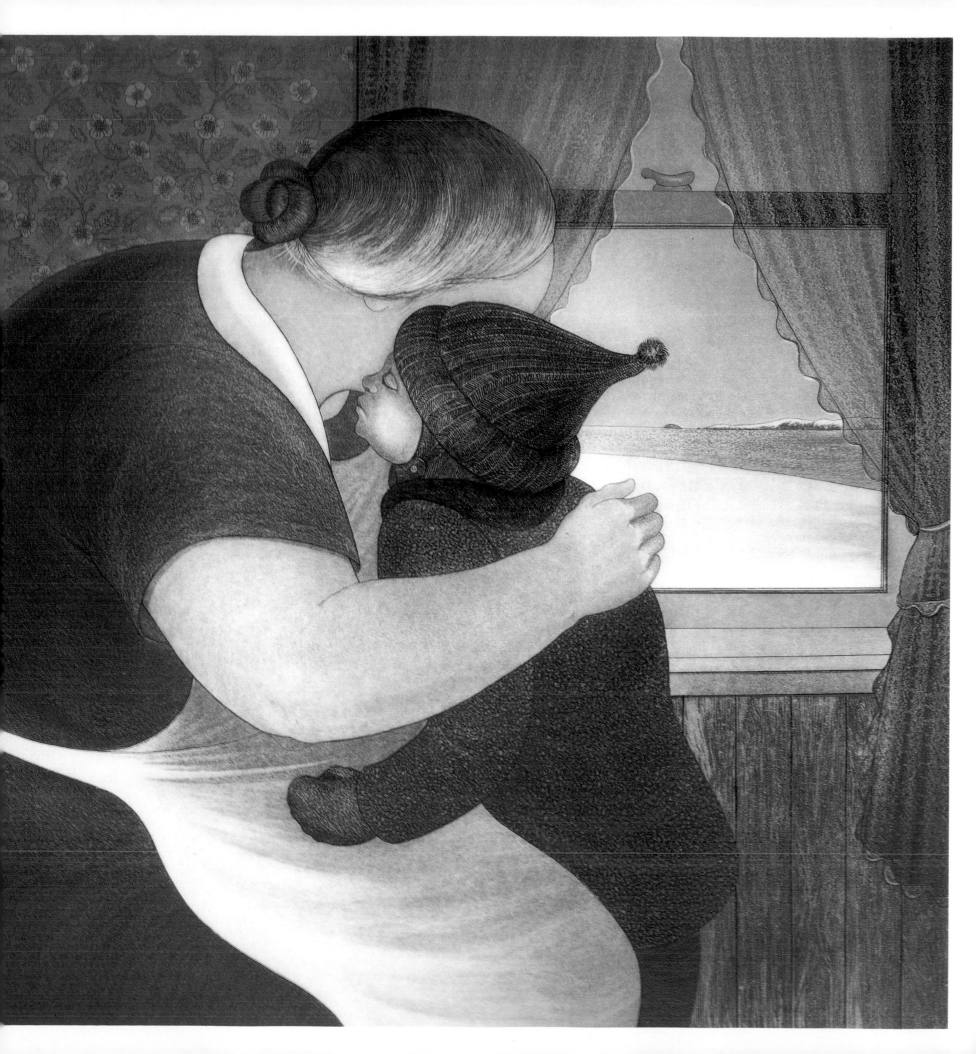

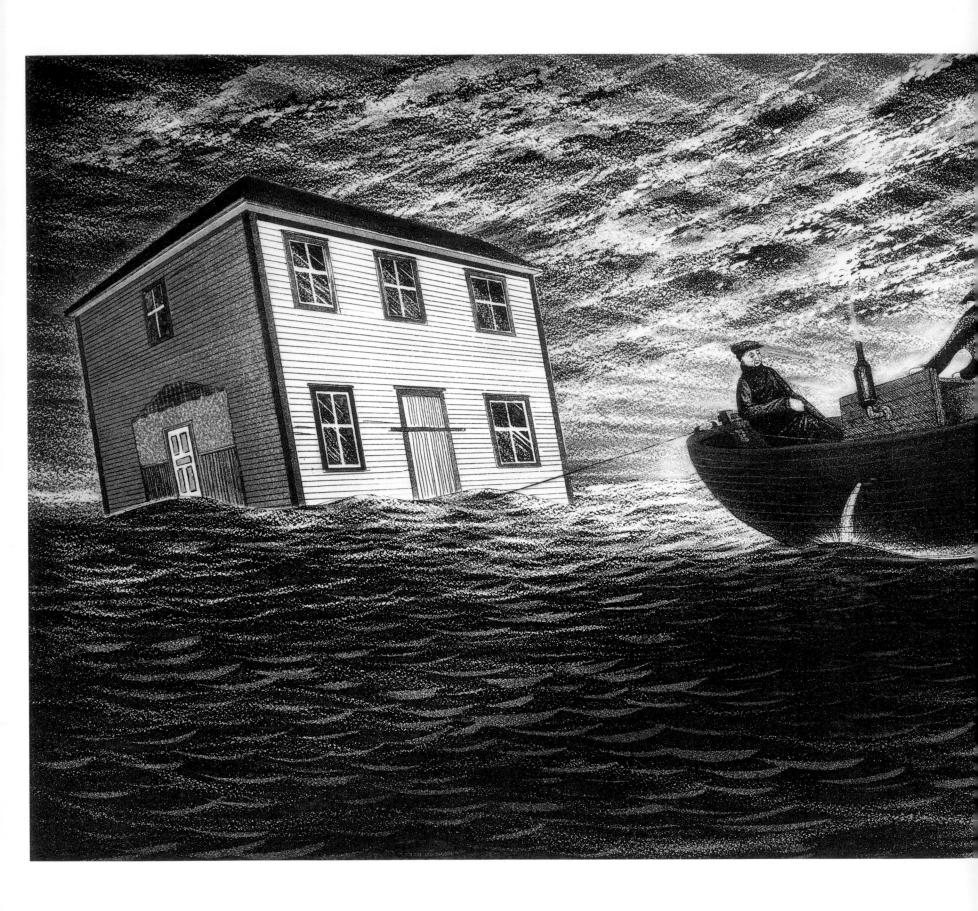

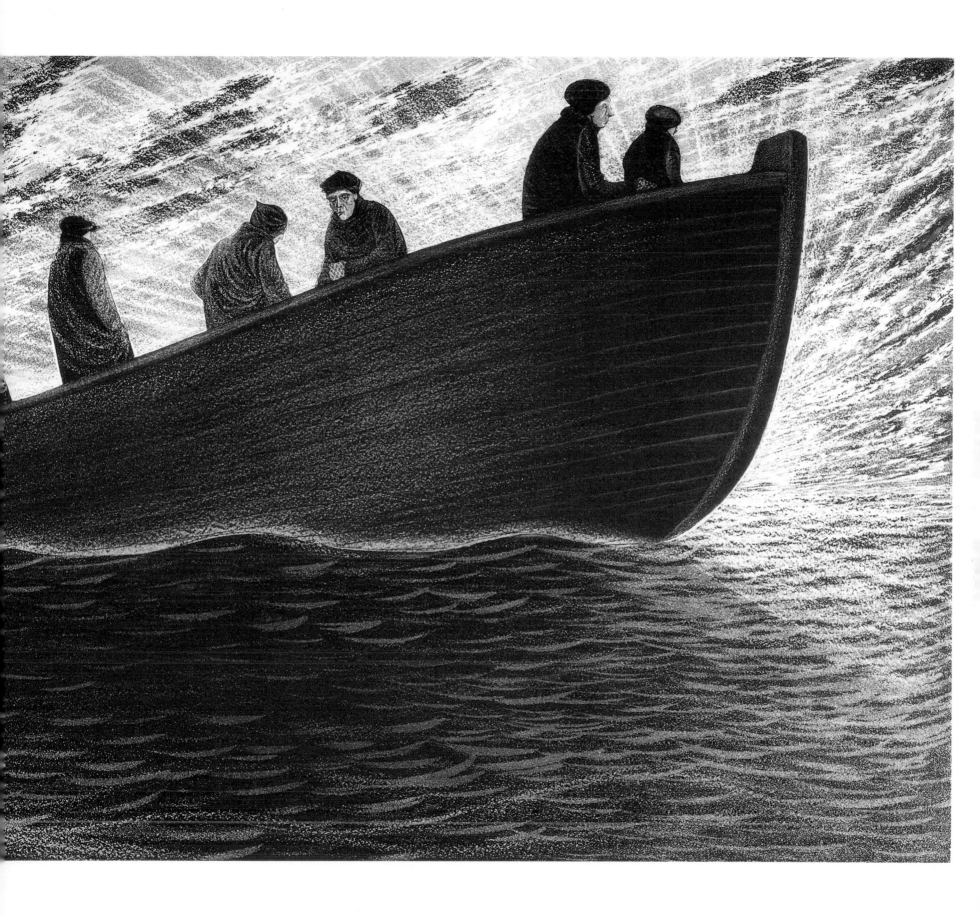

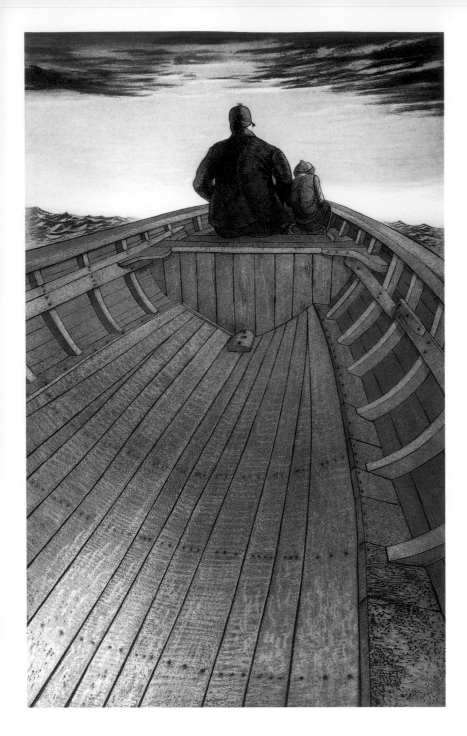

below:
**Aunt Mag and
Uncle Elias
Feltham Home on
Bragg's Island**
1976 · 80 × 50 cm

Vigil on Bragg's Island

1973 · 50 × 80 cm

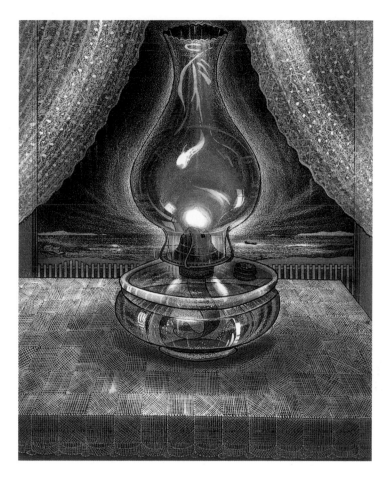

Gram Glover's Light

1985 · 50 × 40 cm

left:

Seabird Hunters
Returning Home to
Bragg's Island

1976 · 50 × 80 cm

Molly Glover
on Bragg's Island
1997 · 80 × 50 cm

facing page:
Molly Glover
Leaving Bragg's
Island
1985 · 55 × 72 cm

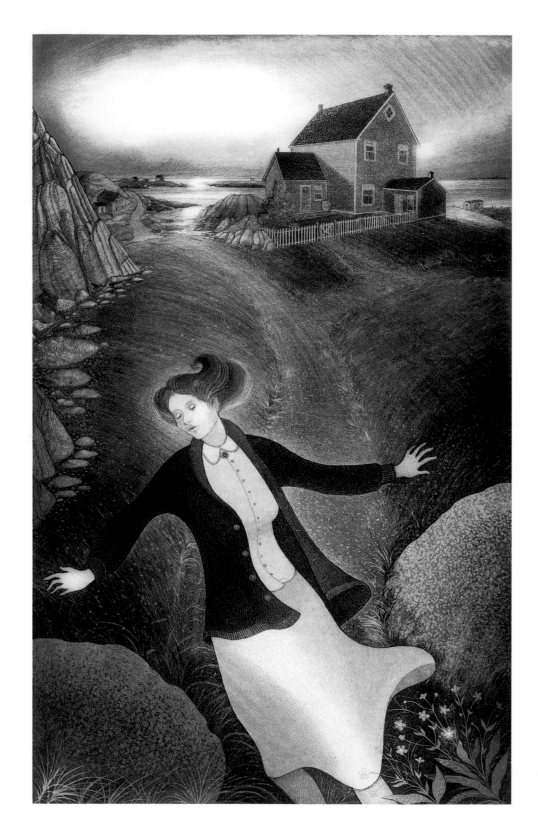

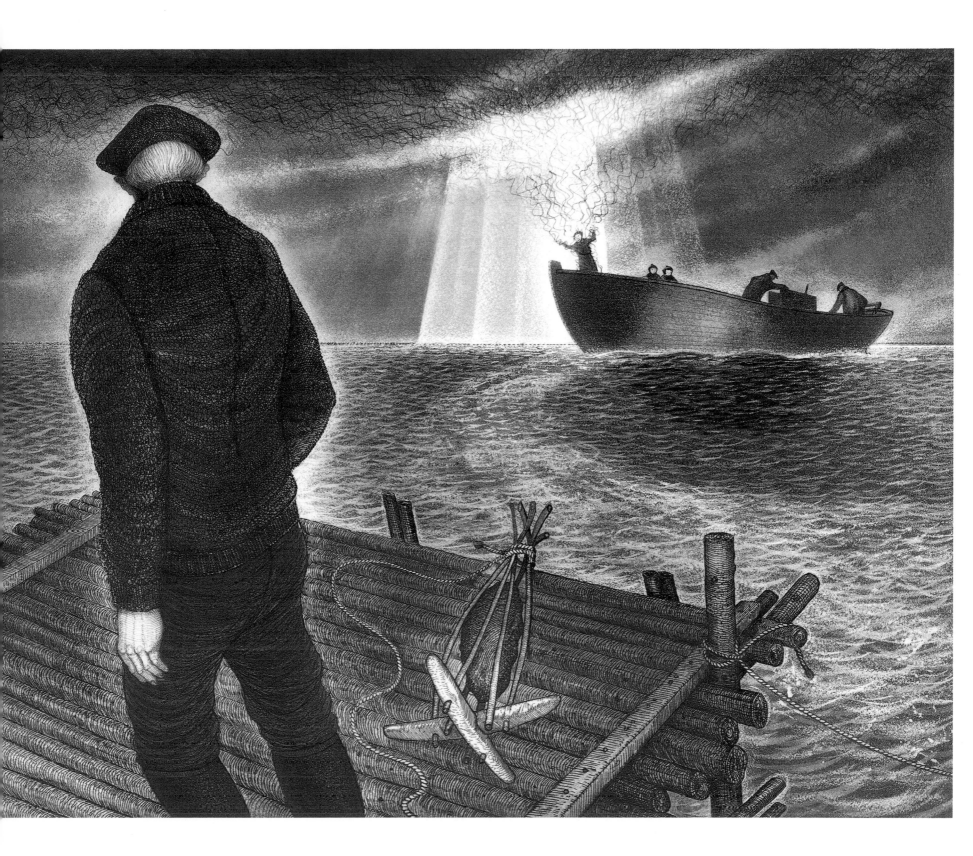

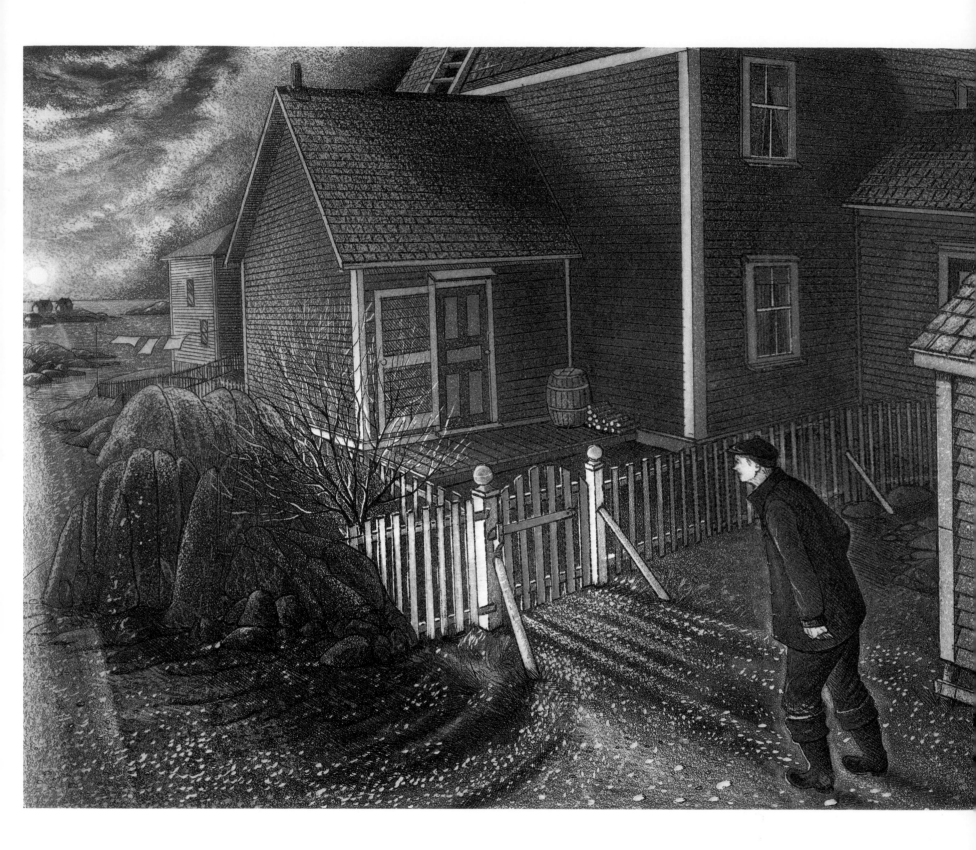

Gram Glover's Tree
on Bragg's Island
1999 · 37.5 × 45 cm

facing page:
Granda Glover
on Bragg's Island
1991 · 27.5 × 35 cm

left:

Gram Glover's Dream

1969 · 80 × 50 cm

Notes from
Bragg's Island

1992 · 37.5 × 90 cm

facing page:
Passing

1978 · 27.5 × 35 cm

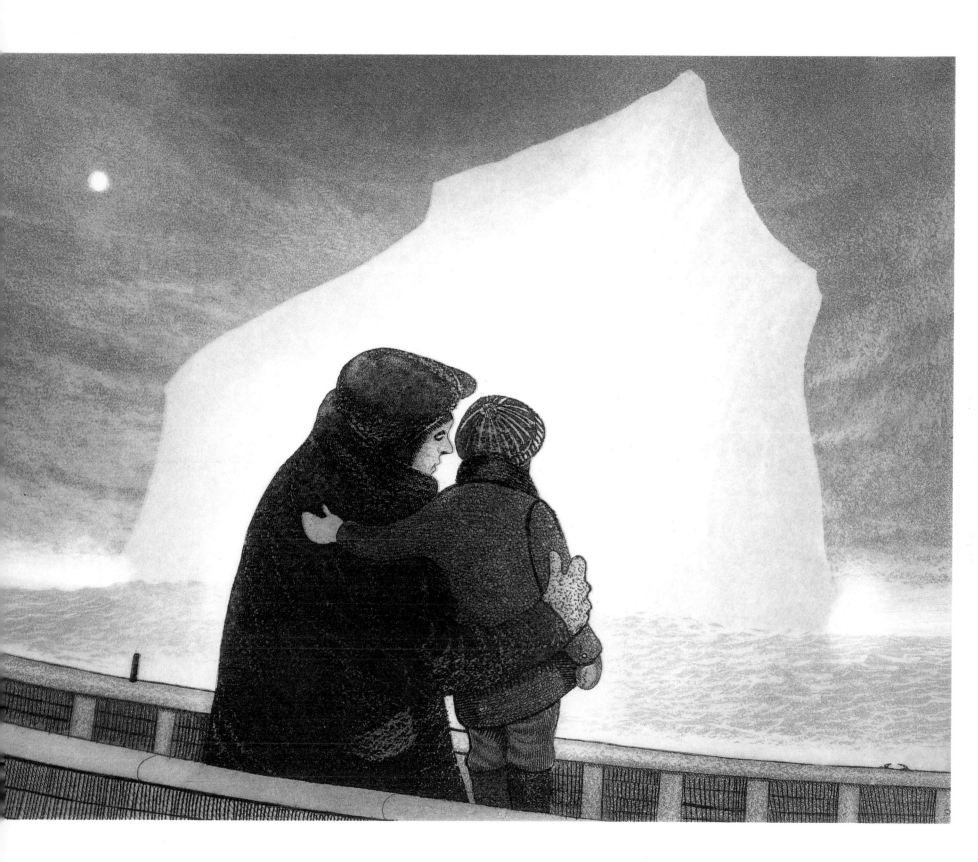

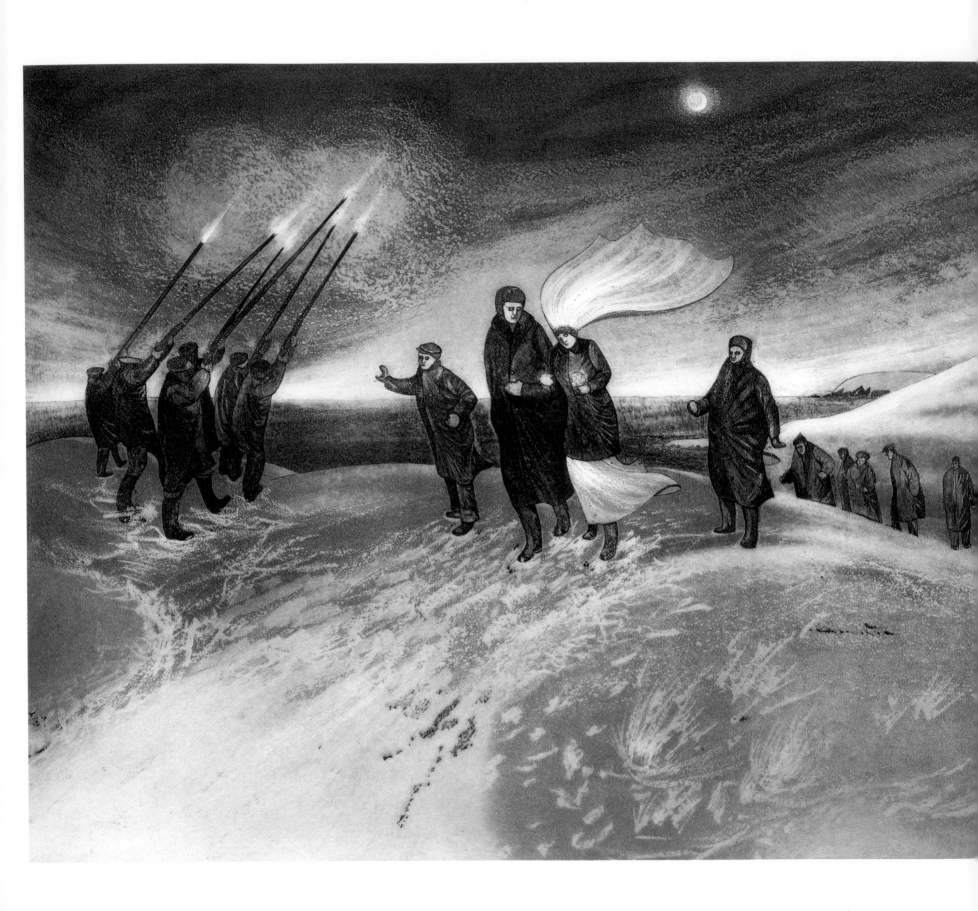

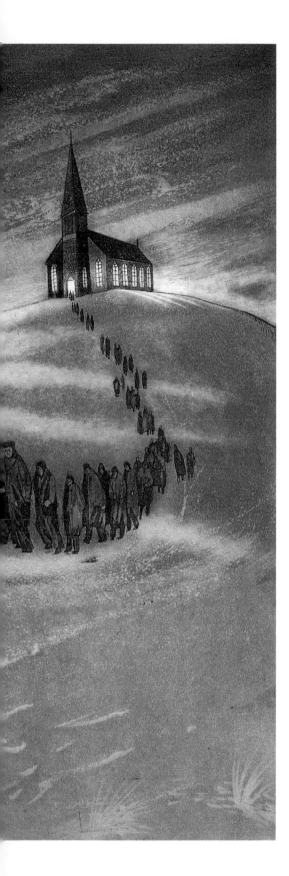

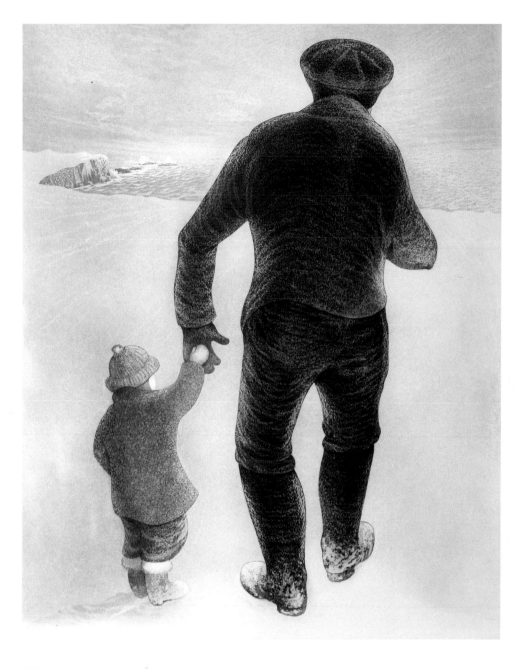

Winter on
Bragg's Island
1975 · 72 × 55 cm

left:
Wedding on
Bragg's Island
1973 · 50 × 80 cm

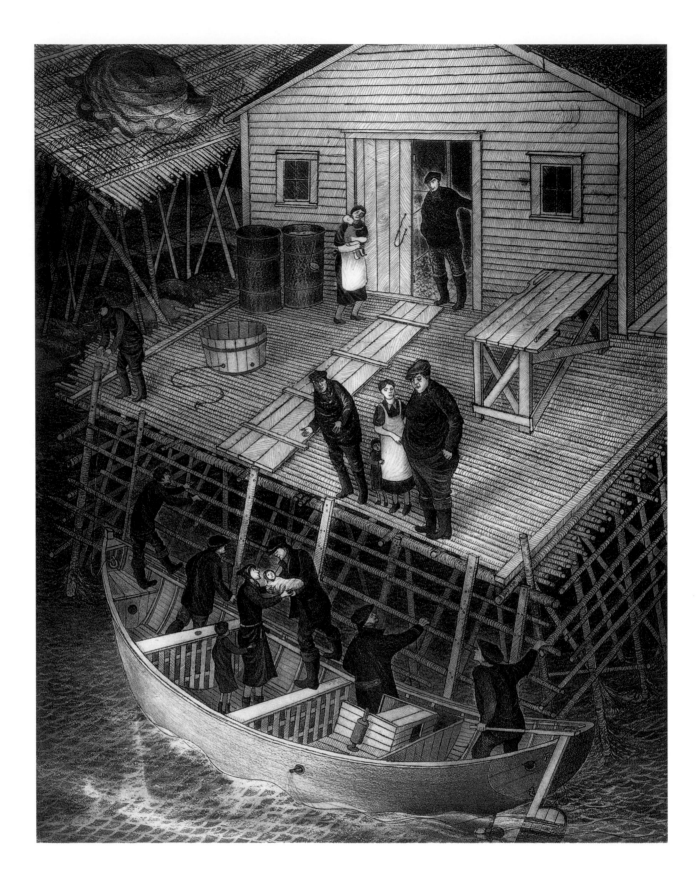

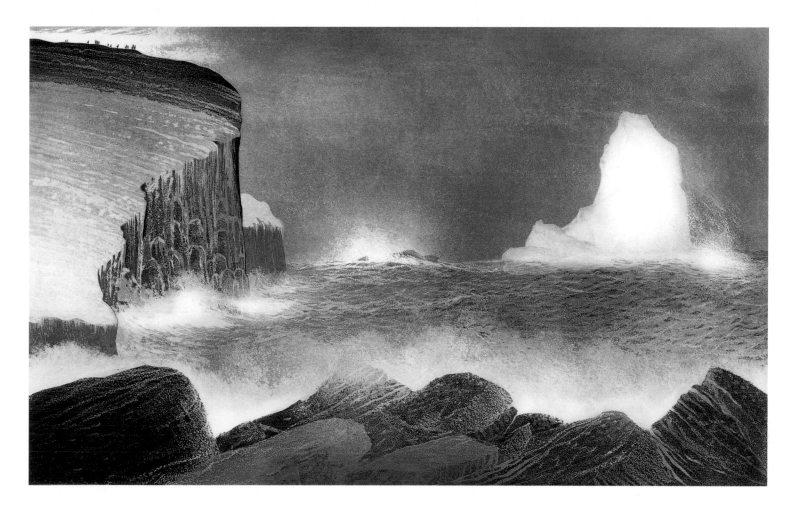

April Iceberg
off Bragg's Island
1976 · 50 × 80 cm

facing page:
Visitation on
Bragg's Island
1997 · 50 × 40 cm

overleaf:
Passage
1984 · 35 × 85 cm

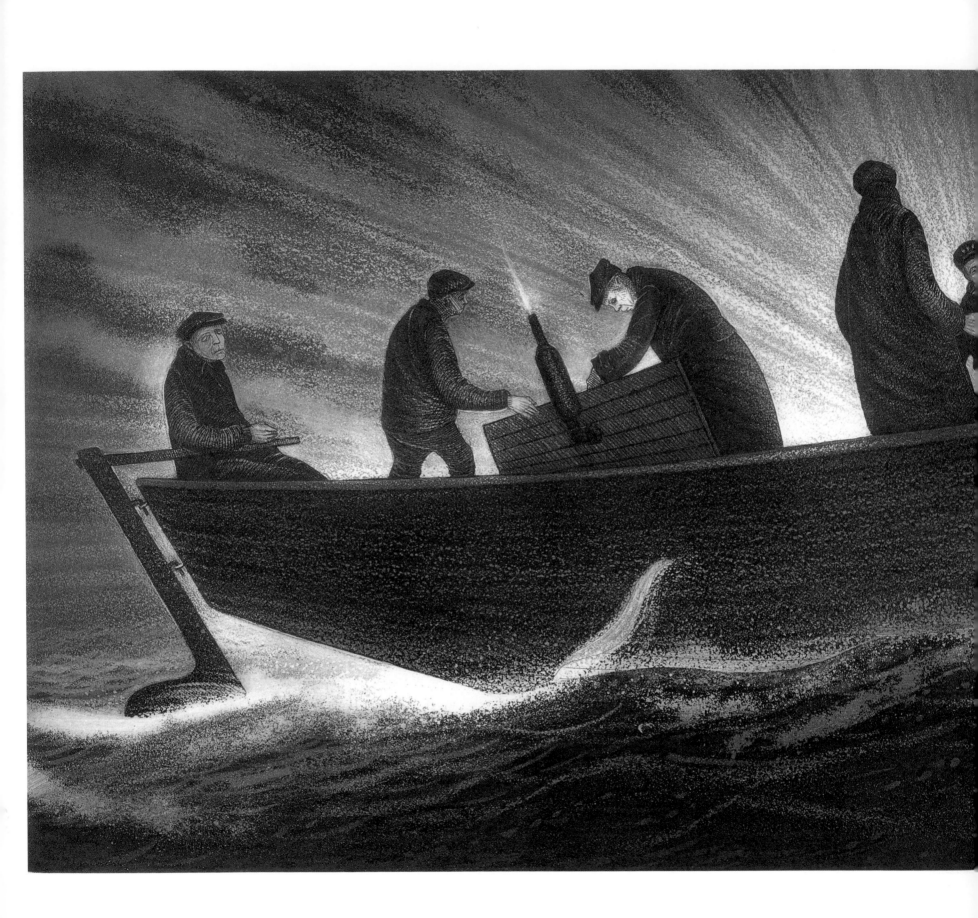

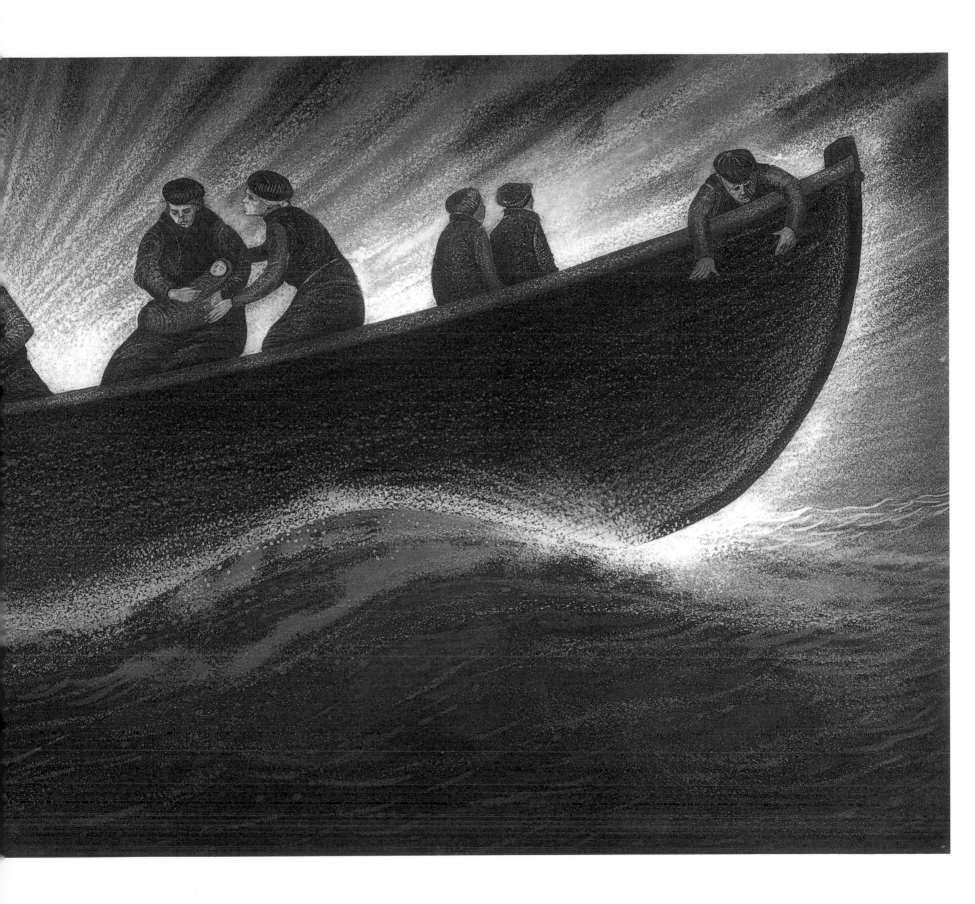

Gram Glover
Waiting

1972 · 80 × 50 cm

facing page:
William Lane
Leaving Bragg's
Island

1971 · 40 × 50 cm

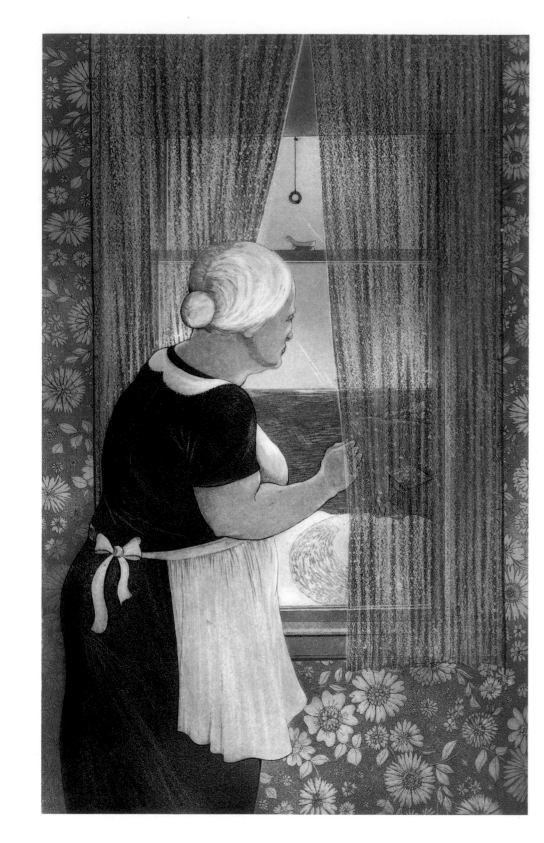

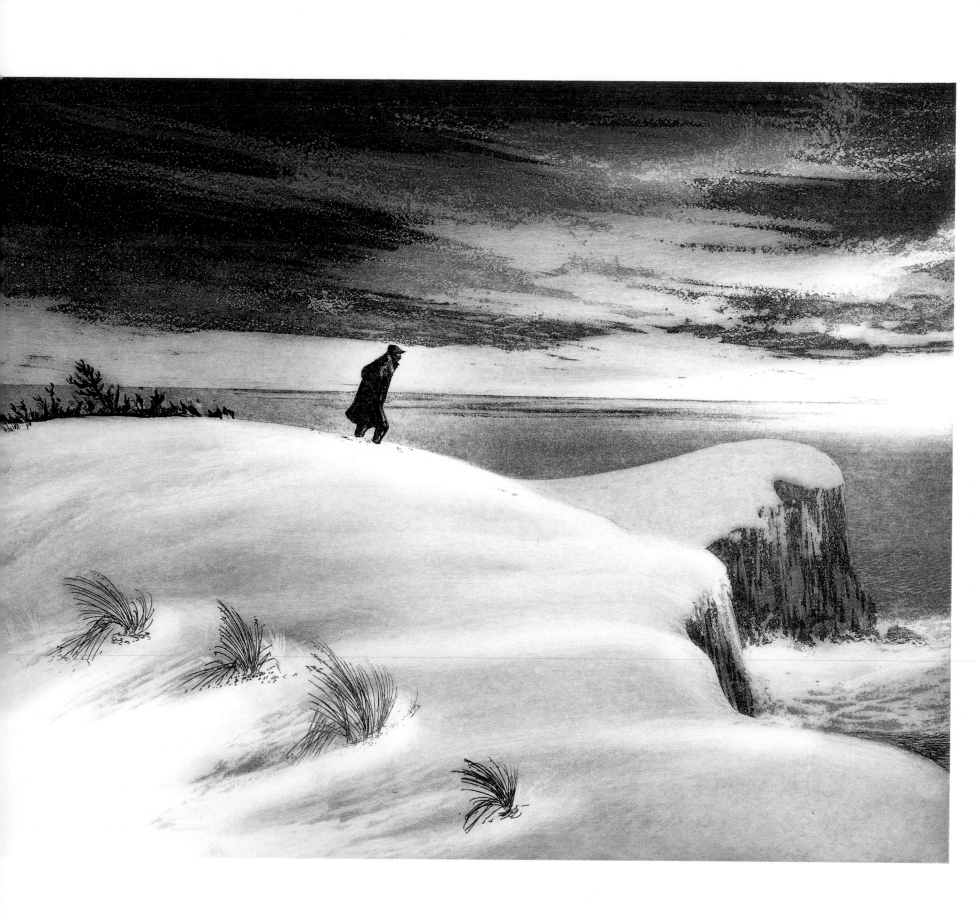

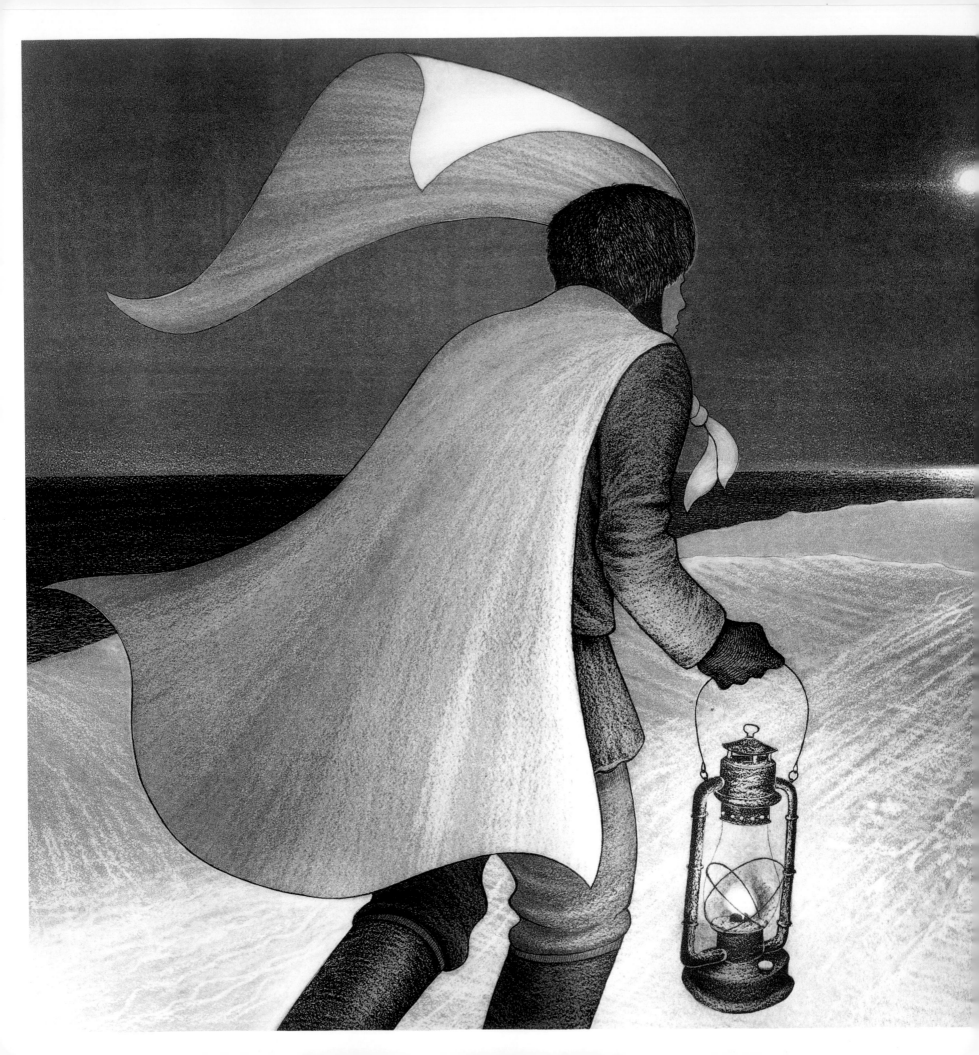

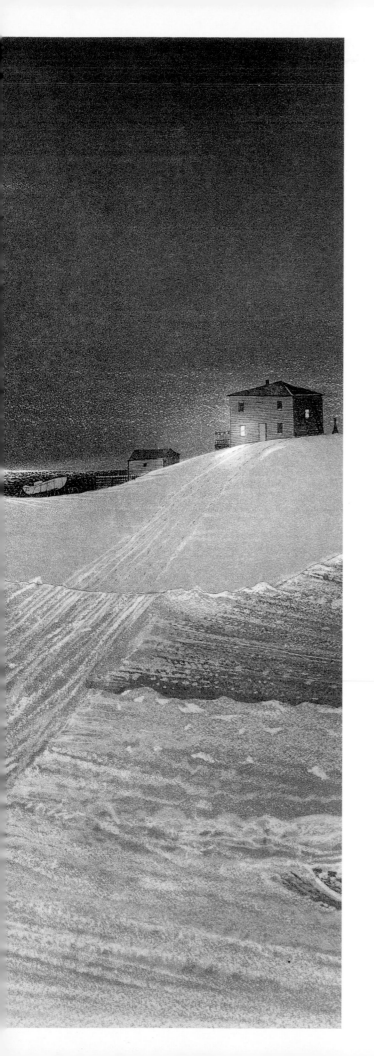

Lone Mummer
Approaching
1976 · detail

A VEIL
OF SHADOWS

Pound Cove
Mummers Crossing
Cold Harbour Pond
1985 · 50 × 80 cm

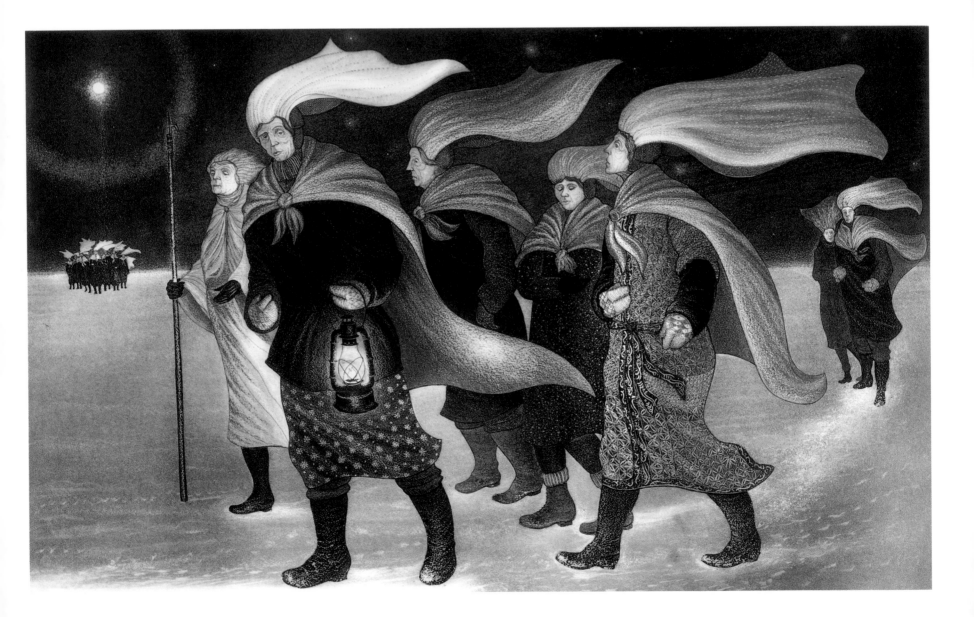

FLYING A KITE, you can feel your feet on the ground, your hand clutching the thin string vibrating in the wind. At the end of that string there's something miraculous and amazing—a kite with a multicoloured tail. Imagine David Blackwood's feet on Yuletide ice as he runs and slides. This time, the multicoloured kite tail contains images from a world of magical vision—the world of mummering. Much happened when the everyday world chose to disguise itself, to dress in costume and open creaking doors, to enter winter while seeing the world through a makeshift veil.

Wesleyville, when David Blackwood was a boy, was filled with the pulse of the Old and the New Testaments. People's lives revolved around the difficulties of surviving in a harsh world and dealing with an ocean that claimed lives while giving bounty. When winter gripped an icy shore and skies turned slate grey, smudged in freezing rain, when light grew dim and lamps were lit in the afternoon, it was a time to seek escape, a time to reclaim a tradition of fun that belonged to older days. As the twelve days of Christmas approached, thoughts turned to mummering.

When you think of mummering—of people dressing up, disguising their voices, going in costume from house to house—don't think of Halloween. Mummering, or "jannying," as it was called in some places in Newfoundland, was for grown-ups even more than it was for the young. For youngsters, those twelve days in late December and early January were times of fear, of awe, and also a chance, when the scary part was over, to have a laugh at the adults. But before the laughing there was mystery. All year round parents were a fairly sober lot; they knew when to scold, when to teach, when to advise, and when to leave a child alone. There was a distance between people in an outport that could not be violated, a dignity to be observed. Even though calling older people "Uncle" and "Aunt" made everyone in the community seem part of an extended family, it rested in a more important tradition. Elders were to be venerated; nothing disrespectful was to be said of them. They might have terrible and sometimes ridiculous flaws, but only adults were permitted to laugh amongst themselves about such things.

As David Blackwood recalls, there wasn't much physical display of emotion, especially between males. "Children kissed women; they didn't kiss men, not even fathers. Men would lift children and spin them around; sometimes my great-grandfather would lift me up and place me on a tree branch, and, perched there, I'd look down at the world. Sometimes my grandfather would hold my hand as we walked. Distances between people are, I think, very important."

There was an order to things, a proper distance to be maintained—until the twelve days of Christmas drew near.

The weather was generally bitter by then, nights as black as Imp stove polish, ice on the ruts of the road slanting

against the dark, looking like steel sounds when it clangs, one piece against another. And what Christmas in Newfoundland had to offer in the way of gifts and bounty wasn't much. Such things as Christmas trees weren't popular— a tree was meant for a practical purpose, and in older times to kill one for use as decoration would have been regarded with disapproval.

This was also a world where the threatened could actually happen. When William Case, my own grandfather, was young, not only was he told that St. Nicholas would fill his stocking with lumps of coal for being such a bad boy, but on Christmas Day one year, the coal showed up, and he received no gift.

Into this world, with indrawn voices making every word sound otherworldly, streeled the mummers.

Adults would start to disguise themselves as night drew near. Husbands would put on their wives' frocks over their own winter garb. Wives would haul on their husbands' trousers, Cape Anns, and sou'westers, then burn cork to black their faces. People would tuck a piece of lace up under a flowered hat or a cap; the lace, transformed into a veil, would shade the mummer's face. Sometimes a veil would have phantom eyes and a ghostly mouth painted upon it. Faces hid behind the snowdrift of lace.

On these nights children yelled in delight at not being forbidden to yell; children flung on their own costumes and for once weren't told, "Don't be so silly."

When children spilled into the roads and danced, why, so did the adults. When the grown-ups danced on ice far into the moonlight, children spun around them. David Blackwood was there to watch it all. He saw the tuck of sleeves into mitts, the cushions that stuffed the frocks, the veils that were lifted for a drink, the heavy boots that scuffed a jig across linoleum or canvas. Standing at the corner of the stove, sheltered by heat and shadow, he watched the man with a hidden face play the accordion, heard adults suck in their breath to disguise their voices. He felt the room grow too hot, stared as the grown-ups went silly, and then,

when everyone had gone, ran to the window and scraped a small peephole so he could watch the mummers vanish into the night. The laughs would die, the sound of singing would fade, and the windows of ice would hold only a faint echo of the mummers' farewell. Outside, the night would be still, moonlight skimmed like frozen milk over the road. The graveyard creaked in the dead of winter.

The mummers, from a distance, were spirits, no longer people David knew from everyday. They'd become magic. The house frocks, the lace doilies that usually lay on polished wood, the boots of winter, had all been taken by the mummers and charmed into disguise, into song and whirling dance. And even though the frocks no longer shimmered after the twelve days of Christmas, and doilies were replaced on pump organs next to Methodist hymn books, the ghost of them lingered, lighting eyes from behind to show the mystery of the ordinary.

But sometimes in the mystery an even deeper shadow stirred, drifted between moonlight and ice. Once, David Blackwood remembers, one of the mummers died—died outdoors, on a lake between friendly homes—and the men, still in disguise, laid the body out upon the ice. They waited for a horse and the sled of death to take the man away.

In Blackwood's prints of mummers, the moon shines anew upon the scene. Deep inside the detail, there is mystery in the darkest shadow. Look and you will see this man. Look and you will see David Blackwood watching.

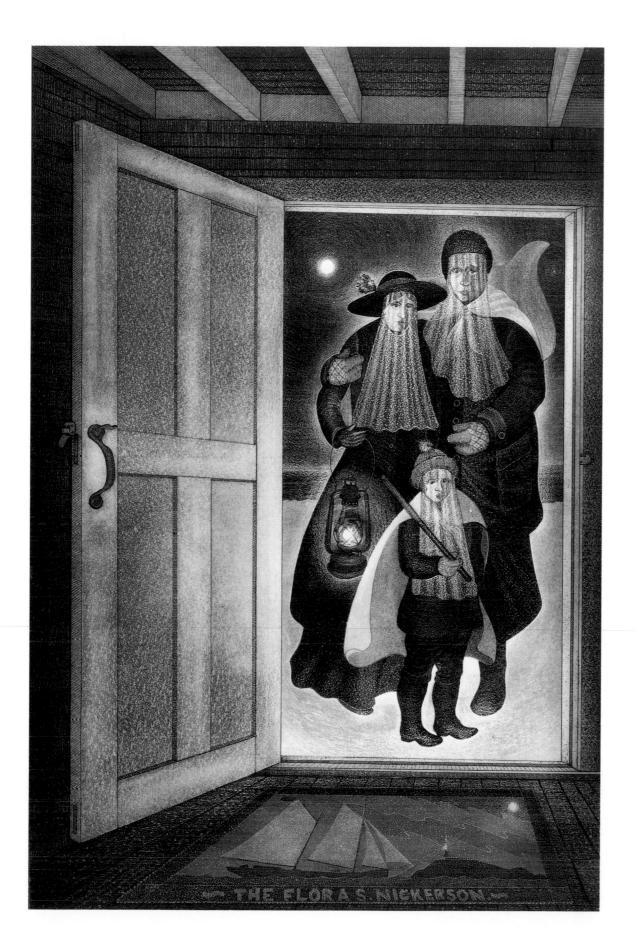

**Mummer Family
at the Door**
1985 · 90 × 60 cm

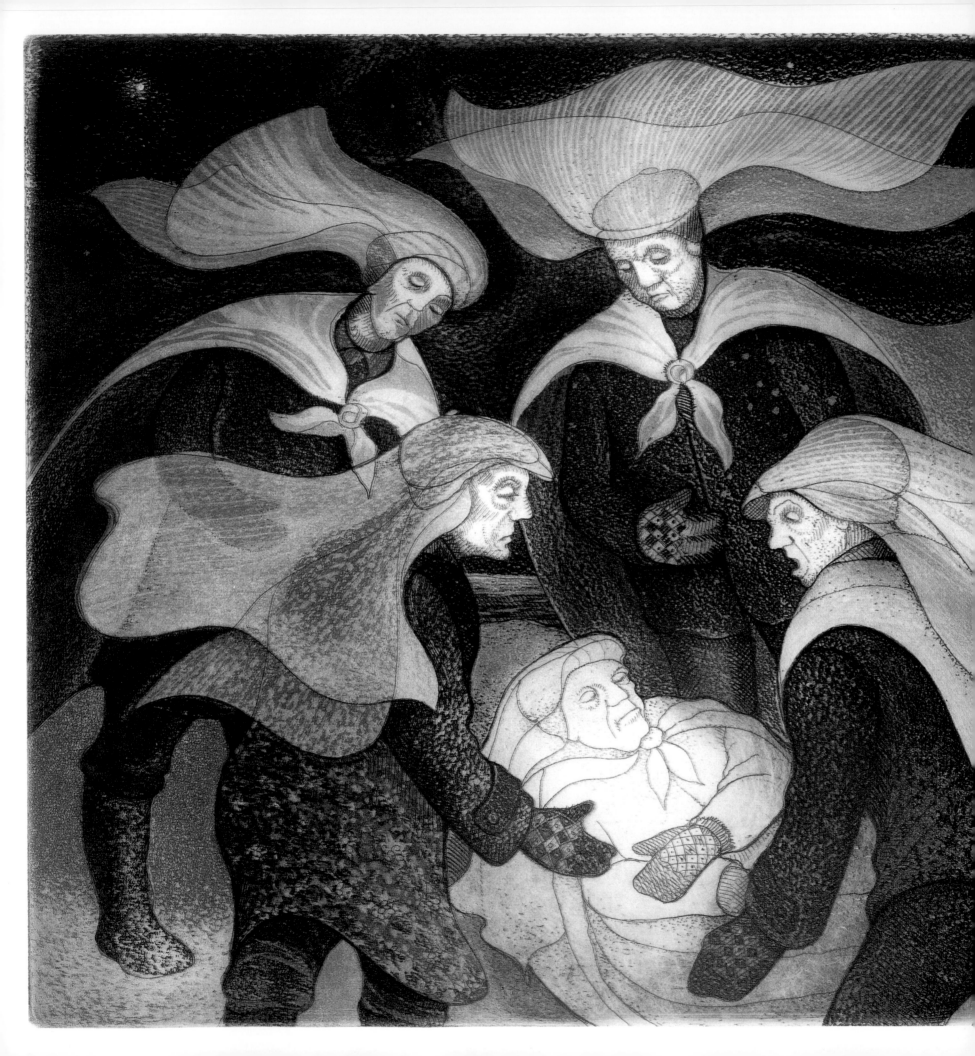

**Fallen Mummer on
Brookfield Marsh**
1996 · 22.5 × 30 cm

DEATH OF A MUMMER
William Gough

His indrawn breath has sucked the moon
between his teeth
while stars stub sparks
upon his tongue.

The wind rolls wind and ice
along his lips.
His lip is cold shale
in a glitter storm.

Friends, dressed against their sex
in mummers' dresses
watch frost grow blue
snow blossoms
on his cheekbones.
"I minds the time,"
says Uncle Billy,
"when drunk, he tried to hang
his hat
upon the crescent moon."

Mummers shuffle
foot to foot
and wait for horse and sled.

The wind blows
shadows from his open eyes.
The clouds fill with
those shadows.

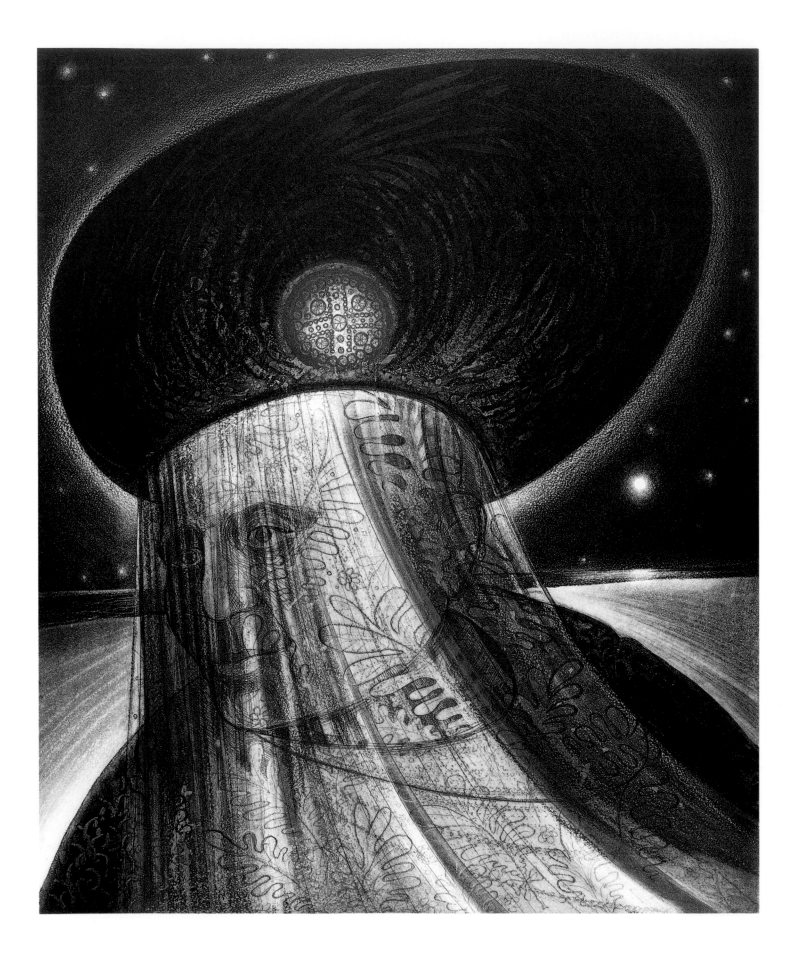

facing page:
Great Mummer
1989 · 60 × 50 cm

**Three Mummers
on Winsor's Point**
1979 · 50 × 80 cm

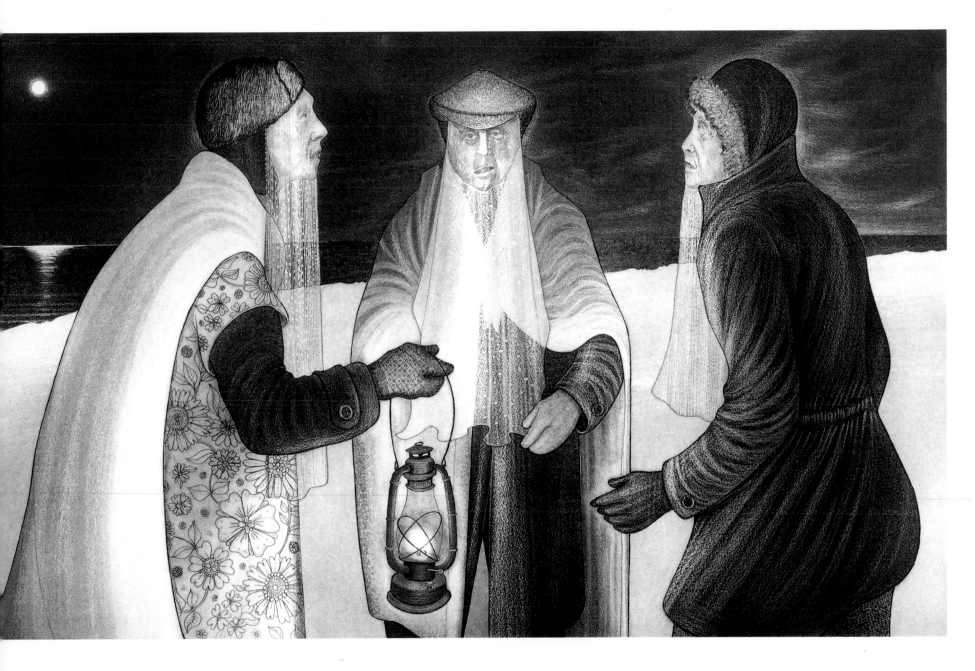

93

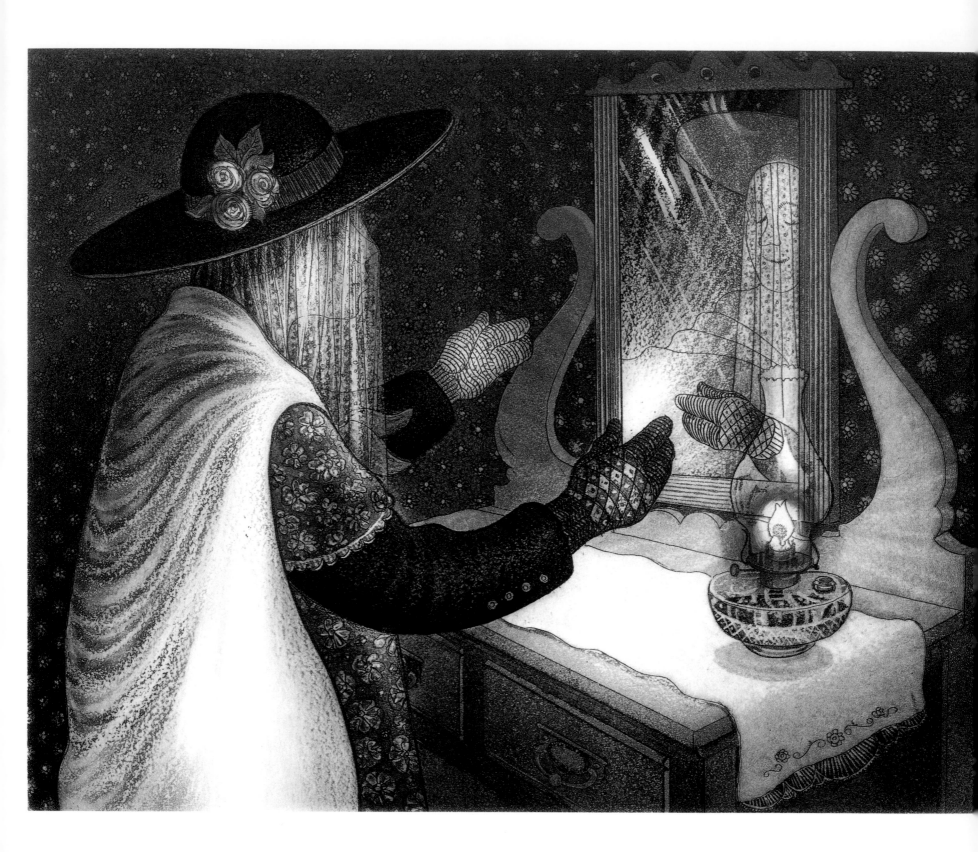

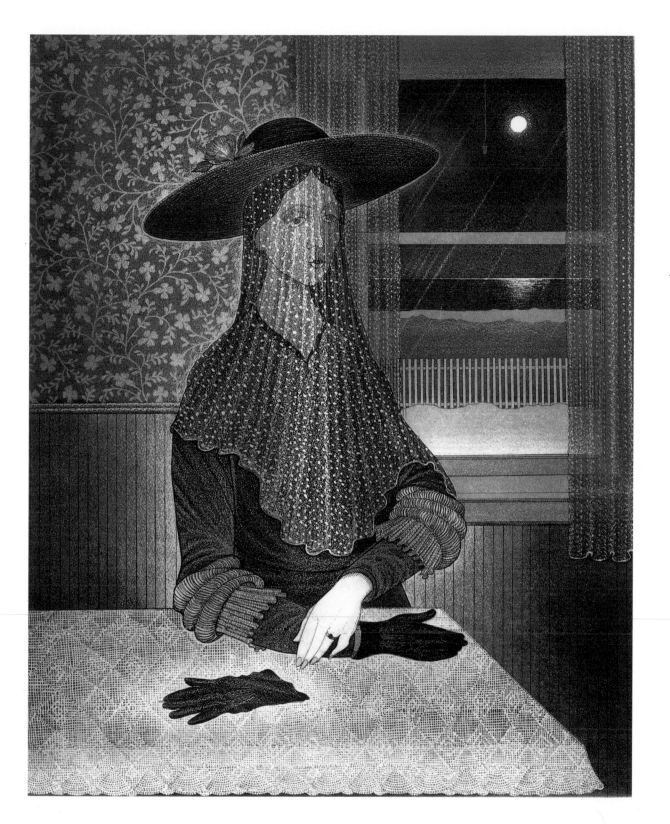

Beautiful
Young Mummer
at Margaret
Feltham's House
1985 · 50 × 40 cm

facing page:
Young Mummer
Dressing
1986 · 30 × 60 cm

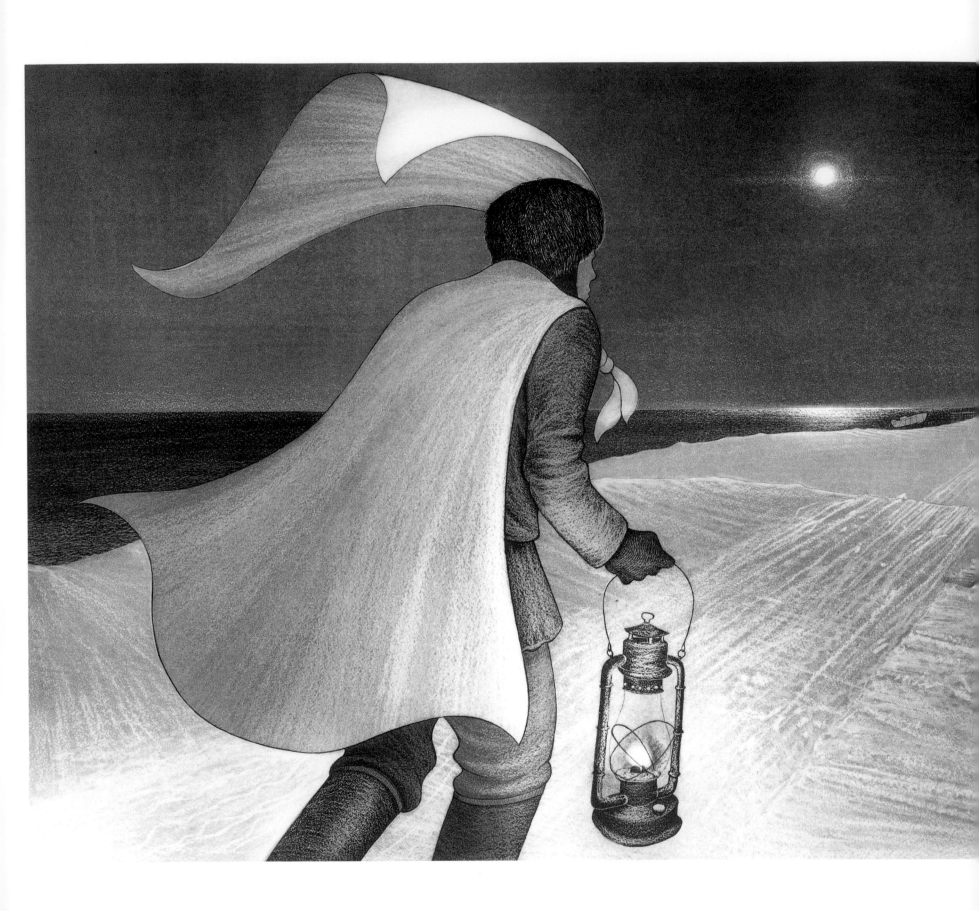

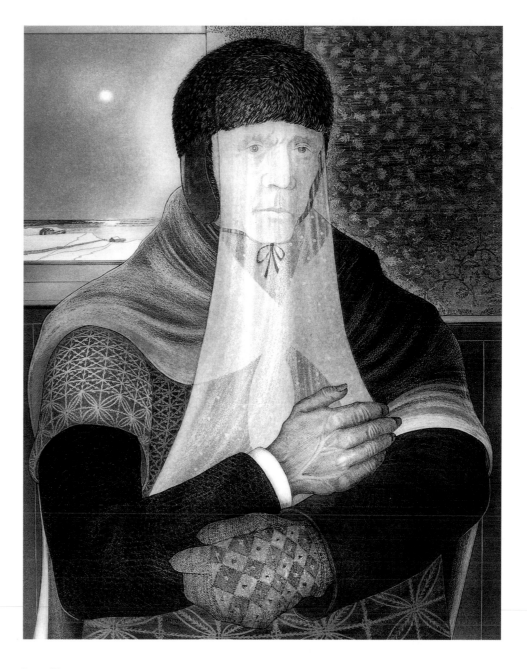

Lone Mummer
Inside
1979 · 72 × 55 cm

left:
Lone Mummer
Approaching
1976 · 50 × 80 cm

**Mummer in
Lantern Light**
1993 · 35 × 27.5 cm

facing page:
**Lone Mummer
with Cat**
1987 · 72 × 55 cm

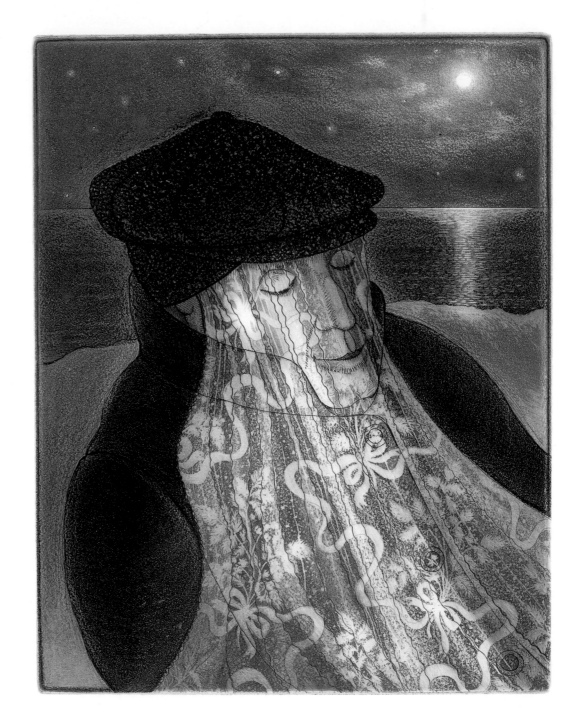

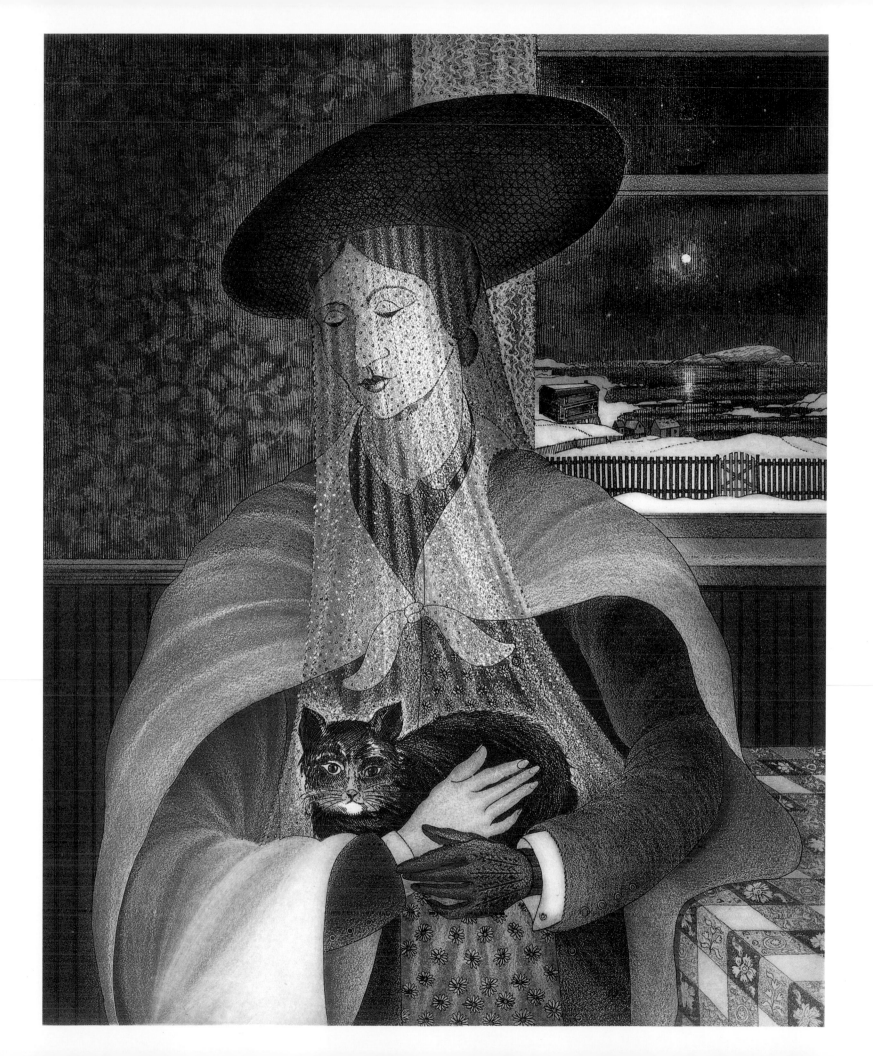

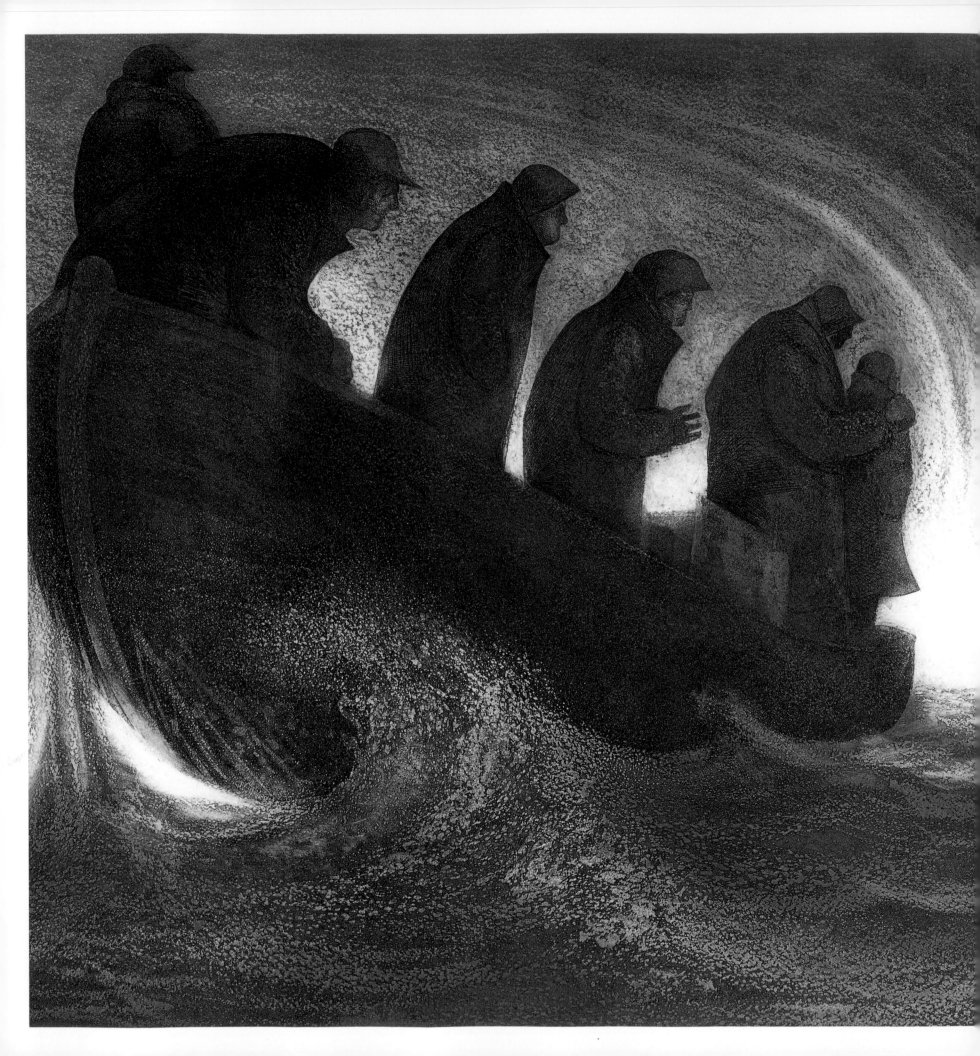

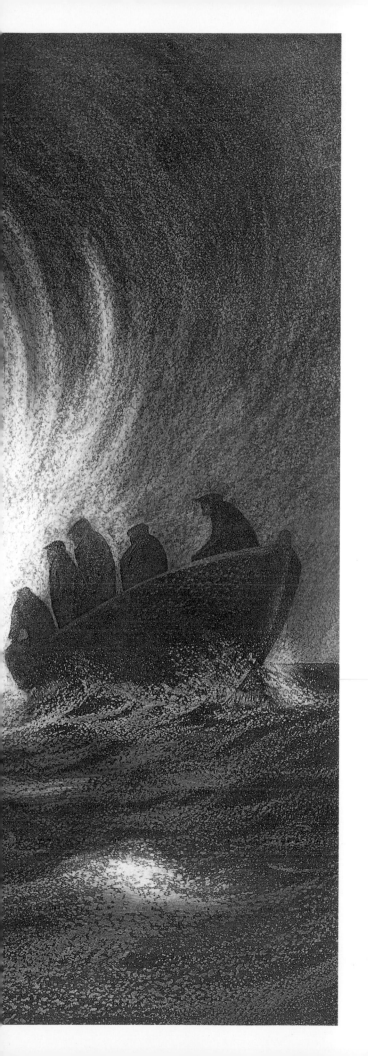

Fire at Sea
1970 · detail

LABRADOR

September 3rd:
Uncle Dan Sturge
Home from the
Labrador
1975 · 50 × 80 cm

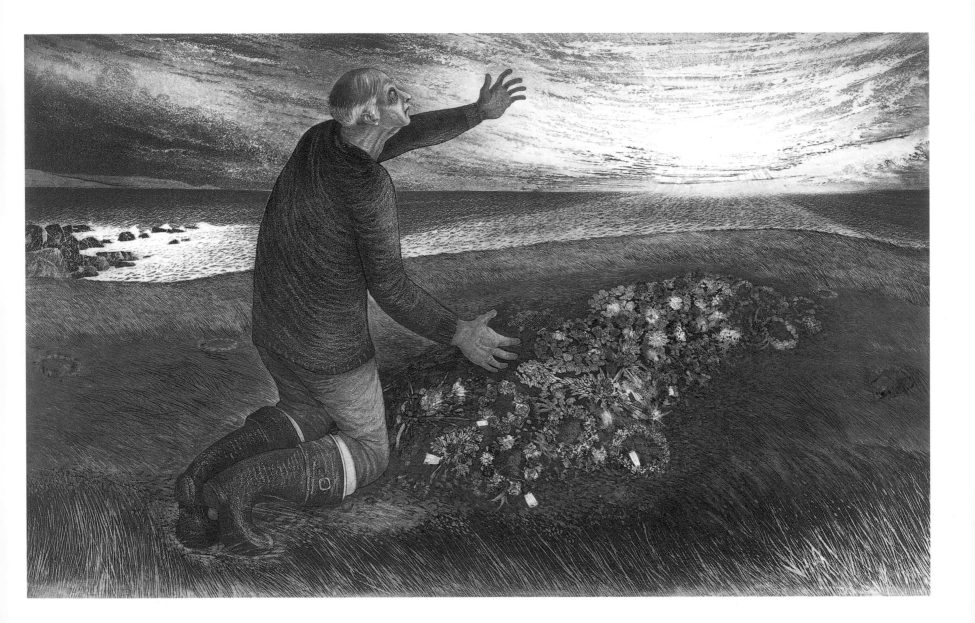

For newfoundlanders, much of living in New-foundland has involved going away from home. It's part of the island's history, sometimes born of economic necessity, and part of being a people who chose to live where they were forbidden to settle. The destination for both adventure and income was always the Labrador.

It's hard now to think of Labrador without recalling one of the unkindest descriptions ever offered of it: "The land God gave to Cain." As with most clichés, there's a poetic impulse behind that description. Fishermen who returned from Labrador's springtime spoke in horror of thick clouds of blackflies, which could "suck a man dry of all his blood, in the blink of an eye." When they'd finished their description of bloodsucking insects, there'd be stories of what would happen if you were to stay there into the autumn—images of people standing in rainfalls of massive houseflies that buzzed and thrashed down collars and into food and drinking water in horrible whirring death dances, or crept in a great burr of noise across a sleeping face.

Wonderful stories filled with these Münchausenian descriptions made the annual departure of ships for the Labrador a memorable event, and there was hardly a family in Wesleyville who didn't have some relative making the annual journey. Still underfished at that time, the Labrador area had resources aplenty. It also had many snug coves where a summer encampment could be made, fish caught and cured and then brought back at the end of the season.

While the men were away, there were entertainments in Wesleyville. Aunt Rene would take to the stage of the Orange Hall, standing alone in front of a galvanized tub full of underwear. While she scrubbed on the corrugated washboard, she'd do her monologue—a monologue that dealt with the "dirty linen" of the town. As she whipped the clothes towards the ceiling, she'd reveal who was saying what about whom, who was doing such-and-such to so-and-so. Most people would laugh, a few would leave in anger, but another lonely night would fly by.

Often a husband and wife would spend months without being in touch, and the reunions after Labrador would be times of joy. But that joy was not expressed in great embraces or weeping at the time of return. Outward, easy expression of emotions wasn't welcomed; instead, the depth of feeling could be seen in a simple touch upon the shoulder, the way a plate was placed upon the table, the way a man carefully removed his boots before entering the house. To someone from the outside things would look remarkably restrained, but to the people involved the emotions were deep and true.

My own grandmother, Julia Case, was shipwrecked at least three times on the Labrador. But she didn't think all that much about the crashes, simply accepting them as part of her way of life. She was more interested in telling me of the time she got to spend three days and nights with the fairy folk, making sure I knew that, if the same thing ever

happened to me, I must avoid eating any food that my supernatural hosts offered. Otherwise, I'd never be able to leave. Labrador in many ways had the same power: people who sailed there, who made berths on the rugged shores, who looked into the crystal skies as winter nudged closer and saw sheets of coloured ribbons tug northern lights through the sky, had sampled a special food. Once you'd gotten the taste and scent of Labrador, it stayed with you forever. There was something in the way the berries tasted that was magical. There was magic too in the smell of wood smoke from scrubby blasty boughs, in the way a kettle charred and boiled in the clean air. And the fish—ah, that was the way it used to be, and strong backs were required to take the bounty of the sea. Labrador became a state of mind, a dream of small boys and girls.

Sometimes, however, as with Captain Jesse Winsor, a ship would come back into port carrying with it sad news: the news of death. Captain Winsor had been engaged as pilot for the Labrador coast, and he did that job well, the ship resting secure by the rugged coast. But what awaited him, according to the Reverend Naboth Winsor, was one detail, a detail fatally overlooked. The crew finished the day "trimming the pole" from one part of the ship to the other. But someone had left the round bunker hatch off. After the sun had set, Captain Winsor went out on deck, into a night of vivid stars, fire on velvet as Labrador starry nights can be. His eyes to the pole star, reading the map the sky had traced for ships, he never noticed the open hatch. He fell down the bunker and, far from hospitals and doctors, died in the bunker hold. Wesleyville watched as his casket was brought home, and that night the stars once again drew their map upon the sky.

Sometimes when a ship returned, the news of death awaited those on board. Sorrow would be spelled out in full by one house or another, its blinds drawn like yellow teeth against the daylight, with mirrors inside turned to the walls. On those days there would be a great stillness amongst the youngsters lined along the wharves. Even the small boys

who'd run to help catch the hawser would do so without a smile to their lips. And Uncle Dan Sturge knew by the quiet, by the still, by the sound the wind makes as it rounds the shape of a new grave, that he had lost his cherished wife. He kneels in David Blackwood's print, with boots still on, to try to say good-bye.

Such was the way of Wesleyville that David Blackwood could picture what had happened before his time without having to be there. In how people still spoke of Captain Jesse Winsor, in how old men and women described Uncle Dan Sturge's return, he could see the events painted by words.

For Blackwood growing up, Labrador and the *Flora S. Nickerson* were always connected. The image of her stayed vivid, newly outfitted in springtime, heading bravely for Labrador, then sliding back into home port in the fall, sails worn, the look of a hard summer's voyage upon her. The sighting of sails full against the clouds, the look of a bone curve of wave in the teeth of the prow that brought the *Flora S. Nickerson* home. Perched on a rock, leaning into the earth, David would watch the boat, crisp against the day, and dream of the time when he'd head to the Labrador.

These days David Blackwood lives far from Newfoundland and Labrador, and the body of water he looks towards is Lake Ontario. But no matter how his eye is informed by the Old Masters, no matter how his hand moves to draw all manner of subjects, the underlying rhythm of where he grew up informs all that he does. Sometimes in a chill wind of spring he can still feel the vibration of rigging, can smell oakum and hear the hiss of waves cut by a far-off bow. His mind sees fire on ship, flames on water, and with etching plate and paper he binds the four elements. An artist, down on the Labrador.

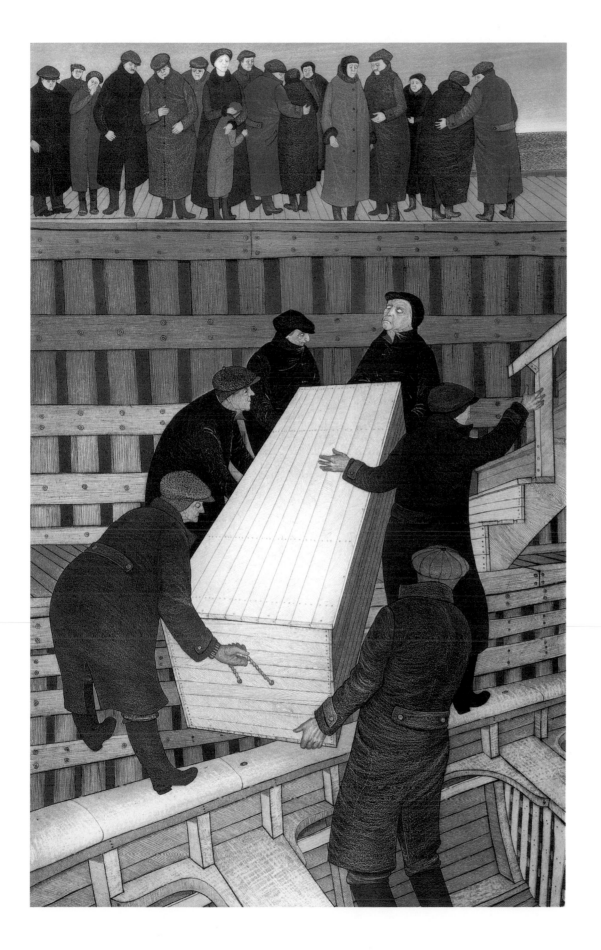

Captain Jess Home
from the Labrador
1976 · 80 × 50 cm

overleaf:
Outward Bound
for the Labrador
1985 · 42.5 × 90 cm

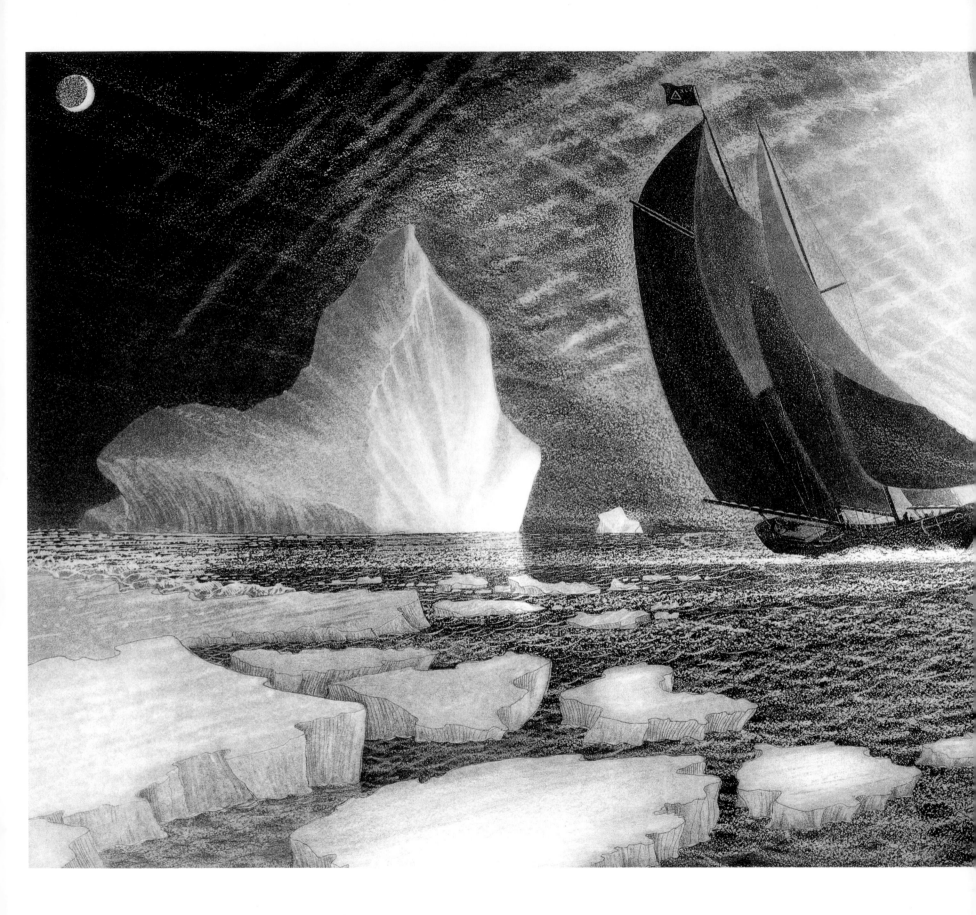

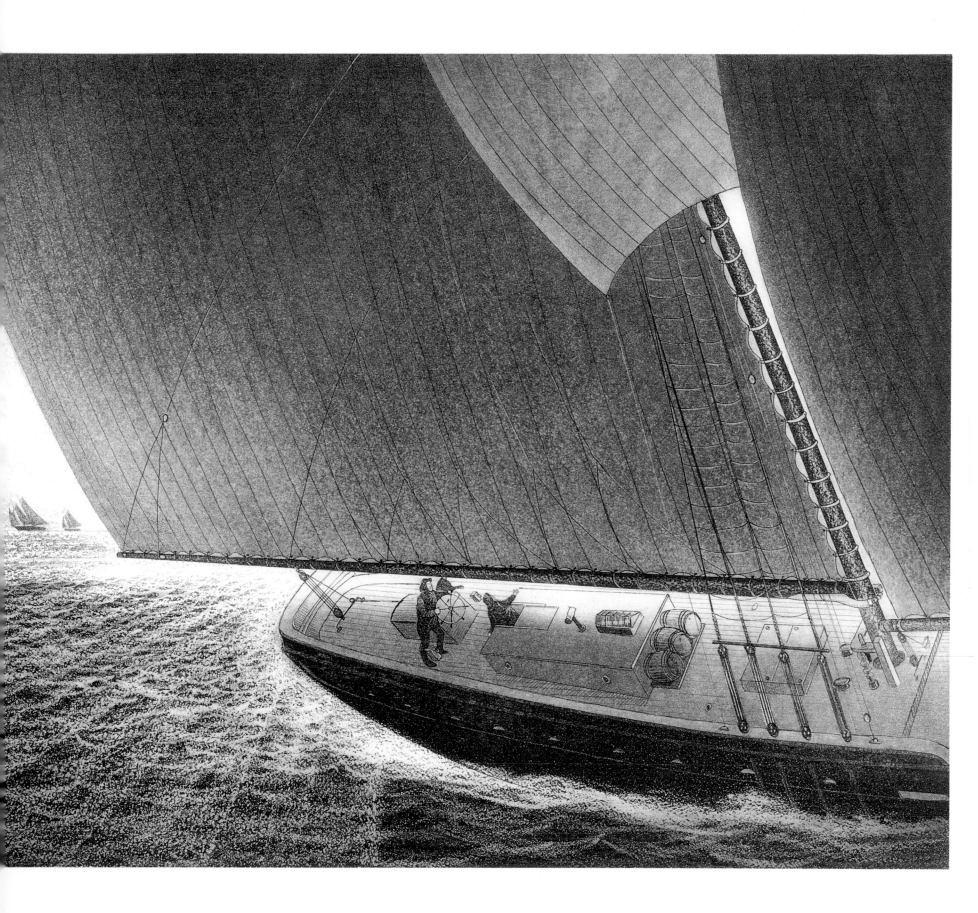

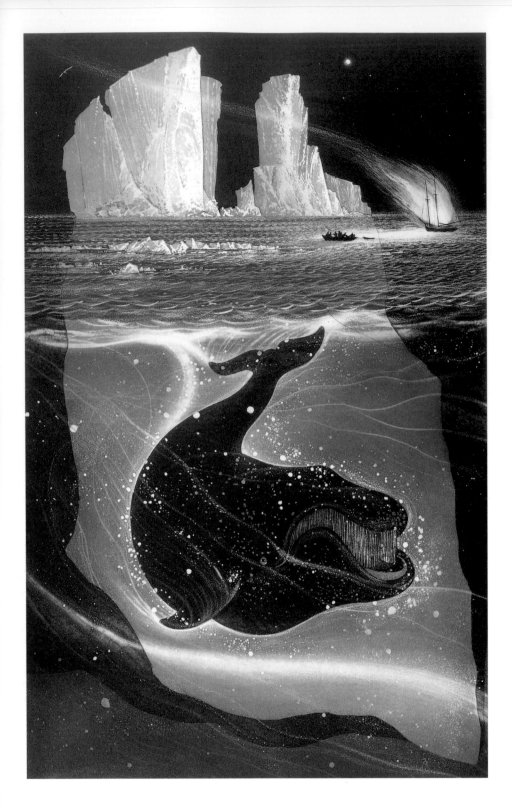

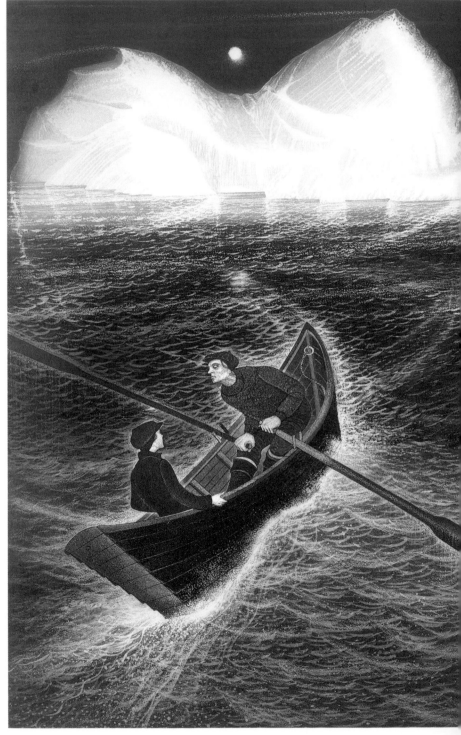

above:

**Fire Down on
the Labrador**

1980 · 80 × 50 cm

108

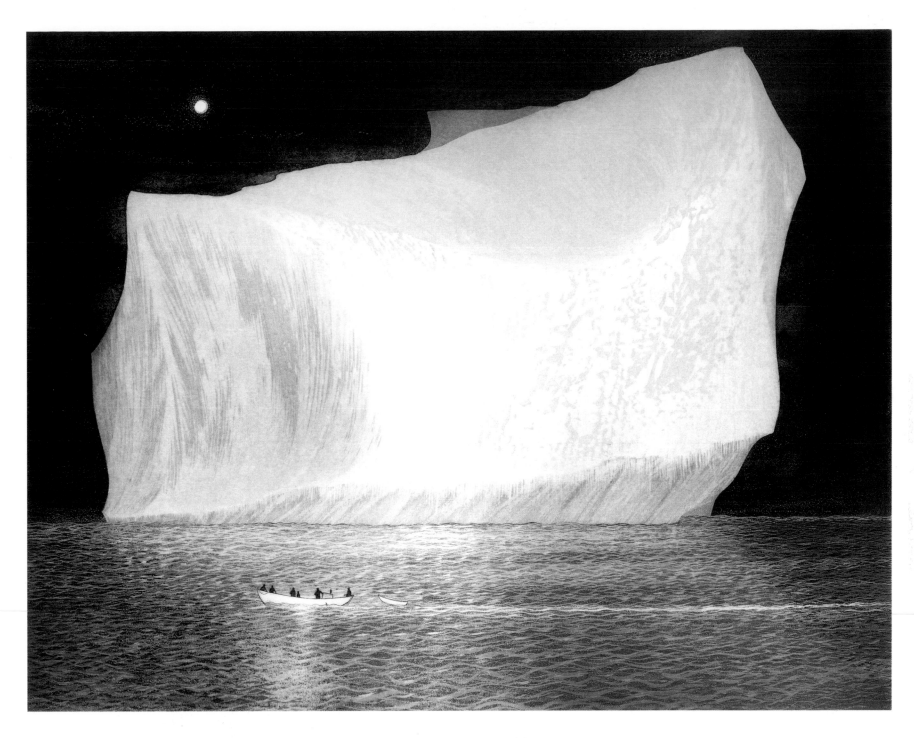

Night Passage
Down on the
Labrador
1978 · 55 × 72 cm

overleaf:
His Father Dreams II:
Labrador Days
1988 · 37.5 × 90 cm

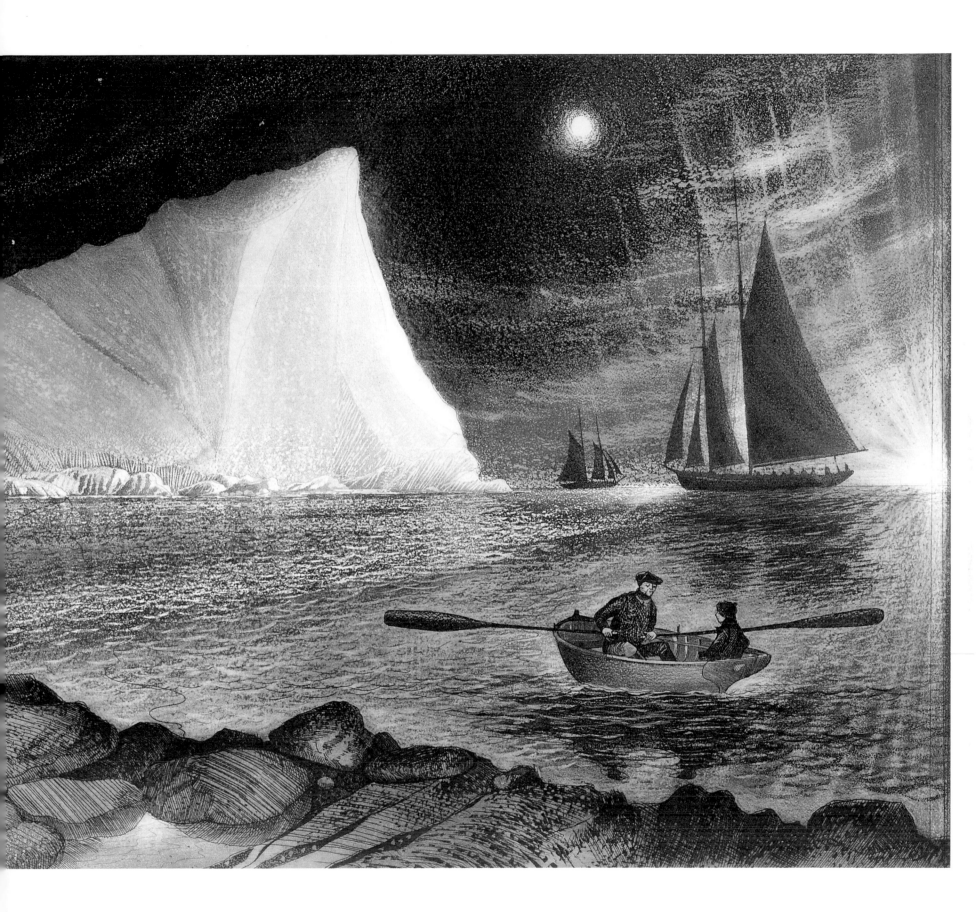

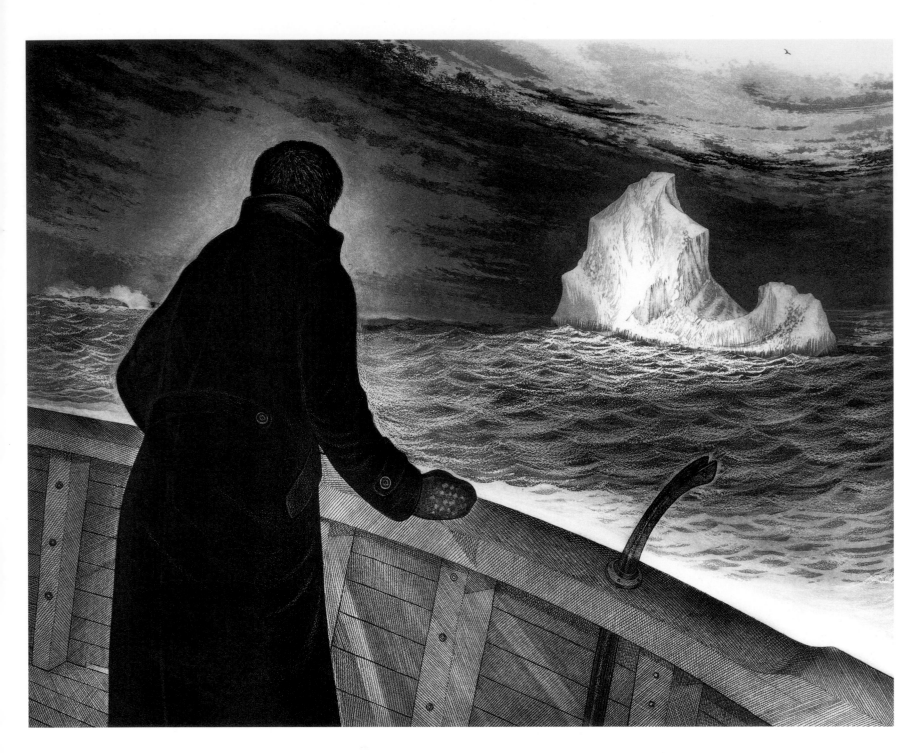

Captain Lew
Kean Passing
1979 · 55 × 72 cm

facing page:
The *Flora S. Nickerson*
Down on the Labrador
1978 · 50 × 40 cm

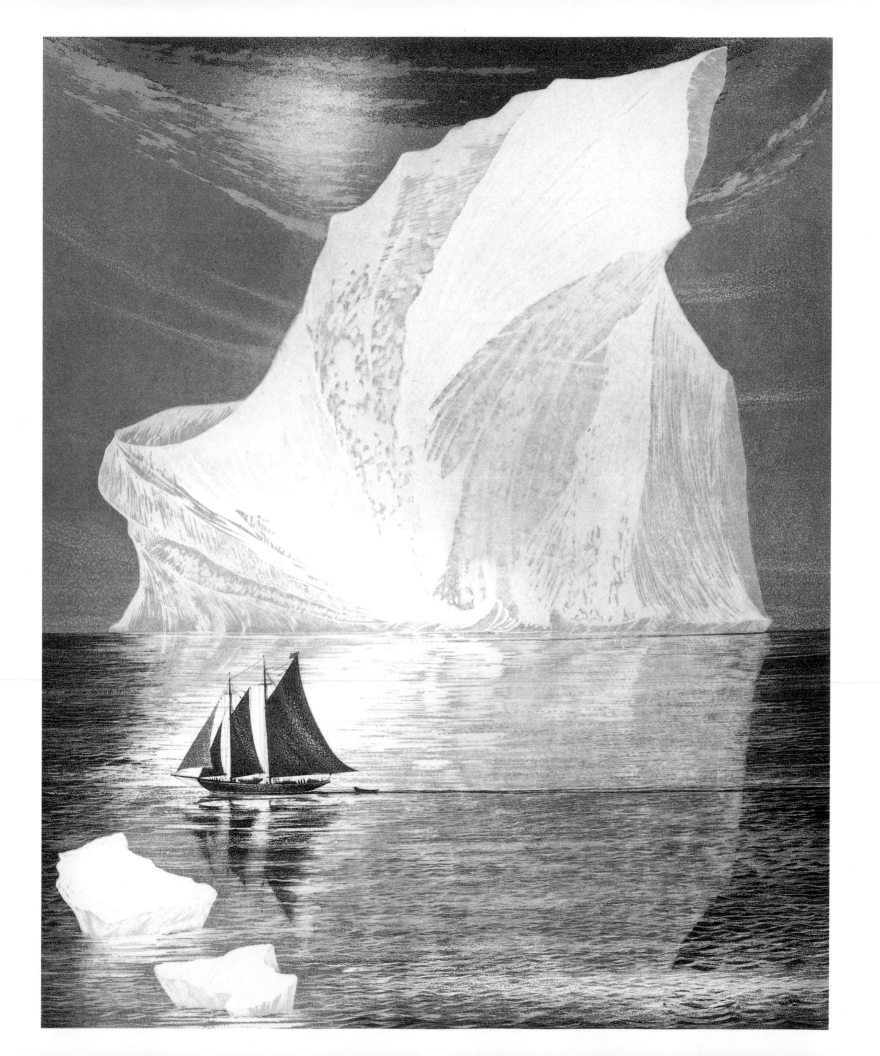

Sam Kelloway
Dreams
1983 · 25 × 50 cm

facing page:
Fire at Sea
1970 · 50 × 80 cm

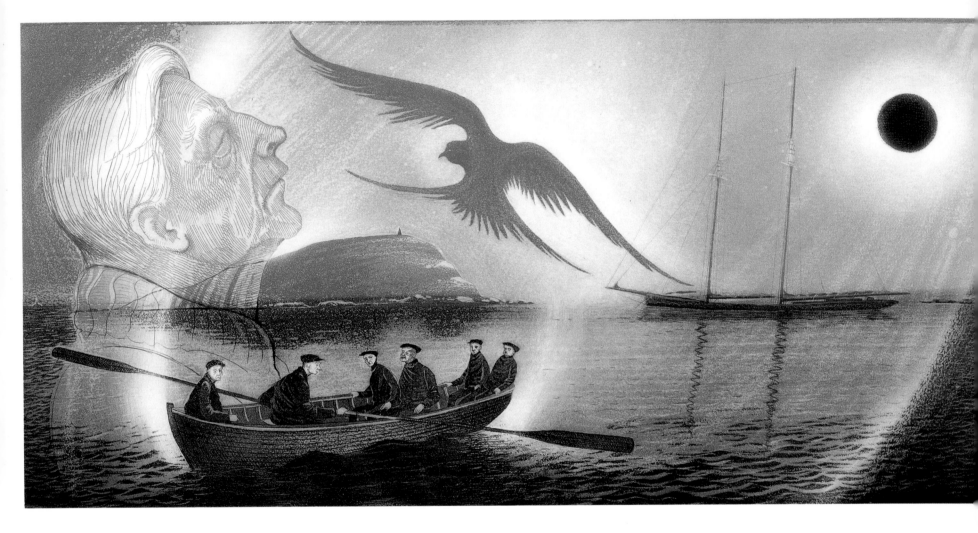

114

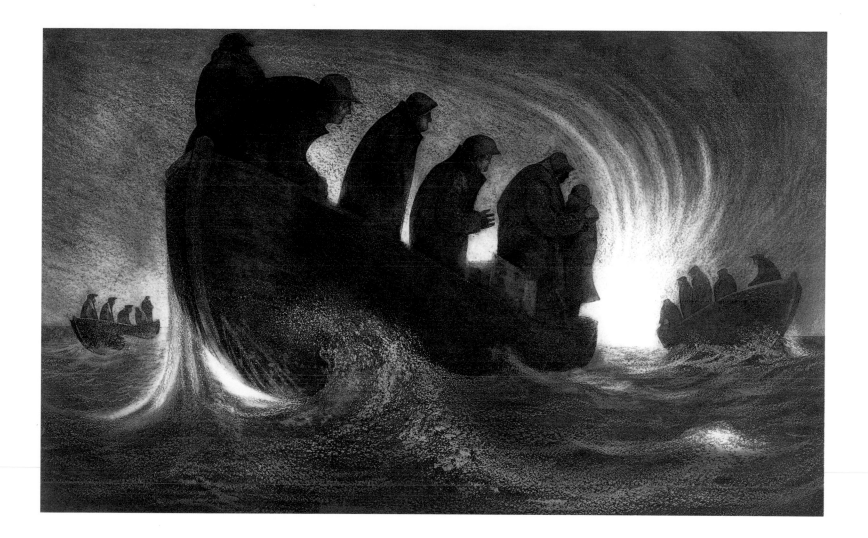

In the Labrador Sea
1996 · 50 × 80 cm

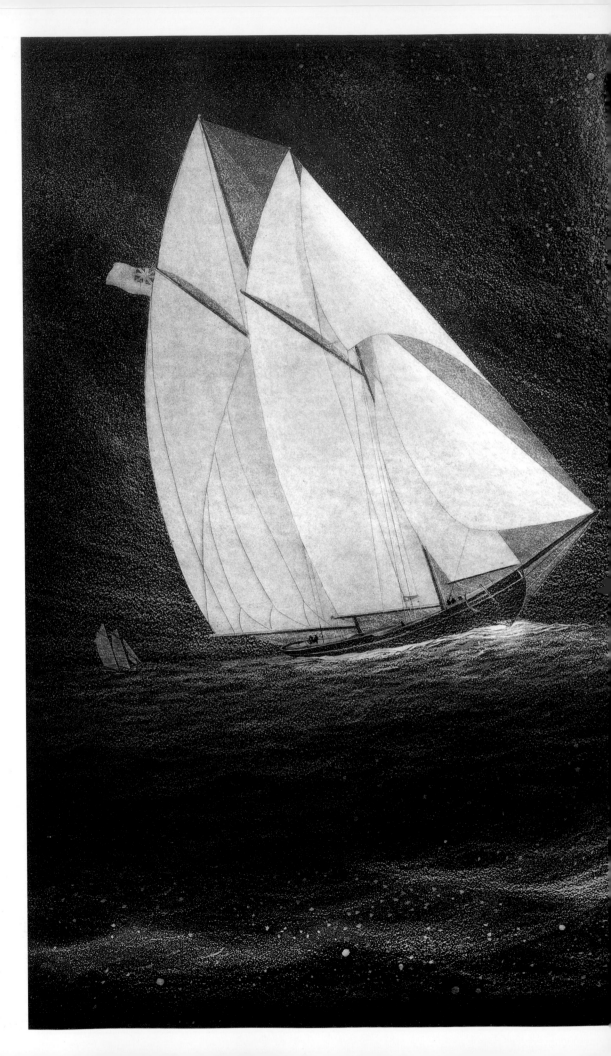

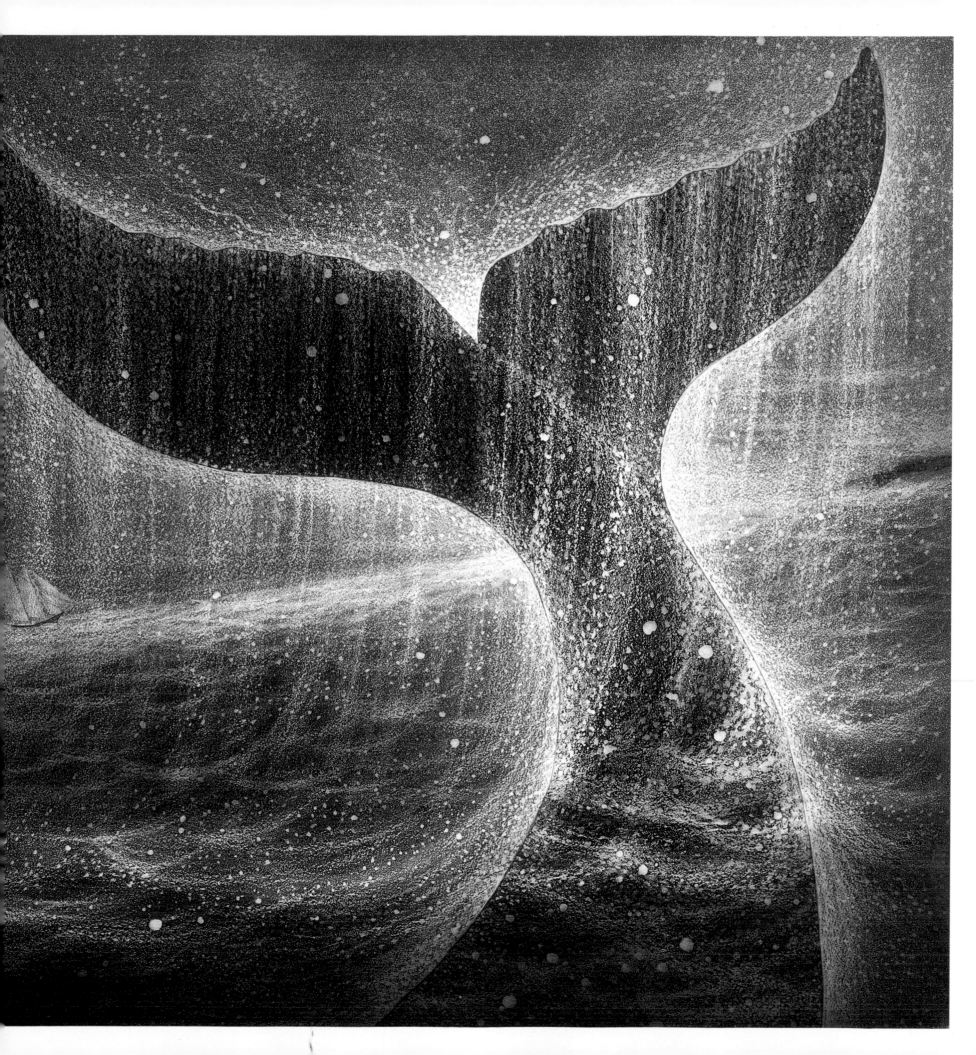

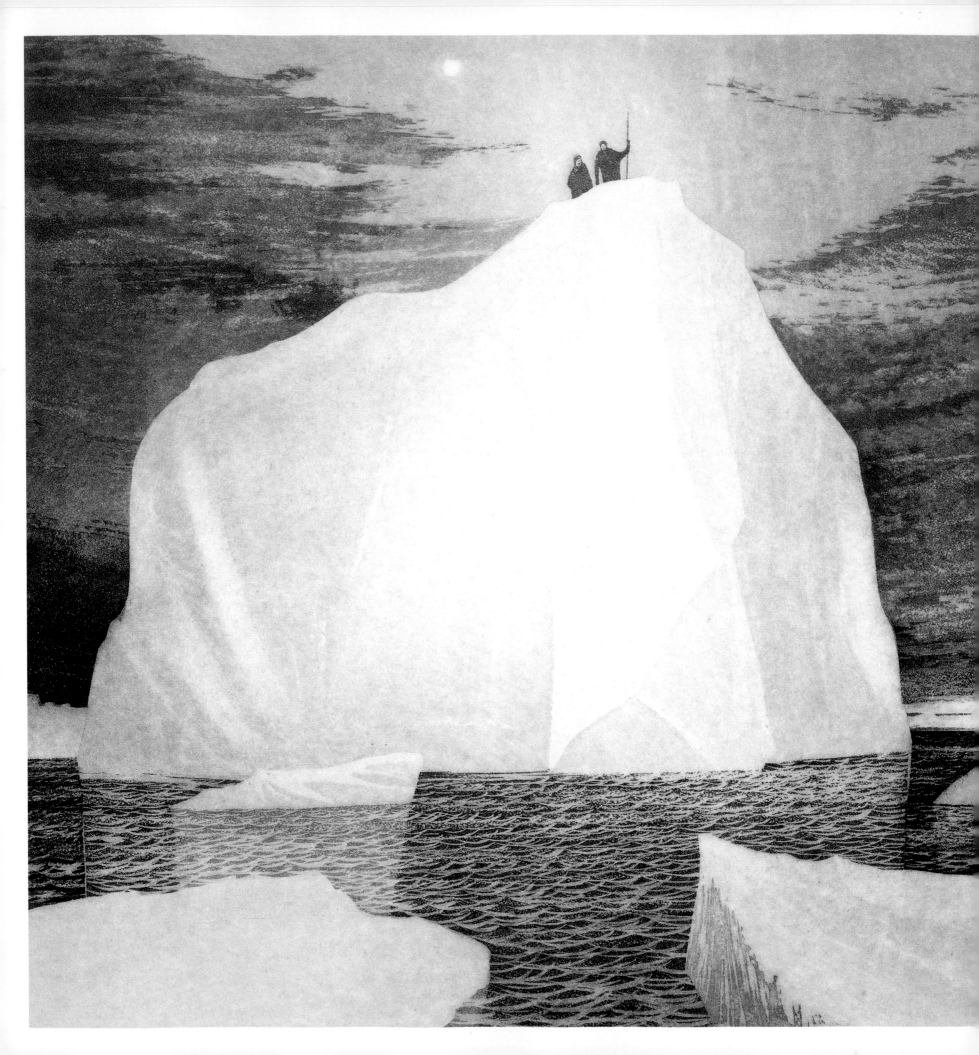

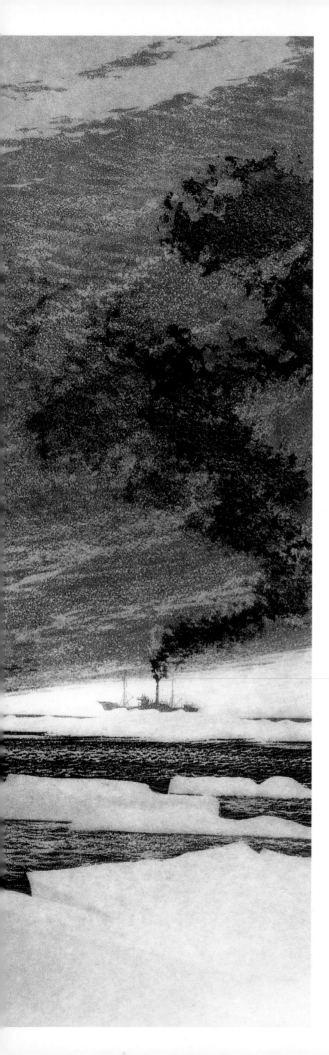

CAUGHT IN

ICE

The Burning of
the S.S. *Viking*
1971 · 50 × 80 cm

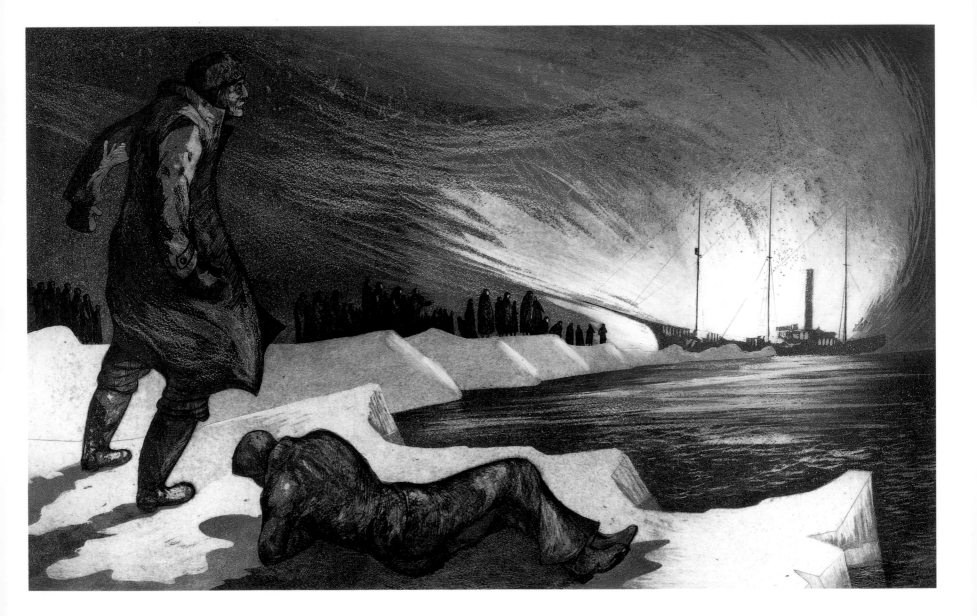

WHEN DAVID BLACKWOOD first found his artistic voice as a student at the Ontario College of Art, it arrived in the form of a lost party. Sealers called across the years to him, and he scratched images on plates, drew lines from a blank sheet. Slowly at first, and then so fast he could hardly shake the views from his hand, came the series of plates known as *The Lost Party,* which captured ice and snow and wind and sealing—and then, like a dream catcher, held the lives of men trapped by the combination of it all. As he peered deeply into the dull sheen of copper, images began to form, ferning over the sheets of metal as frost grows on glass in winter. And in far-off voices he could hear the words "Remember me."

Sealing was dirty and dangerous work. It paid little and offered its greatest reward in being able to return home alive. But sealing was in the blood and the mind of anyone who grew up in Wesleyville. The tales of bravery and of nights of tragedy were part of storytelling sessions at all times of year. The men who went to the ice did so in an age when it was more important to see how you would react to danger than to find ways of avoiding it. Being safe was not the main concern of the community; being a good person was. And the qualities of being good had much more to do with action than with thought. For the Methodist, it was expected that the human mind would harbour all sorts of "unnatural" thoughts; what was also expected was that a human being could withstand any temptation, any strife,

through an alliance with a personal Saviour. This alliance was demonstrated through deeds—deeds of generosity, of sharing, of putting others before yourself—and through the ability to face dangerous situations courageously despite a fear of death. Sealing offered all of those chances to prove yourself, although that wasn't the reason for the trip. Sealing was not, in any sense, a "coming-of-age" rite. It was just that Newfoundland civilization created a breed of men and women who would not avoid doing things because of either difficulty or danger.

Getting ready for the hunt was in itself a kind of adventure, a time to prepare for the quest to come. Sealers had to bring their own provisions with them, and so the preparation of the sealing box was of great importance. Women would soak and press salt beef into thin slices, wrap hard-boiled eggs, and prepare pork tongues to be stowed in the box. Because of the grave danger of getting wet or even damp while sealing, casings for the clothes bags were made from old oilskins. Flour sacks were transformed into shirts and underwear. In those days nothing was wasted.

Miss Alice Lacey of Wesleyville recalled that her father, Lewis, went to the seal fishery for the first time at thirteen. He was a strong boy, with clever hands. "You see, everything they did was with their hands. When they went fishing, they rowed out to their trap, they hauled the trap with their hands, and they rowed back. They hoisted the sails on the schooners, so they got exercise as well as fresh

David Blackwood at the Ontario College of Art, 1963

air. But when they went to the seal fishery, there were some very bad things they had to put up with. Just as one example—if there was a load of seals, an extra load, the men had to sleep on the sealskins, the flesh and blood of the seals. And it wasn't until Coaker [the famous fishermen's union leader] came along that regular meals were served. I know my father had a round tin can, a tin pan, and his initials were stamped into it when he bought it in St. John's, and that was all they had."

When the bite of winter was solid, thoughts in Wesleyville would turn to spring and the journey to the ice in search of seals: rushing from one ice pan to another, jumping from clumper to clumper with the dark sucking waters below. There would be the groan of ships' hulls creaking and grinding against the pressing ice, the dazzle-white of the sudden sharp snow, the blowing drift of ice needles, the rattle of snow against your Cape Ann, and its sting on your cheeks. But there would also be the chance for some extra

The Lost Party
1963 · 50 × 70.5 cm

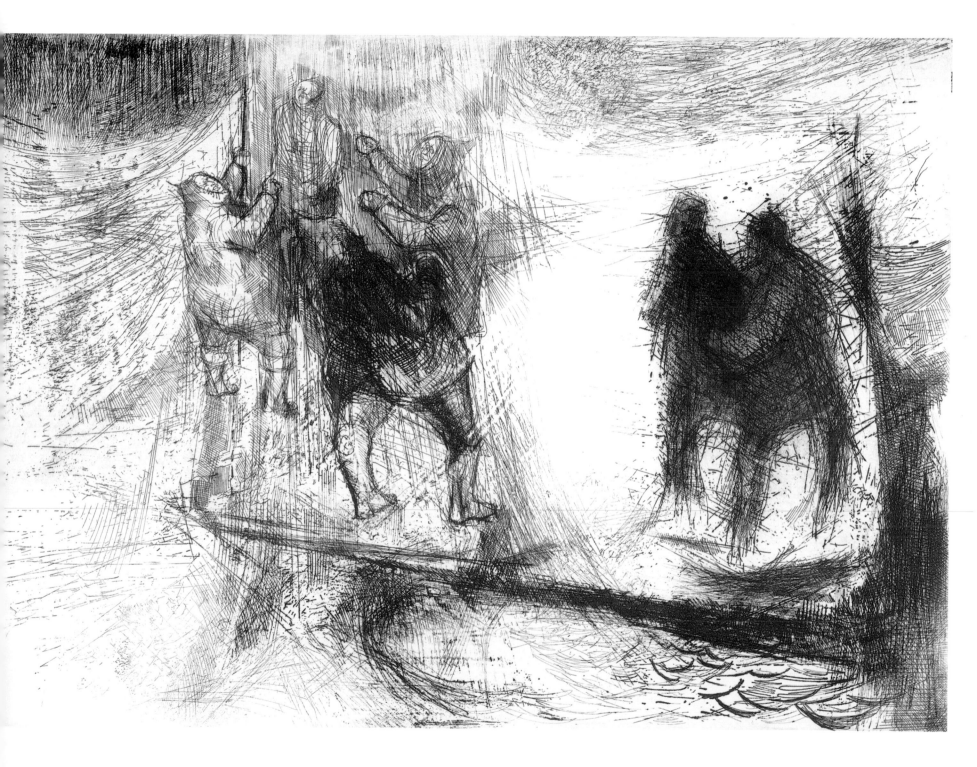

money, the hope of getting a little out of debt, and the excitement of a challenge, the comradeship that facing danger offered. And, at the end, the joy of arriving back in port. Then there would be the feed of flipper pie, flaky and steaming, the smell of cooking that filled the houses, the cups of tea when everyone sat back. Above all, there would be the stories.

David Blackwood would sit and listen to these stories, watching the way huge hands held mugs of tea, the way eyes went sharp as an ice candle as memories of the jagged winter world returned. He would hear the words "Go sealing" and the details of the voyages that went wrong, the names of those who were brought back to Wesleyville and of those who died on the ice and were never found.

Mildred Winsor, formerly of Wesleyville, told me about a night of sealing in 1914 when her mother awakened from sleep. "The night before, the storm was raging and all the sealers from the *Newfoundland* were dying on the icefields and Mother was home in bed and woke up around midnight. It was a fine night, and there was a moonbeam shining through her window. That moonbeam shone past her bed and on her husband and son. And Mother told me, 'You know, they were so close you could see the double stitching that I put on their canvas jackets. They were both kneeling in an attitude of prayer. I looked at their faces and they were so peaceful and so happy-looking. And it was just for a few seconds, and they disappeared.'

"So Mother got up and went downstairs. She lit the fire and wrapped herself in a blanket. When the children got up, she tried her best to get them breakfast. By that time the minister had the news, and he came to the house.

"When he knocked at the door, she said to her eldest daughter, 'Ask him to come in, because I know what he's going to say.' And when he came in, he said, 'Mrs. Crewe, I'm afraid that I've got some bad news for you.'

"And she said, before he could go on, 'My husband and son, they're both gone.'

"He replied, 'Yes, they perished in the storm.'

"And, you know, it was a terrible shock, because her husband, Reuben, had been to the seal fishery before and had an experience where he'd nearly lost his life—so he gave it up; he gave up going to the sea, to the seal fishery; he was never going again. But their son, Albert John, wanted to go this spring, he was seventeen. And Mother said, 'No, my son, I don't want you to go to the seal fishery.' But his uncle had some berths come, so Albert signed on, all by himself.

"Well, when Mother told her husband, he said, 'Mary, I . . . the only thing I can see is for me to go with him, I wouldn't trust him there alone. I know what the seal fishery's like.' So he went and got a berth and went with him.

"And when they found Albert John, he was under his father's jersey and canvas jacket, and that's where he died—the two of them were frozen together in death."

When David Blackwood takes us sealing, we go to the world where fathers and sons froze together on terrible nights; where men as brave as were ever known stood pointing in a storm, compass needles on pure white; where, in a cold so intense it turned you warm, the dreams were of home, of lights left on to show a soul the way to port. Lives that flared like Aladdin lamp mantles, intense as a fire in winter, are held for us in David Blackwood's work.

In these prints, storms edge around the corners, and once more a Blackwood takes us sealing. David Blackwood's hand is upon the tiller of a press as he pulls a plate. It reminds me of the way a fisherman's hand rests on the tiller of a skiff at sea. For a moment fisherman and artist pause, caught in time, tillers in hand. The wind comes around, shifting, blowing away the years, and the two are back on course together. And what do they follow? They follow their history.

Snow falls, time shivers. Line by line, in shade and shadow, the lives of the lost party drift across the page.

Newfoundland sealers,
1920s

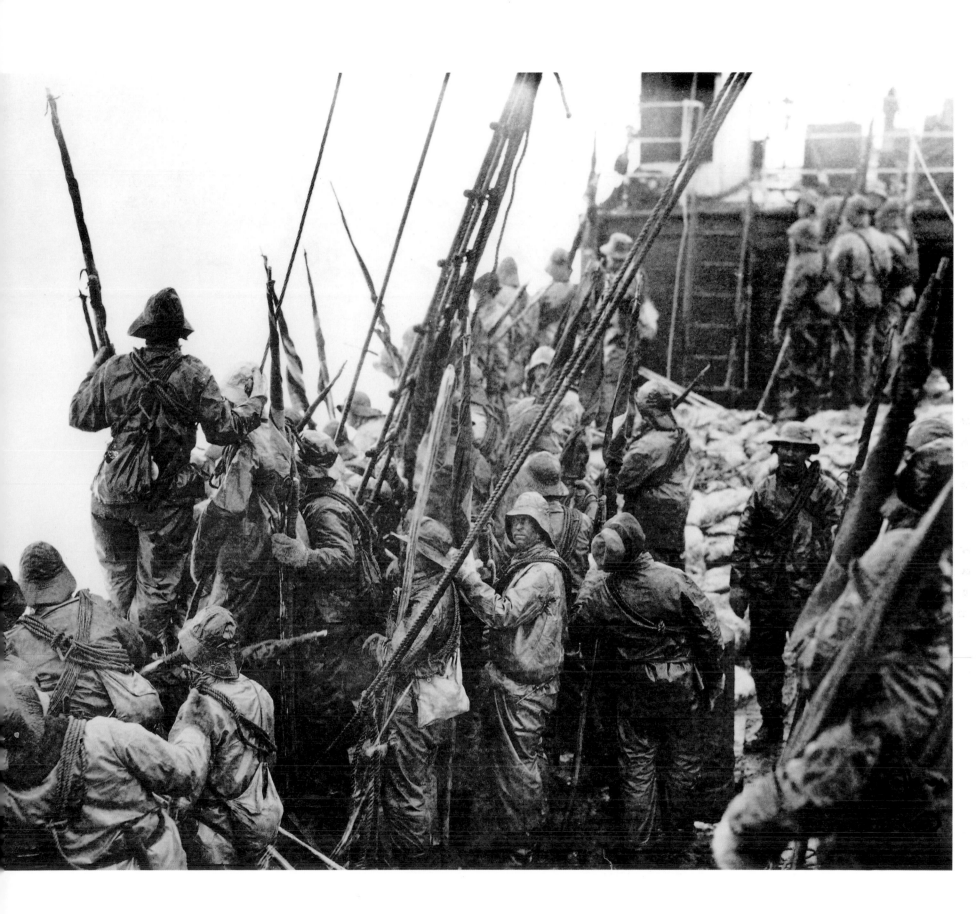

Trap boat fisherman,
Bonavista Bay
photo: John de Visser

facing page:
David Blackwood in
his studio at Port
Hope, Ontario, 1985
photo: John de Visser

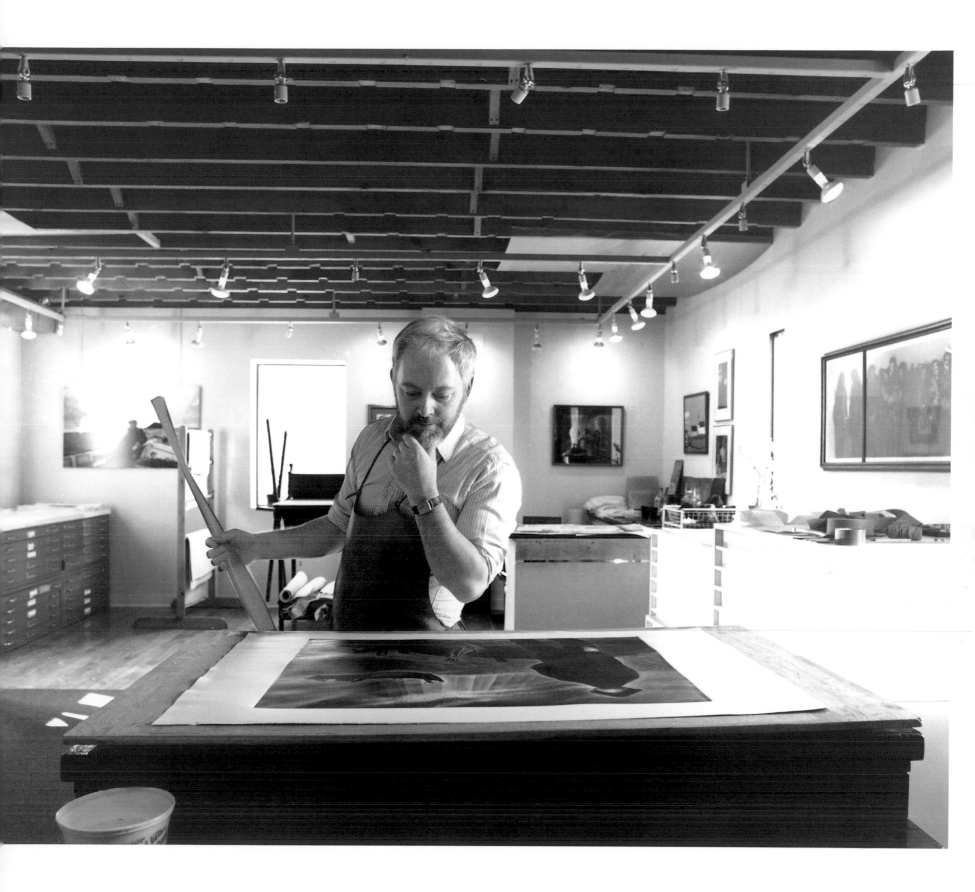

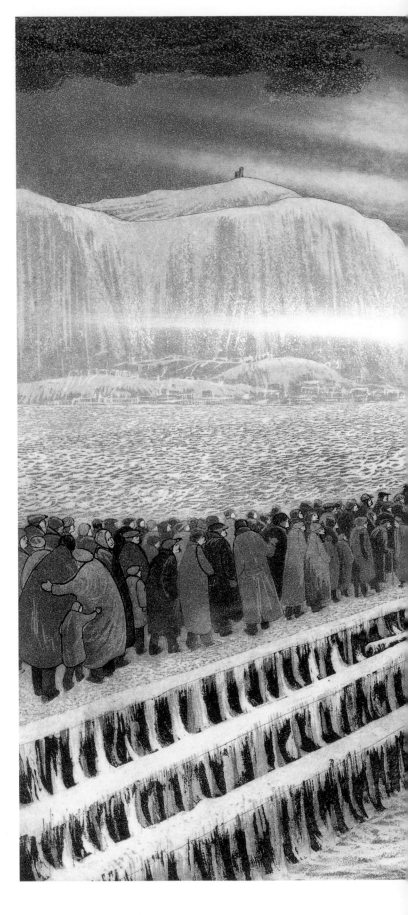

above:
**S.S. *Imogene* with
Crew on Ice**
1967 · 75 × 50 cm

right:
**S.S. *Imogene*
Leaving for the
Icefields**
1973 · 50 × 80 cm

overleaf, left:
**The Departure:
Kean's Men Leaving**
1969 · 50 × 80 cm

overleaf, right:
**Sick Captain
Leaving**
1972 · 80 × 50 cm

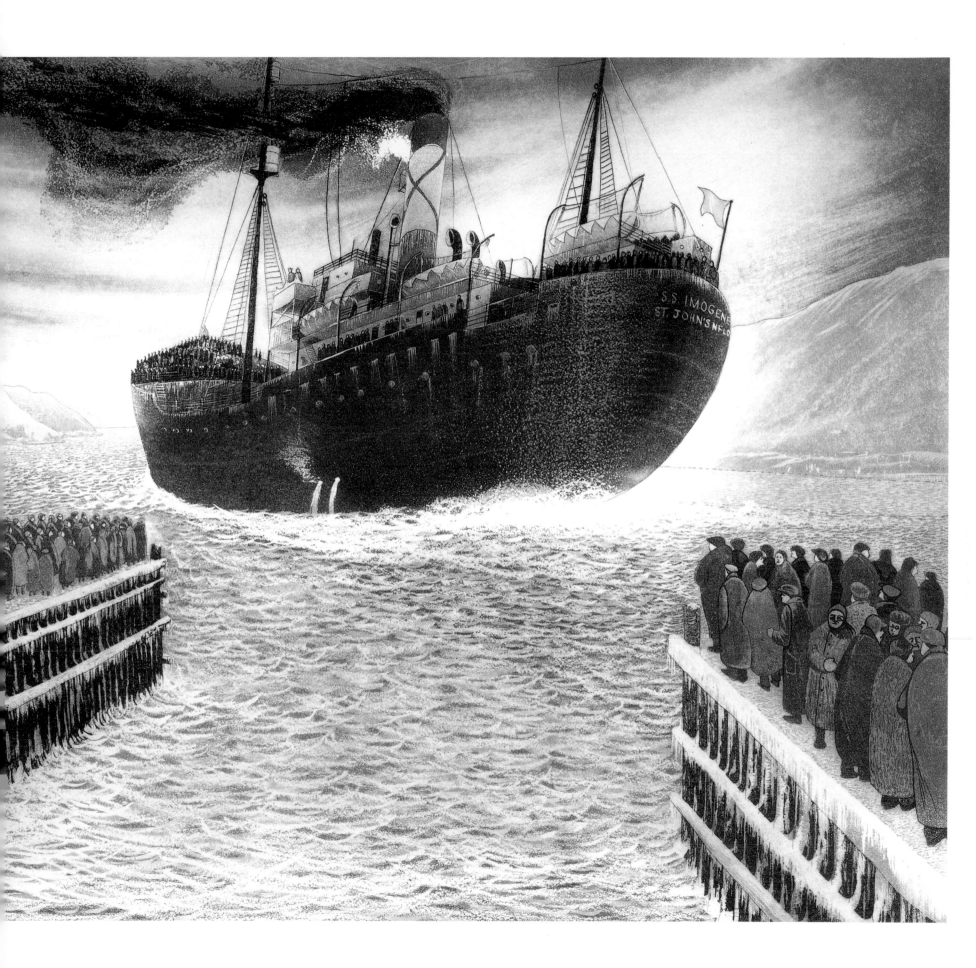

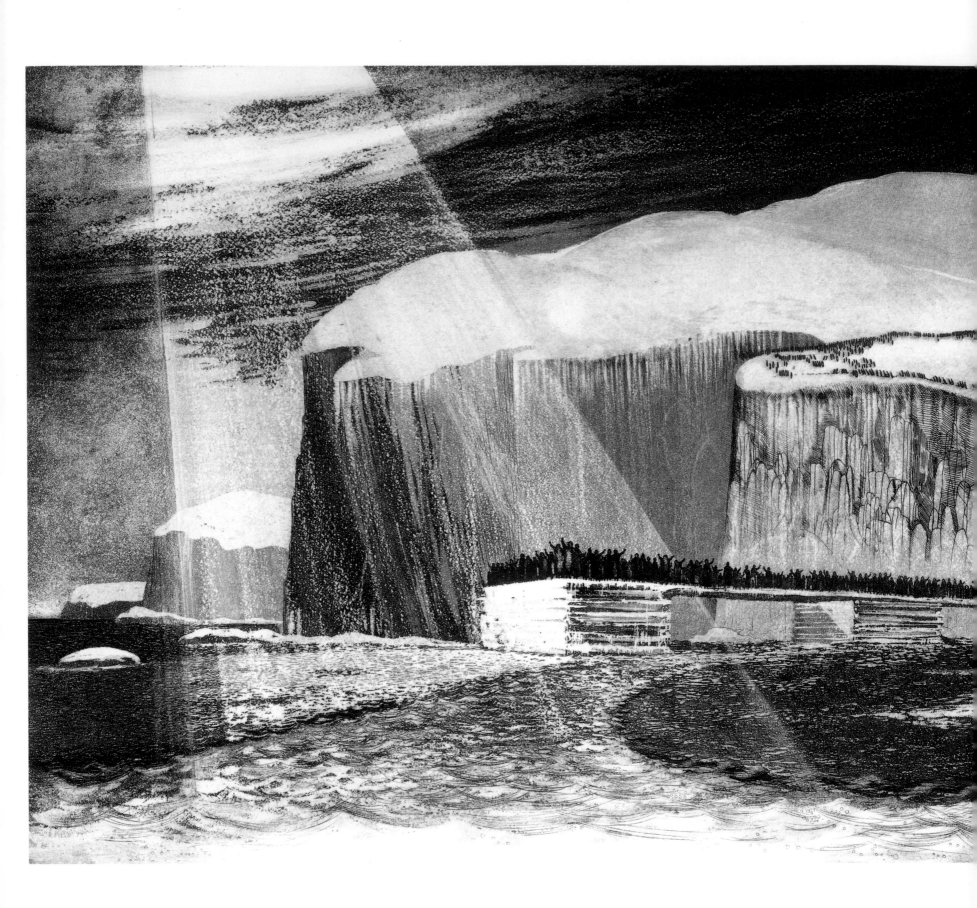

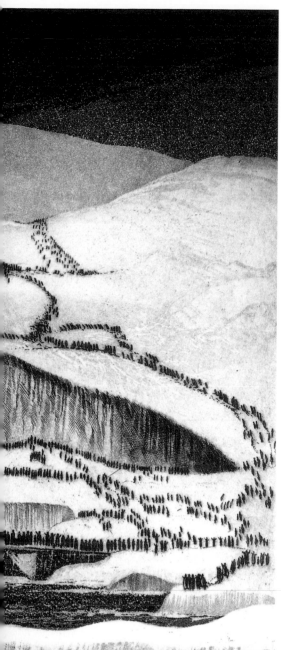

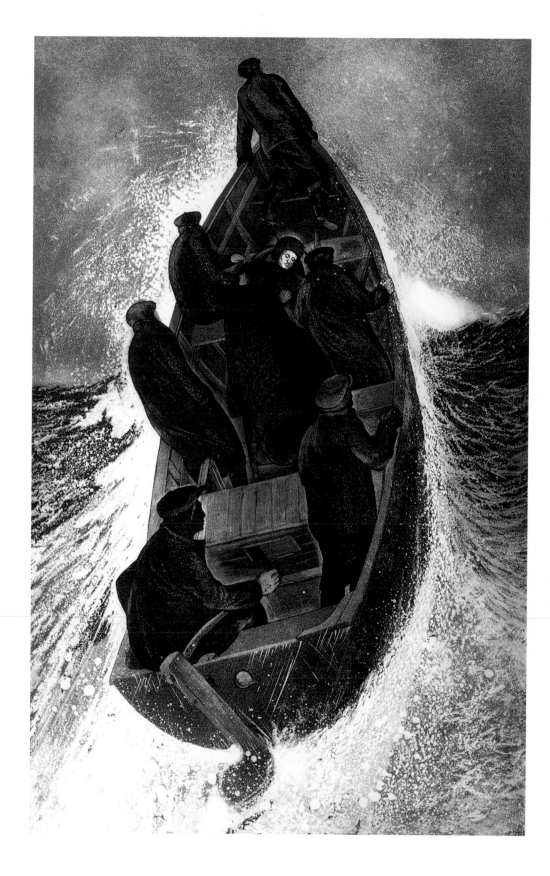

131

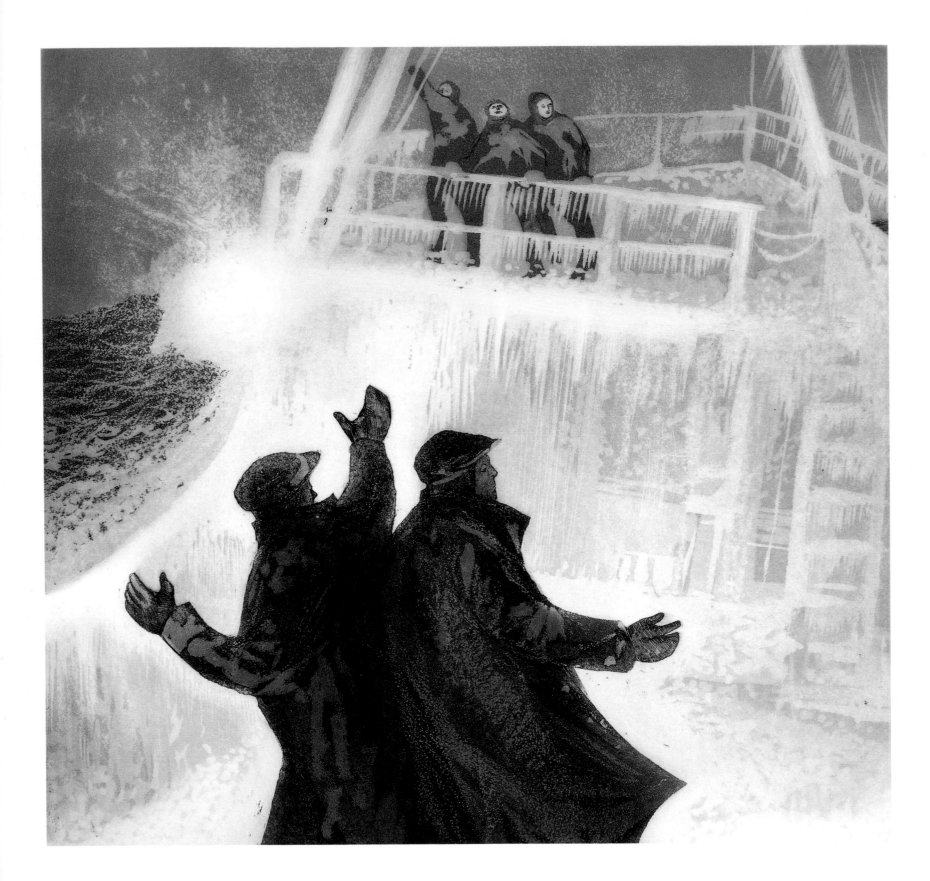

Captain Ned Bishop

with Officers on the

Bridge of the S.S. *Eagle*

1969 · 50 × 80 cm

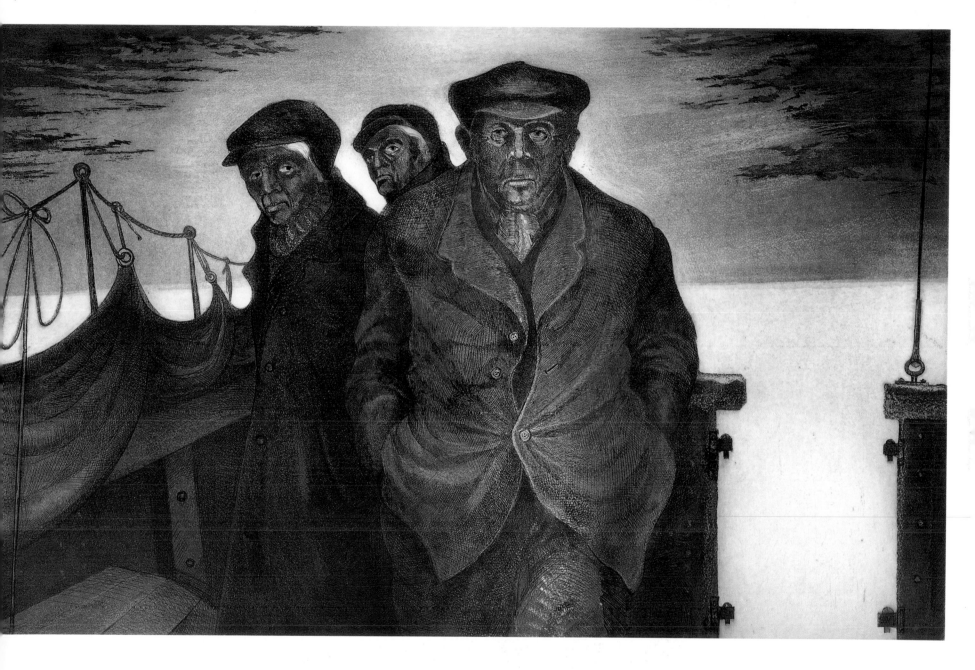

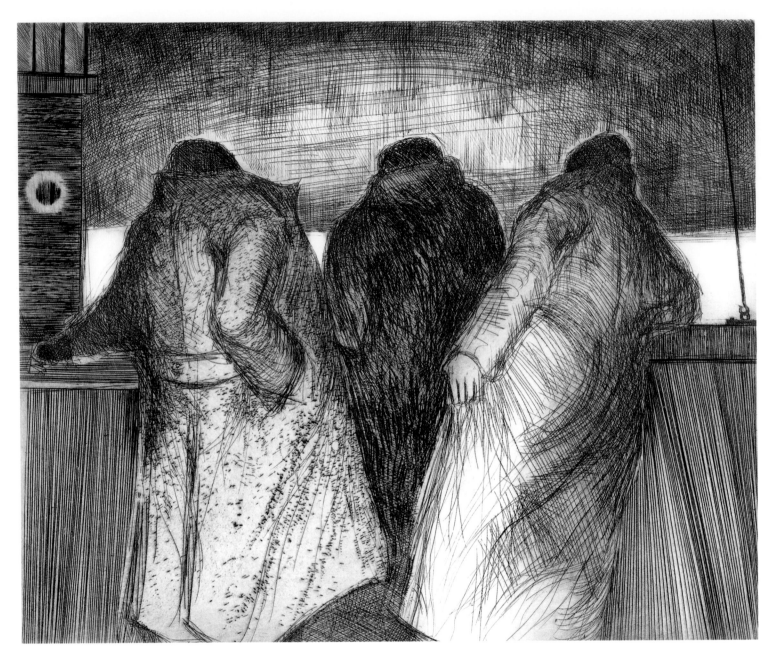

**On the Bridge of
the S.S. *Greenland***
1968 · 42.5 × 50 cm

facing page:
Sealer's Dream
1968 · 50 × 40 cm

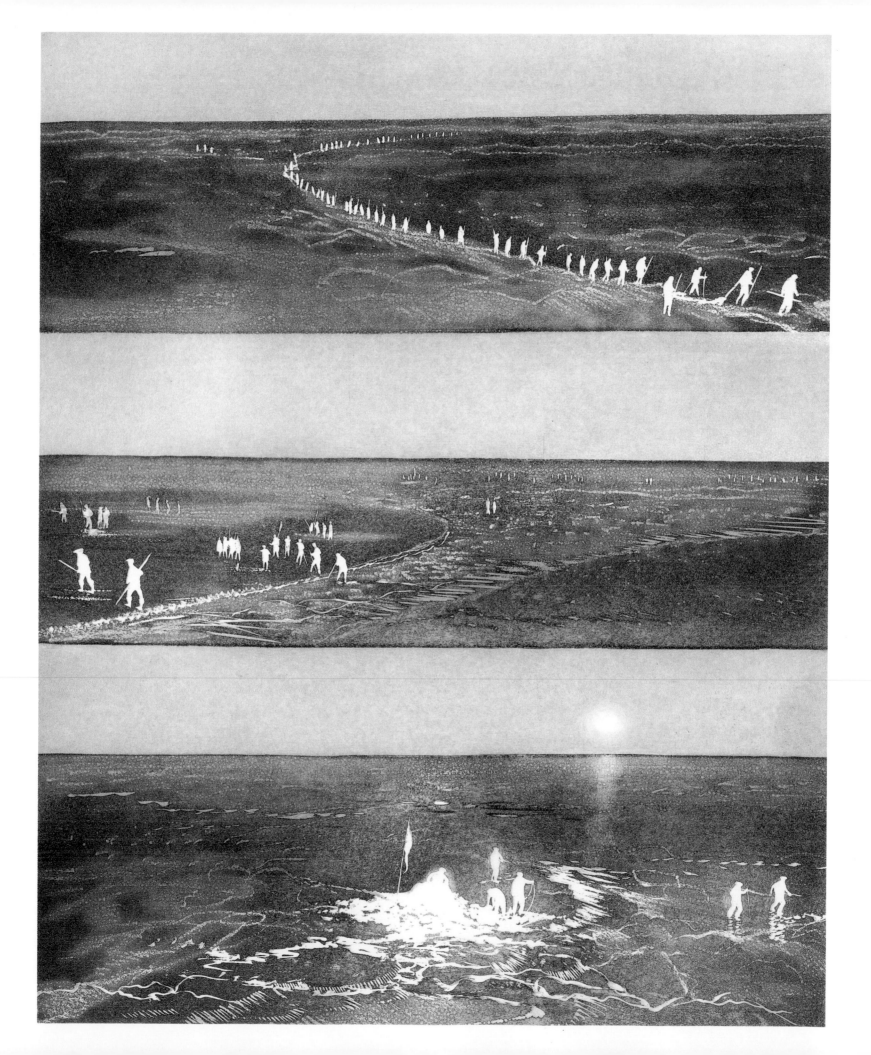

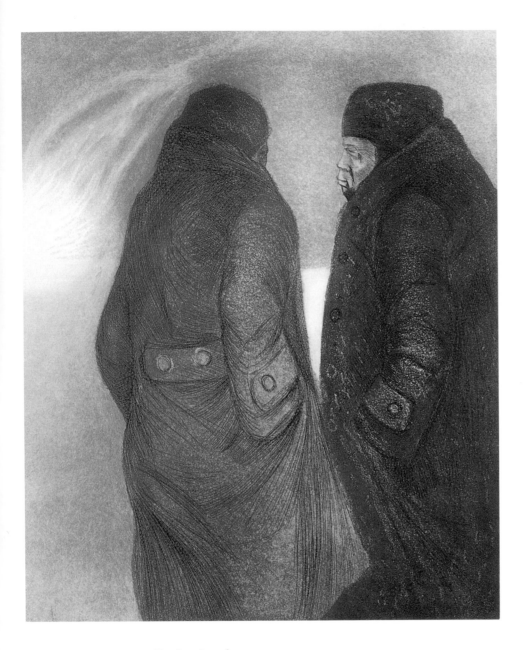

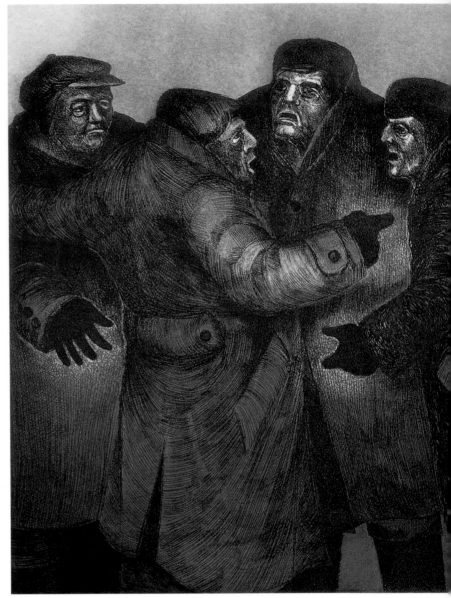

The Burning of
the S.S. *Diana*
1968 · 50 × 160 cm

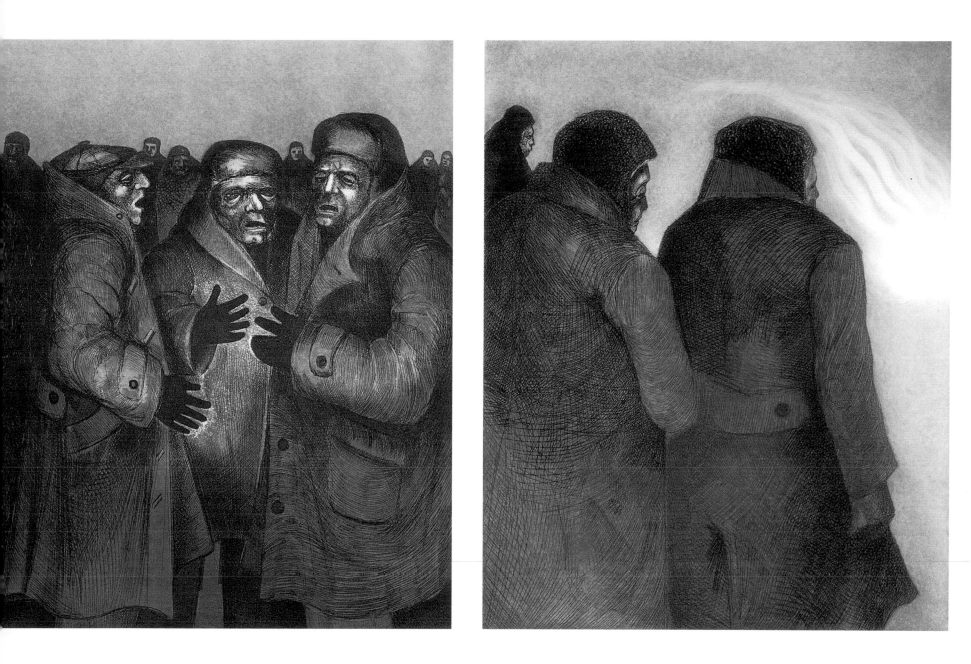

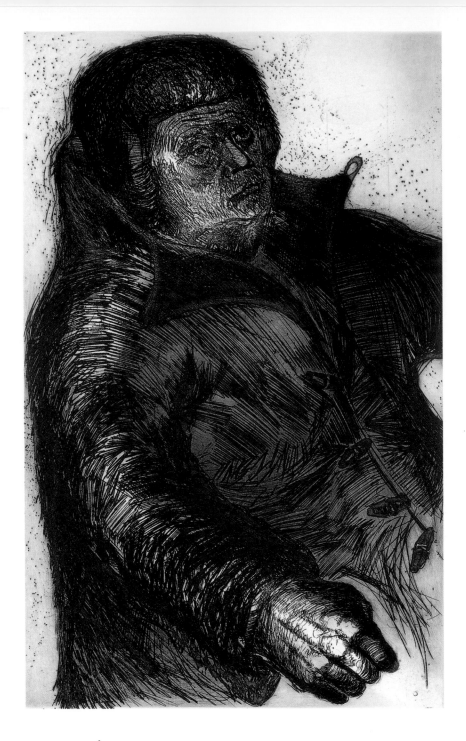

above:

The Master Watch

1966 · 60 × 37.5 cm

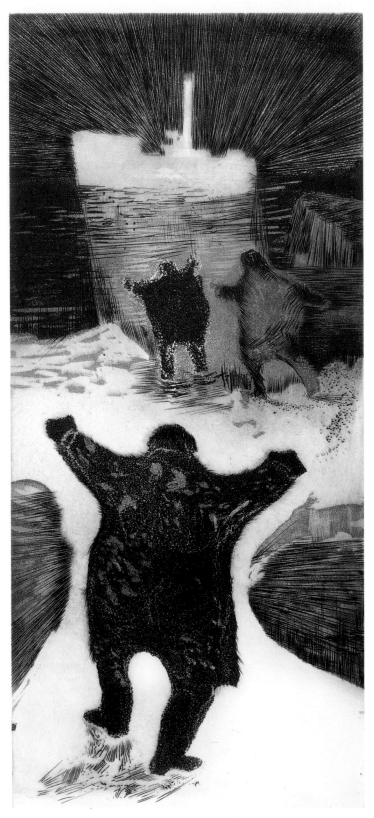

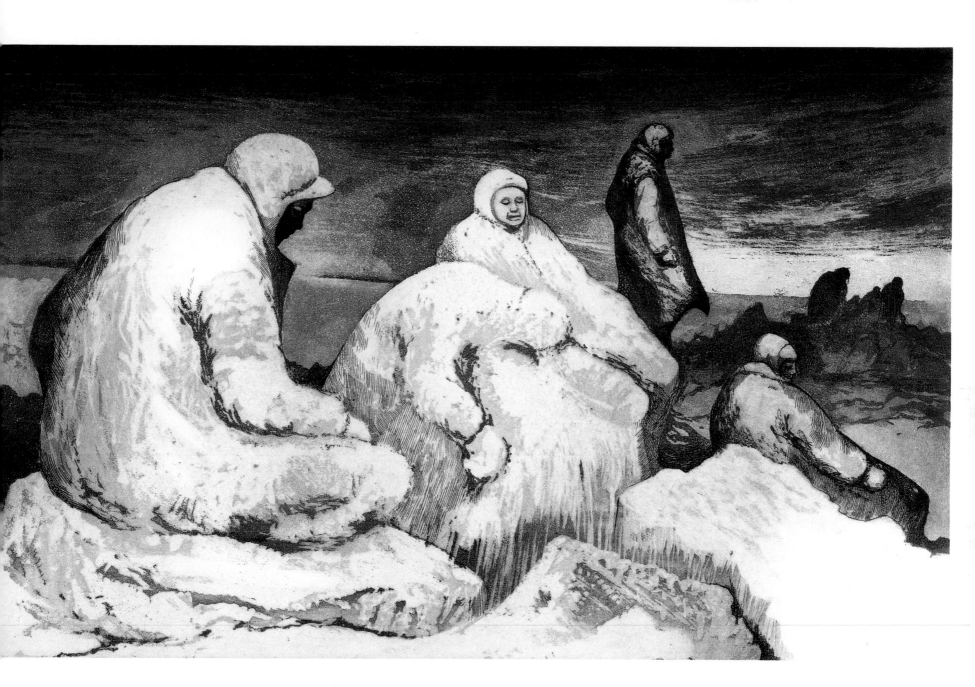

Kean's Men Waiting
for the S.S. *Bellaventure*
1969 · 50 × 80 cm

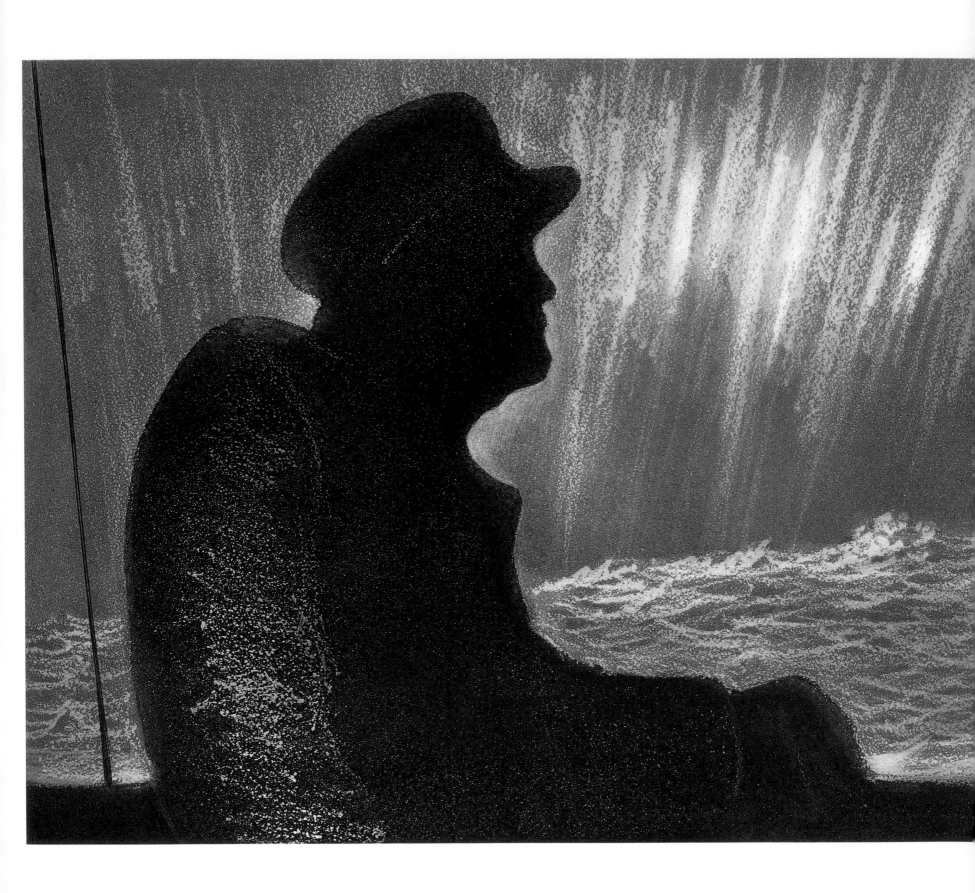

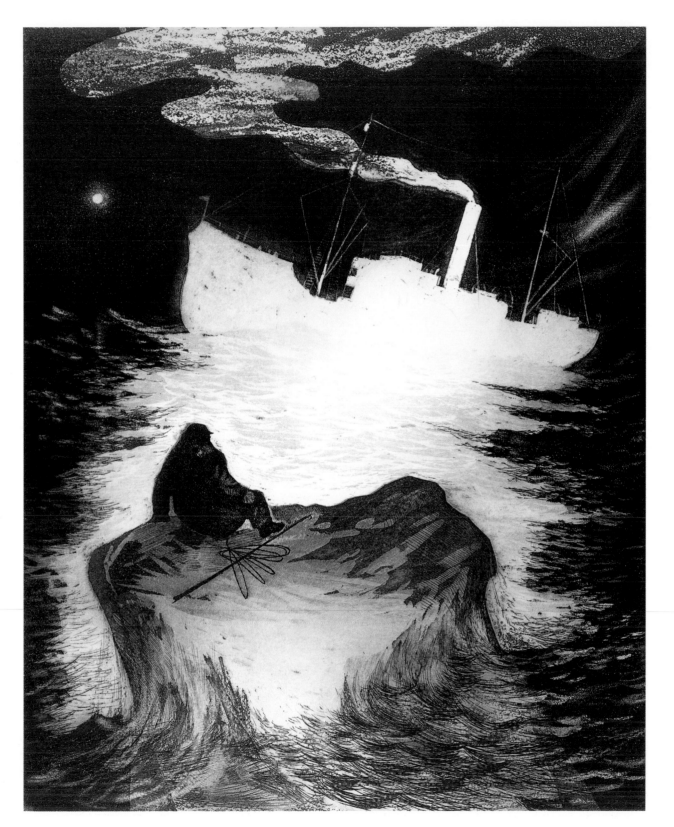

Survivor Drifting
1971 · 50 × 40 cm

facing page:
Captain Wes Kean
on the Bridge of the
S.S. *Newfoundland*
1969 · 40 × 50 cm

141

Vision of the
Lost Party
1964 · 75 × 50 cm

facing page:
**Great Lost Party
with Beast Spirit**
1964 · 50 × 60 cm

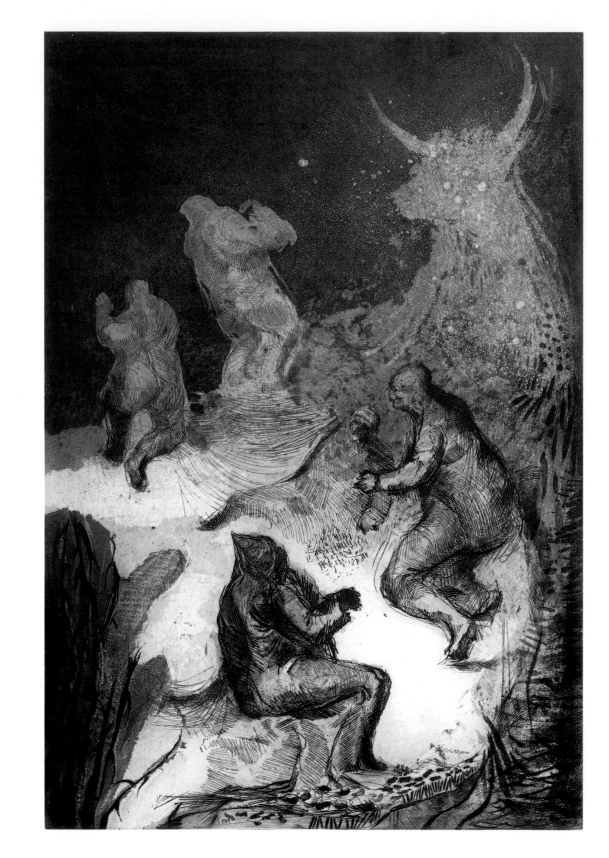

142

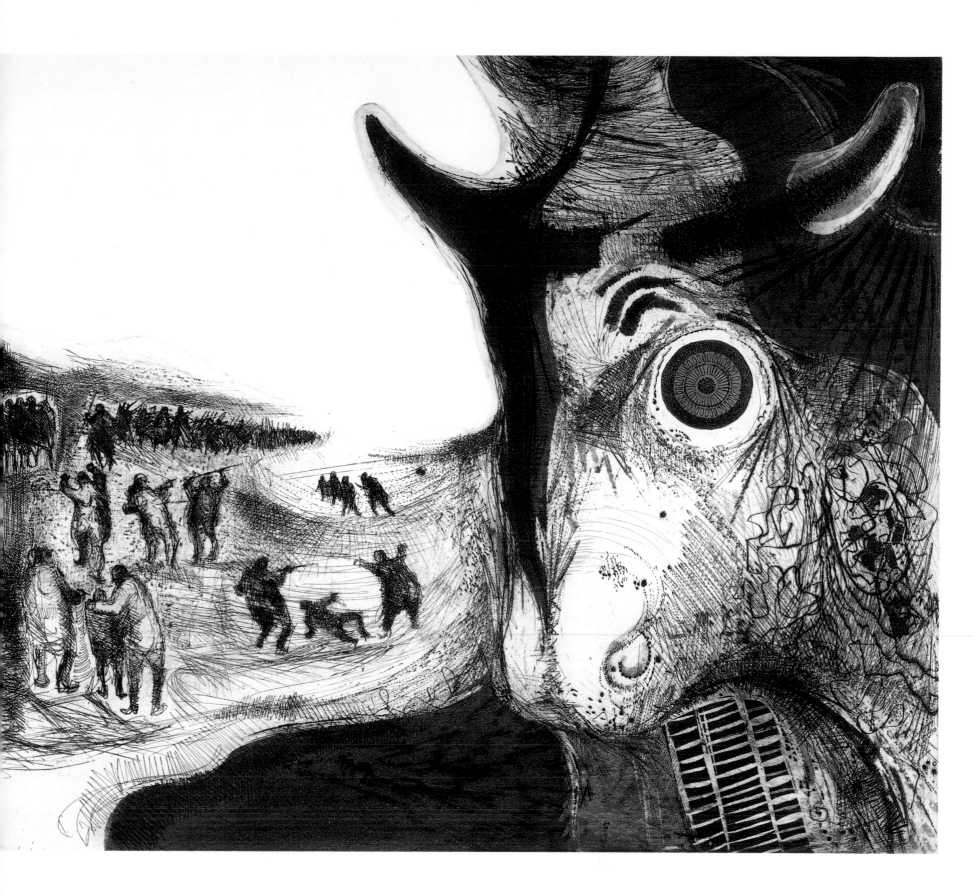

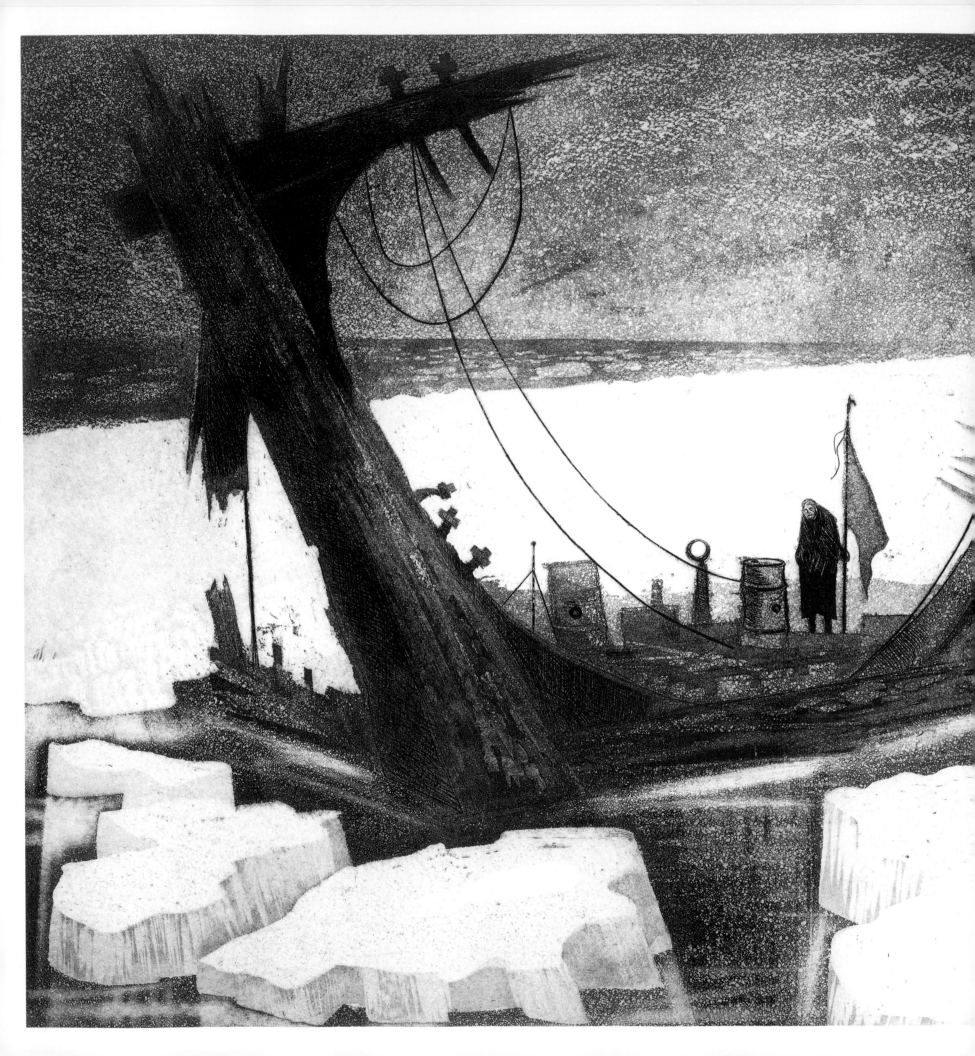

left:
The Survivor
1968 · 40 × 50 cm

above:
The Search Party
1964 · 72.5 × 50 cm

145

above:
**Captain Abraham
Kean Awaiting
the Return of the
Lost Party**
1965 · 50 × 40 cm

below:
**Posthumous
Portrait: Captain
Abraham Kean**
1968 · 50 × 37.5 cm

146

Survivors
Discovered
1971 · 32.5 × 50 cm

Great Lost Party Adrift

1970 · 50 × 80 cm

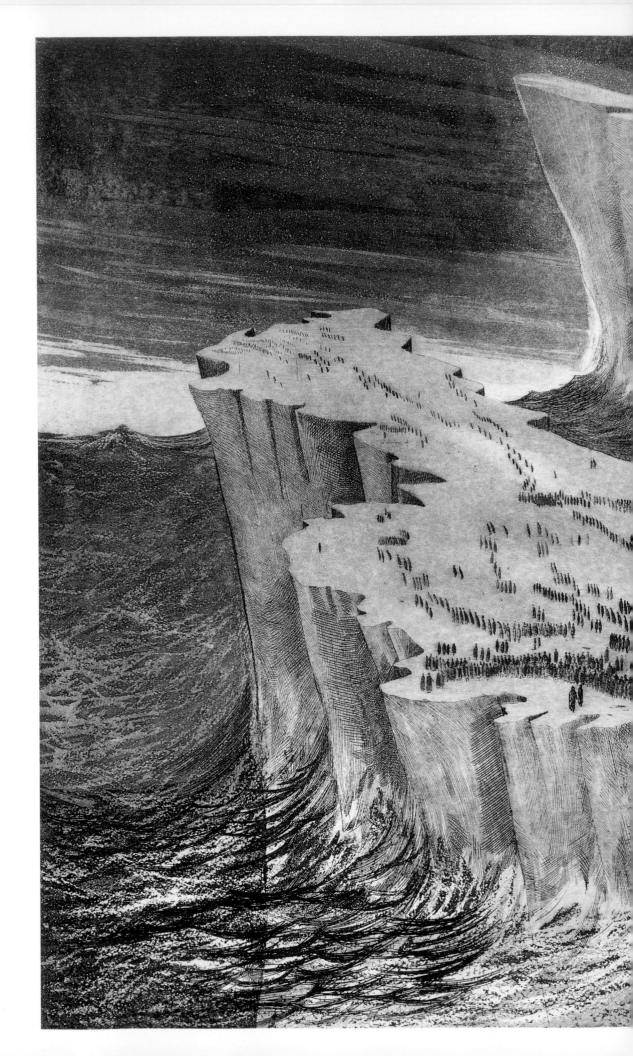

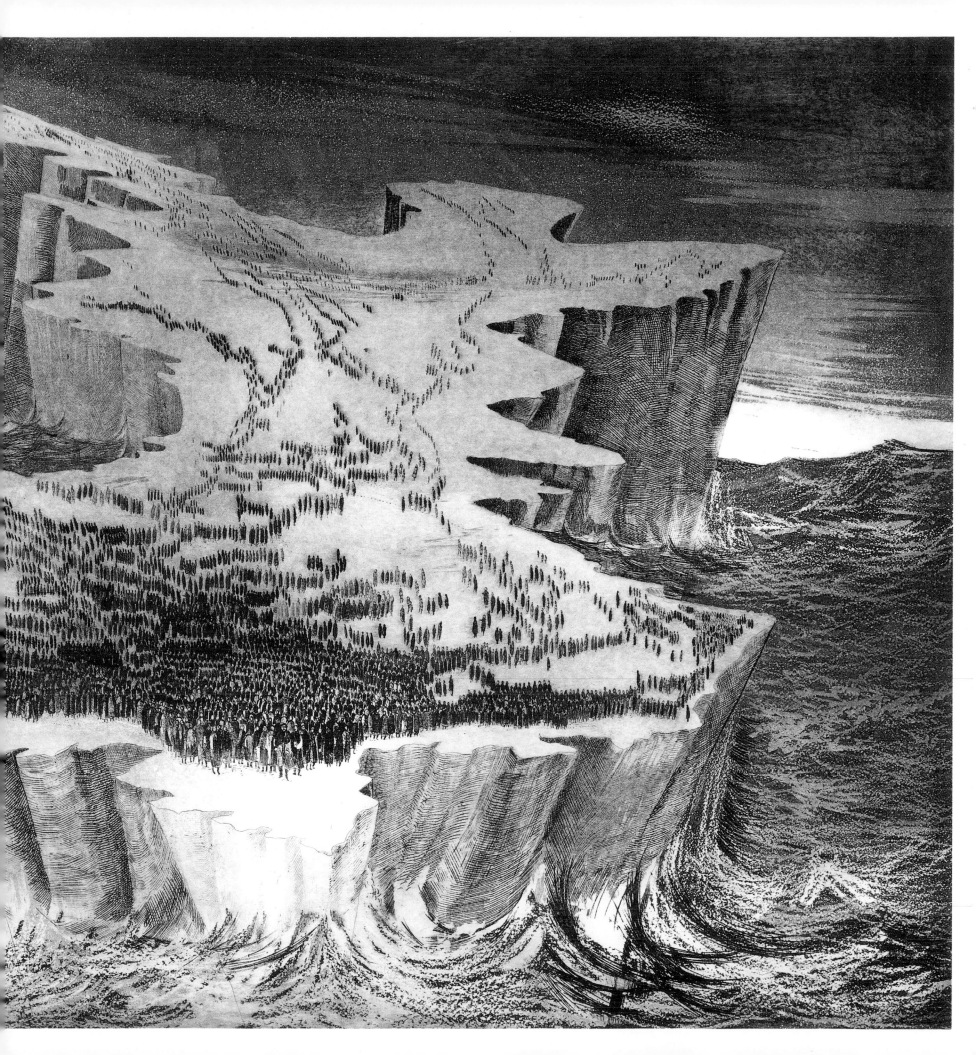

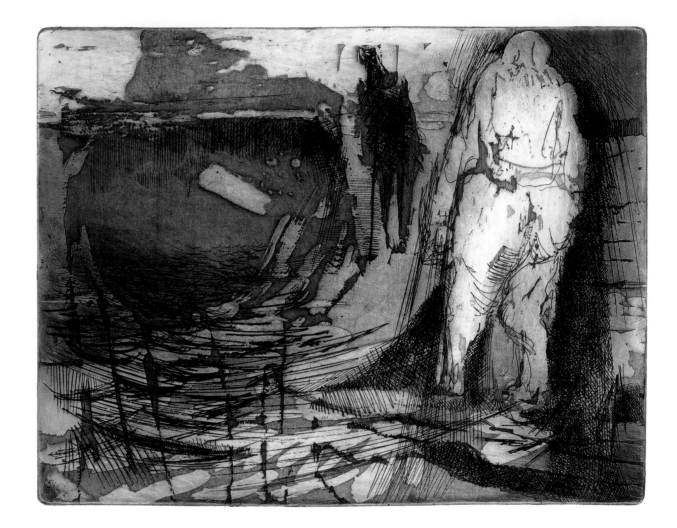

Ice Floe Spirits

1964 · 20 × 25 cm

facing page:

The Messenger

1965 · 50 × 62.5 cm

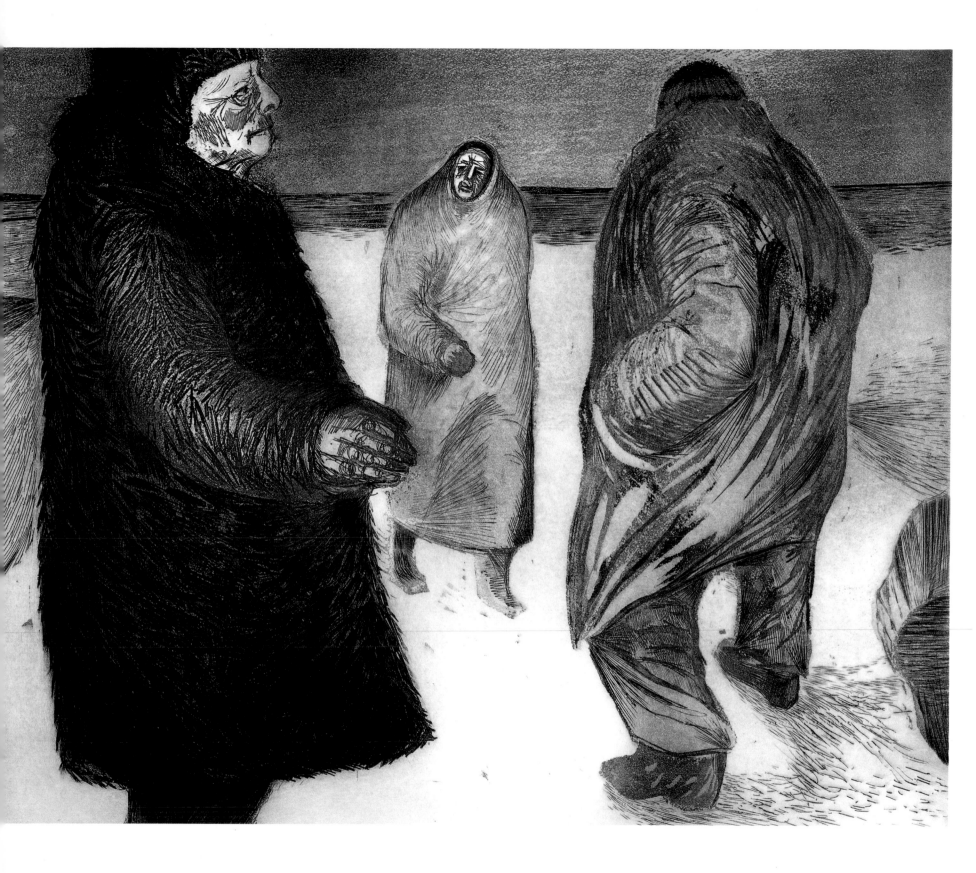

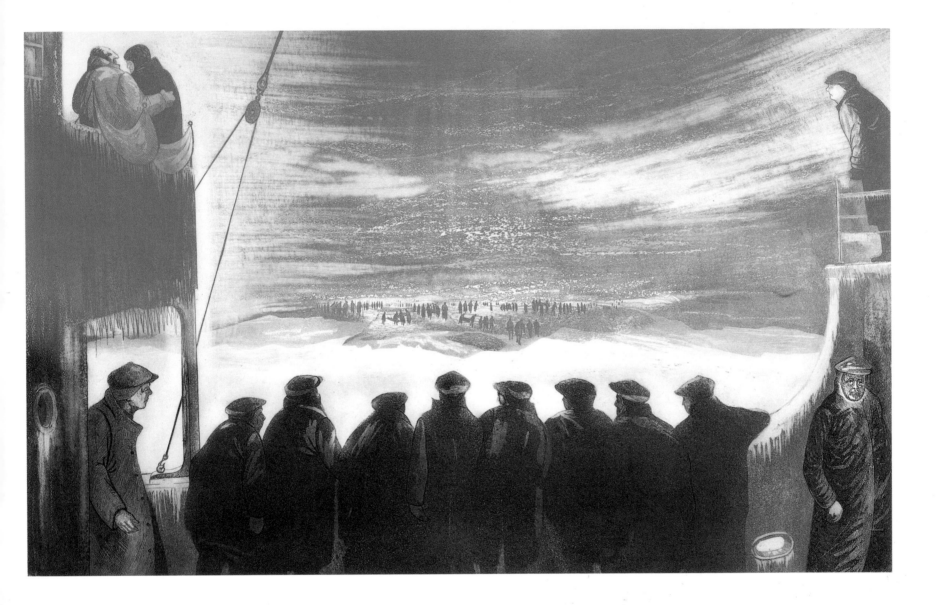

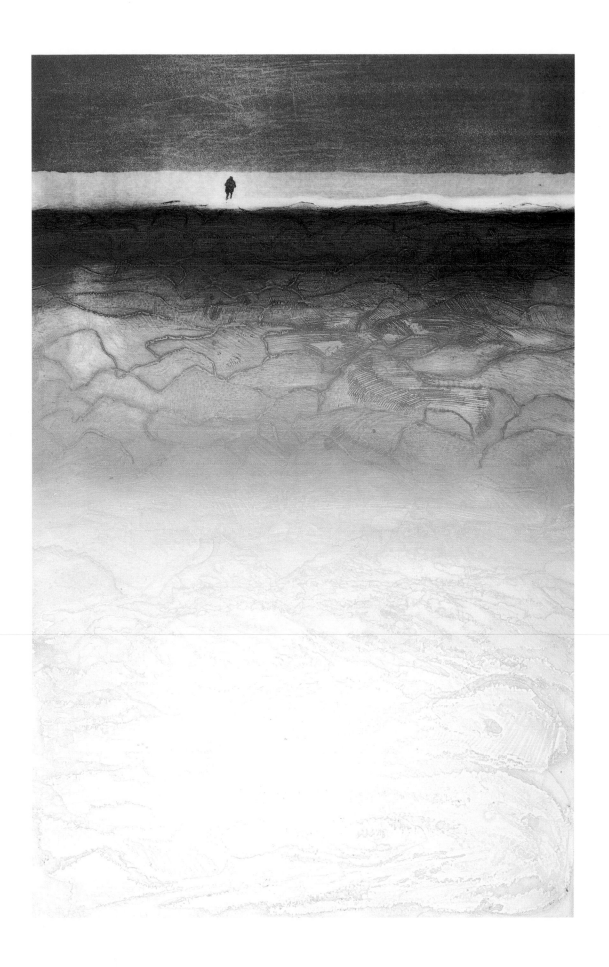

Survivor Wandering
1968 · 80 × 50 cm

facing page:
Search Party
Returning
1971 · 50 × 80 cm

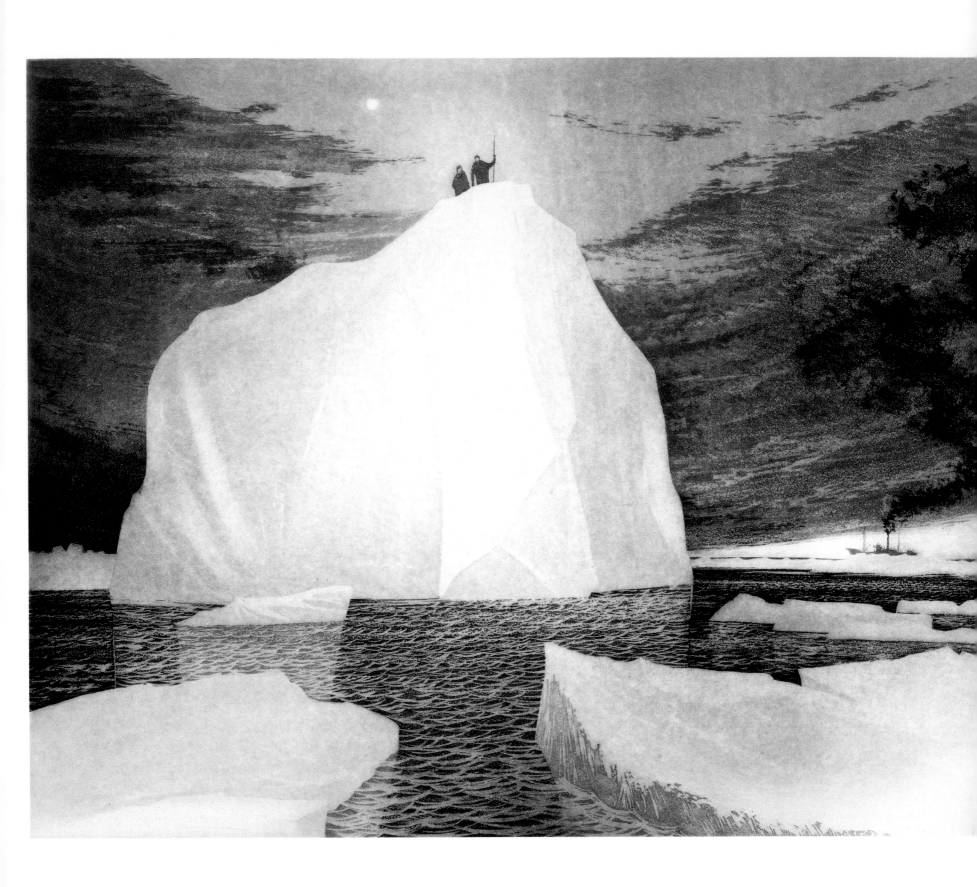

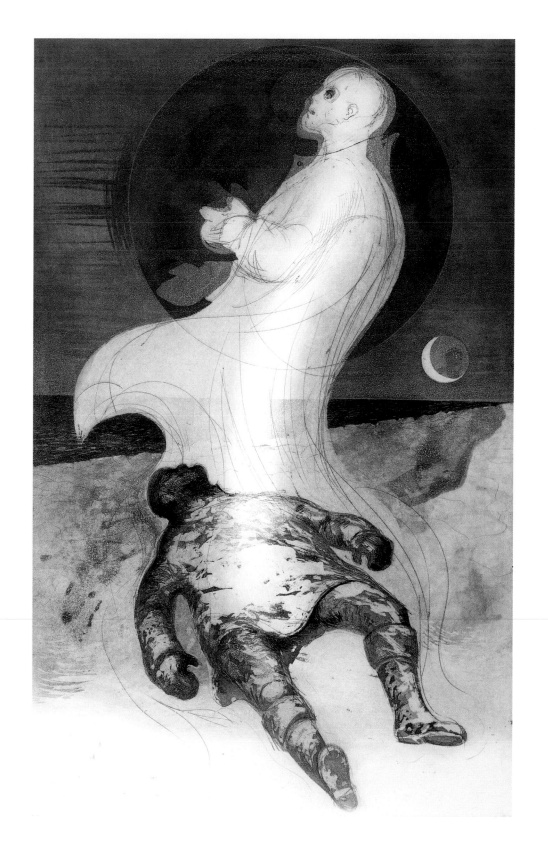

Spirit Departing:
Once Told Tale
1968 · 80 × 50 cm

facing page:
Two Scouts from
the S.S. *Eagle*
1975 · 40 × 50 cm

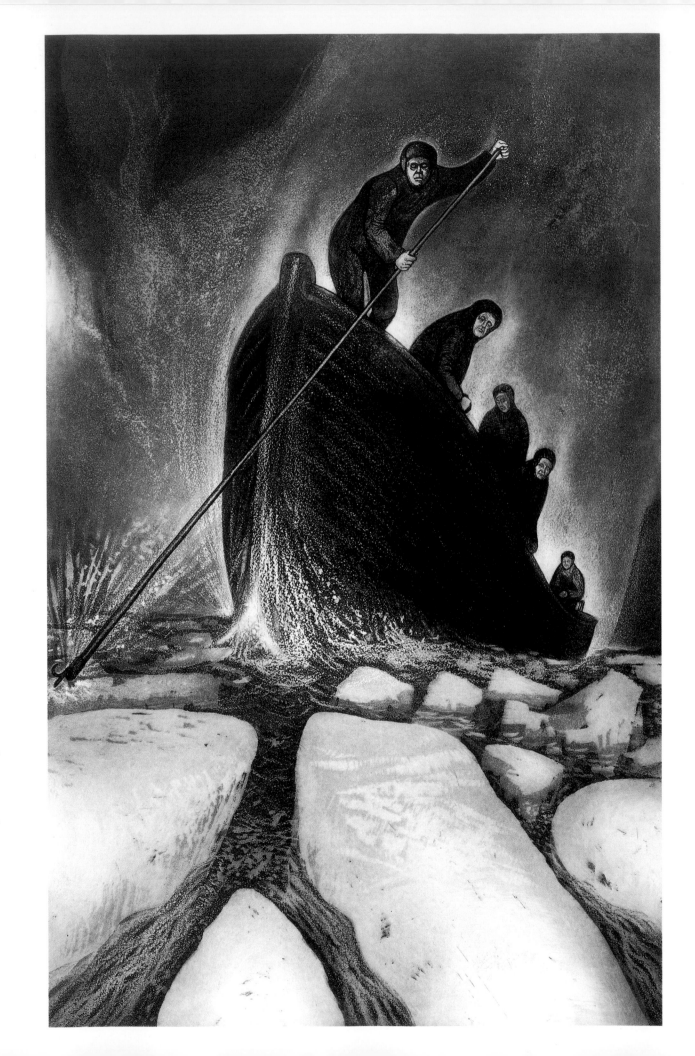

Sick Captain
Returning
1972 · 80 × 50 cm

facing page:
The Retreat
1964 · 40 × 50 cm

156

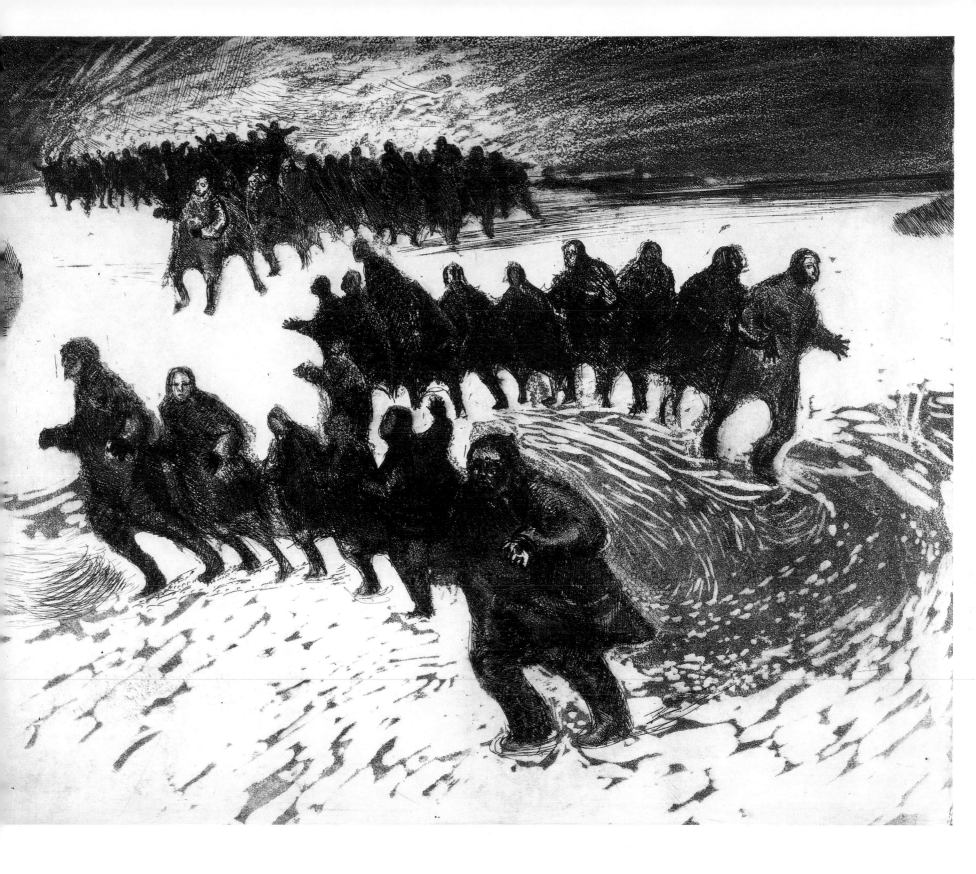

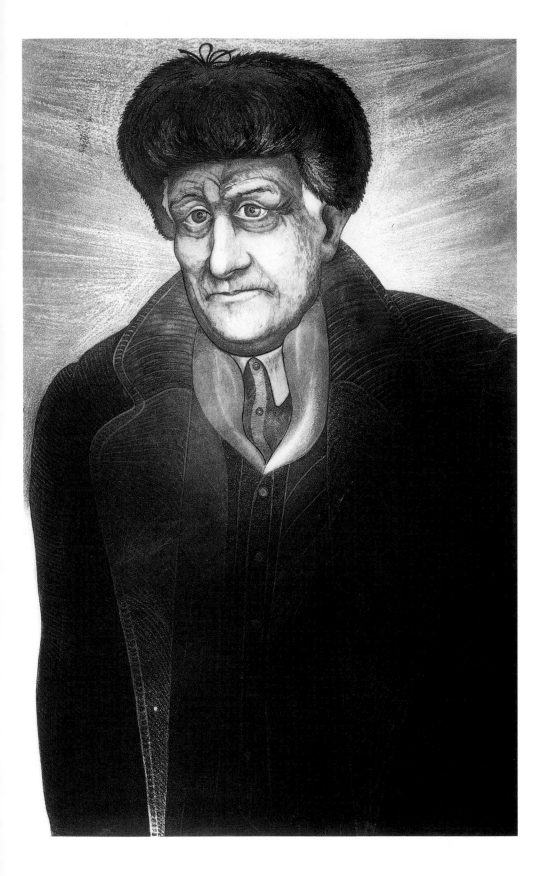

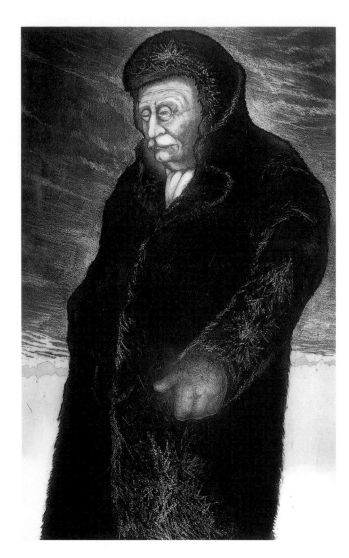

158

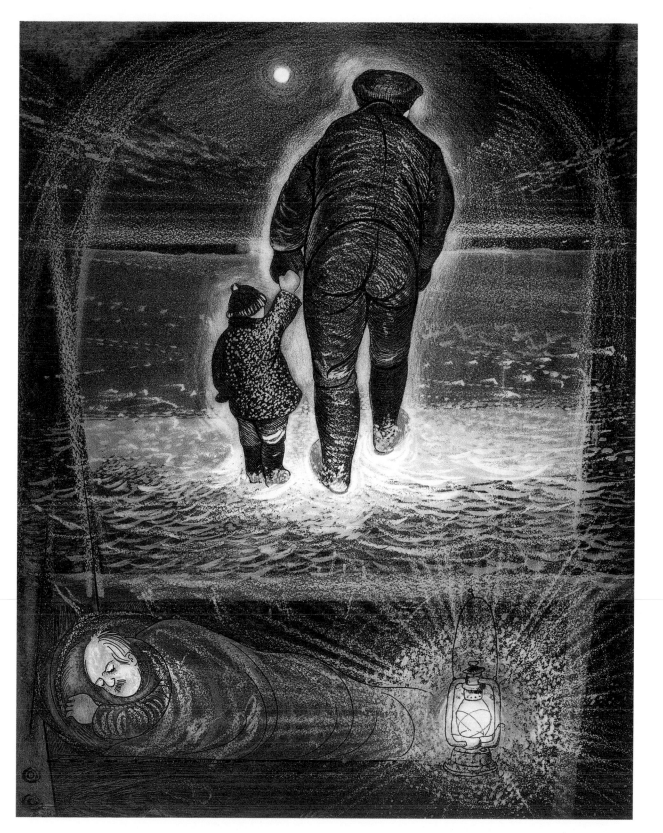

Elijah Mullett
Dreams
1975 · 35 × 27.5 cm

facing page, left:
Captain
Solomon White
1970 · 80 × 50 cm

facing page, right:
Captain
Arthur Jackman
1970 · 120 × 50 cm

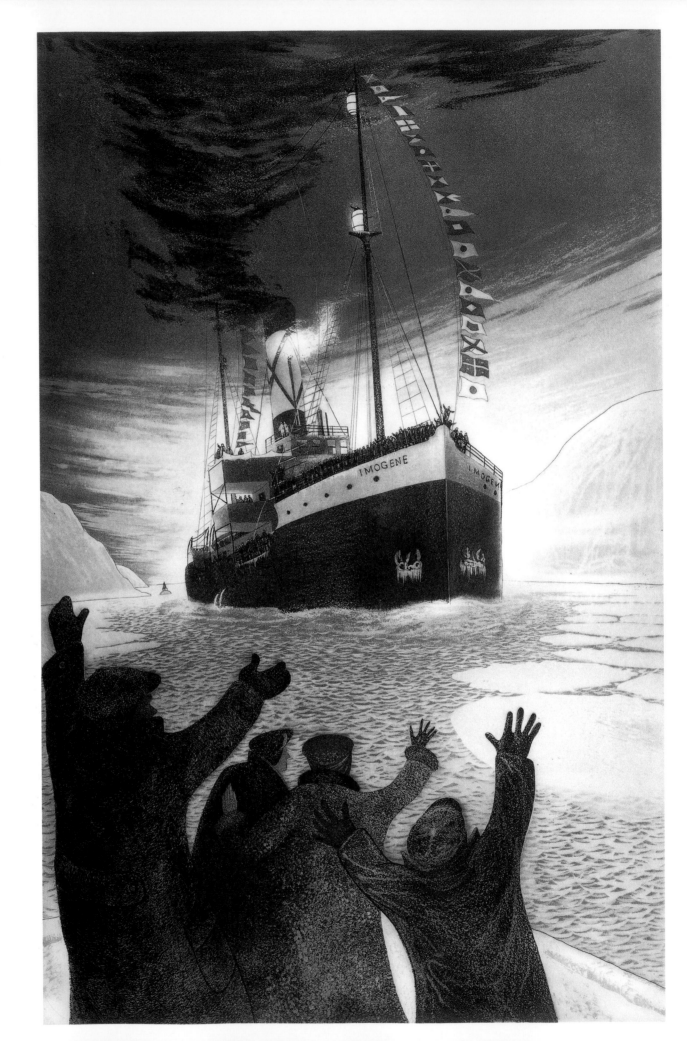

S.S. *Imogene* home
from the Icefields
1973 · 80 × 50 cm

facing page:
Charles Payne:
Inscription
at Belvedere
1971 · 40 × 50 cm

CHARLES PAYNE
DIED AT ICEFIELDS
APRIL 10, 1909
AGE 65 YEARS

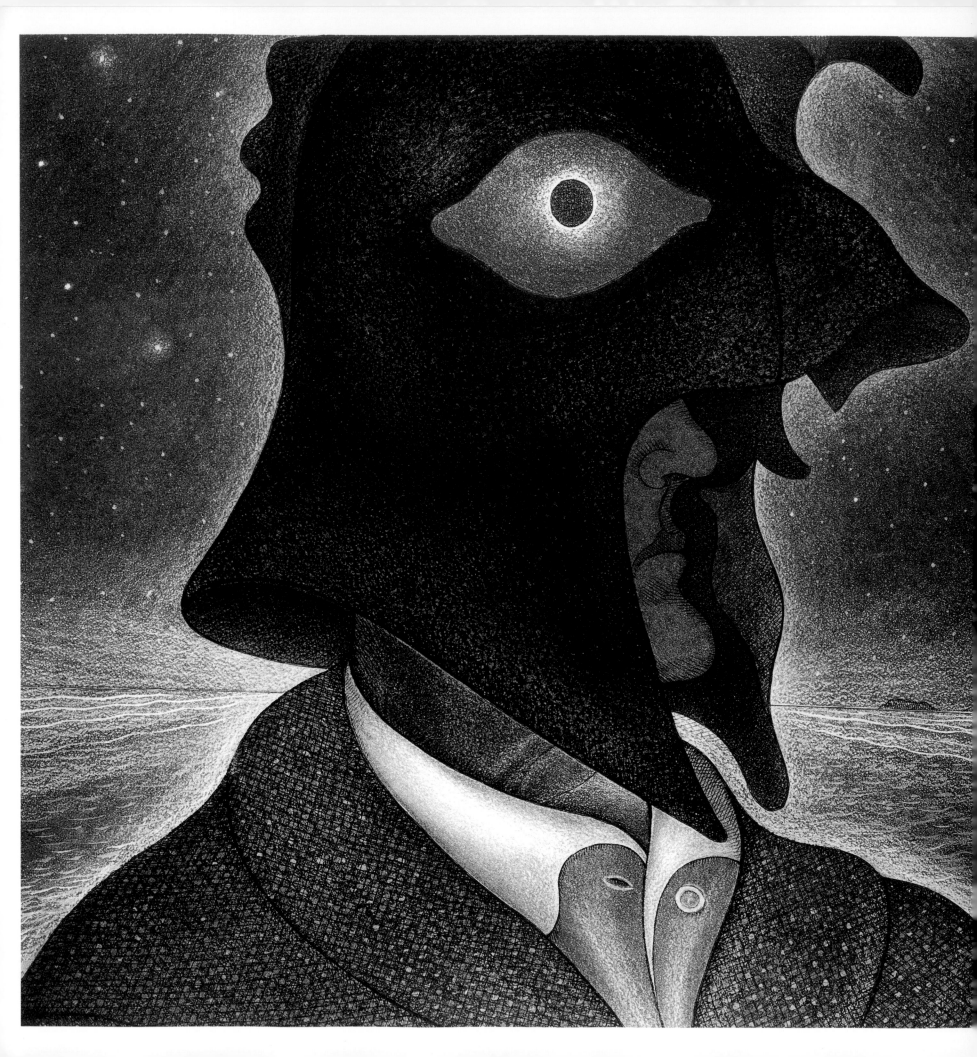

A WONDERFUL

GREAT

MUMMER

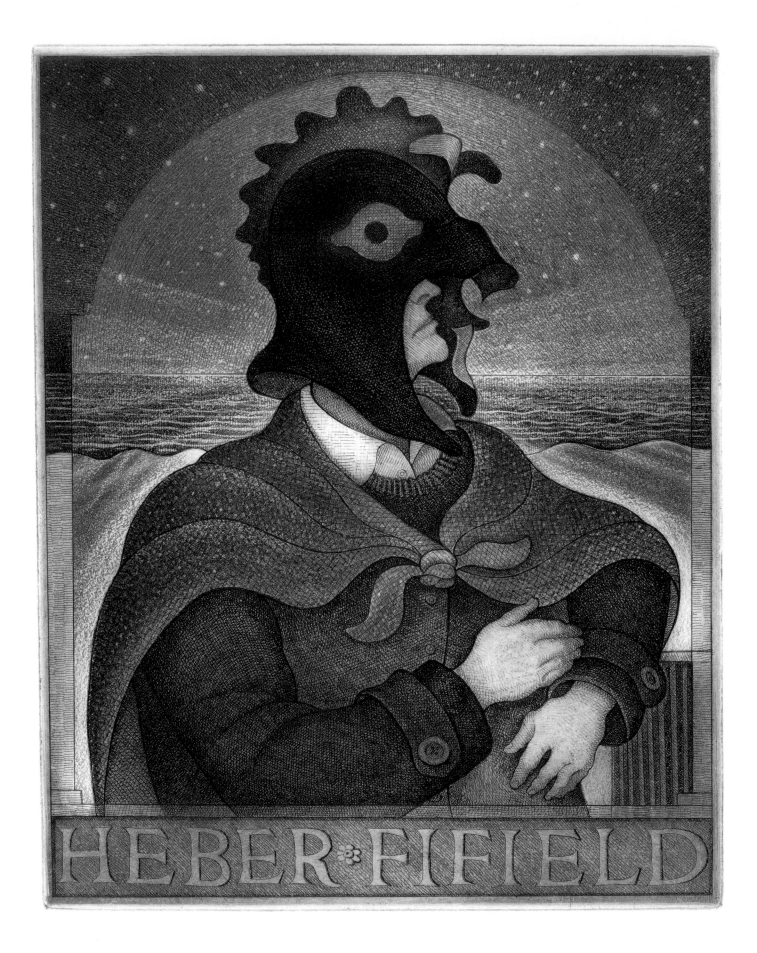

HEBER·FIFIELD

IN THE WORK of David Blackwood there is a magic that goes beyond the childhood of the artist, deep into what Carl Jung called the "collective unconscious." The veil of the mummer is fog draped over the landscape, giving it new rises and hollows but hiding sharp rocks, places where the road drops off. Mummering is fun, but like medieval fun, it accepts disguise as a necessary part of life and hints at what lies hidden behind the twin masks of life and death. In many ways, Blackwood has the characteristics of a medieval artist. One of these characteristics is the power that comes from life-long observation of a given subject. Blackwood grew up in one place, in the midst of people who had also grown up in that place, people who had lived in Wesleyville for generations. He had seen these generations gather together to lower the veil, and to lift the veil, and then to lower and lift it again year after year.

In David Blackwood's etching of Heber Fifield we see a man with fingers held in a symbolic gesture that suggests a gathering of power. The man's hand is harlequin-checked. On his head is the helmet of a rooster. Light spills out from the etching, shaping itself into an archway, and through its glow there appears an entry point to another world. In the everyday artifacts of a simple life we see, unexpectedly, recreated in Wesleyville, the major arcana image of the Fool from the Tarot: the true mystery of Chanticleer, a medieval code for the Fool. The role of the Fool in mummering is also encoded in the very old expression for a mummer, a "Christmas fool." This is all part of the greater mystery that emerges in the homemade helmet of a rooster created by a fisherman who fashioned his mask without benefit of book or knowledge from the secret teachings of any guild.

"I knew Heber Fifield all my life, from the time I was a little boy, through visits," David Blackwood recalls. "This man was my neighbour. He was a fisherman. His daughter was my friend, and she died when she was twenty-four. A very close family."

David Blackwood refers to Heber Fifield using a term that his ancestors used: "A wonderful great mummer." Fifield was someone who totally entered into the spirit of being a mummer. No half-hearted dance—Heber Fifield danced full out. No half-hearted mumble—when Fifield sucked in air to form words, his voice rocked the room.

David Blackwood has emerged, himself, as a wonderful great mummer. His heart can be seen through any veil he wears, and from ordinary objects he creates his magic. The light in his art is from a source that goes back to a time before electricity, before the feeble strobe of television, when people saw each other in the revealed light of the natural world. The mummers understood that the world herself is in disguise, and that when we join her masque in the dark night of winter, lifting our lamps, we are casting as much light inside as outside.

Working Proofs for *Portrait of Heber Fifield as a Great Mummer*

HEBER FIFIELD was a fixture in the up-harbour region of Wesleyville known as Fifield's Point. He was an able-bodied seaman, a fisherman, a sealer, a master carpenter, a musician, and, when the time came, a wonderful great mummer. In his seventies, he combined talents with another Wesleyville man, the tinsmith Griffith Oakley, to fulfill a longtime dream, completing the twin spires on the rebuilt Methodist church. He appeared as a Great Mummer in the Oscar-nominated film *Blackwood* (1975), wearing his rooster mask and playing the accordion in Ishmael and Tillie Tiller's kitchen. The idea of a Heber Fifield portrait has been with me for a long time.

The concept for a new etching begins with a series of small drawings, which over time develop into a full-scale design for the plate. All the prints I've made since 1964 employ the techniques of etching and aquatint. As a student at the Ontario College of Art, I started using a lithographic crayon to draw directly on the aquatint ground. It proved such a useful tool that it came to determine the character of all my prints. I also frequently use a scraper and a burnisher, traditional tools. Occasionally I will use an engraving burin to cut a quick line rather than resorting to the wax-ground method. But this is rare.

To start an etching, a copper plate is covered with an acid-resisting material called the "ground," a combination of beeswax and asphaltum (asphalt varnish). The wax ground is applied in a hot liquid state to the preheated plate. When the surface has cooled, it is ready to receive a full-scale tracing of the design. This outline is transferred to the wax ground in reverse, using carbon paper. An etching needle is then used to draw over the outline, exposing the bare metal. Then, with its edges and underside protected by varnish, the plate is immersed in a tray containing an acid bath. The acid bites into the metal, and after a set period of time the wax ground is cleaned off to reveal the etched design. The plate can now be inked and printed to yield the first working stage or proof. This simple outline of the design serves as a guide for the stages to come.

The wax-ground and needle method is used many times throughout the development of a work, and aquatint is used to create the tonal effect. In this process, one of several methods is used to deposit fine granules of resin onto the metal plate. The plate is heated after the particles of resin have been spread on the surface, and each particle, upon melting, becomes an acid-resisting dot. The fineness or coarseness of the deposit determines the extent to which the acid will corrode the metal. Since the acid bites the surface areas surrounding the dots, pitting the plate with an ink-retaining "grain," the artist "stops out" the surface with acid-resisting varnish where he desires a highlight or white area. He permits the acid to work longest where he desires the deepest tone of black.

Accident plays an important role in the preparation of an aquatint, for the laying of the ground is not easy to control. This is especially true when the artist seeks to vary the character of the granular surface by combining fine and coarse granules or attempts to predetermine the quantity of resin particles that will settle in certain sections of the plate. These uncertainties contribute to the excitement of the process, and often the best results come from this lack of control.

An etching passes through many different stages before it is completed. It can take weeks or months before the final working proof is reached and the plate is finished, ready to be printed in a numbered edition. The first working proof for *Heber Fifield as a Great Mummer* was printed on April 26, 2000. The twelfth and final working proof was pulled seven months later, on October 18.

—DAVID BLACKWOOD

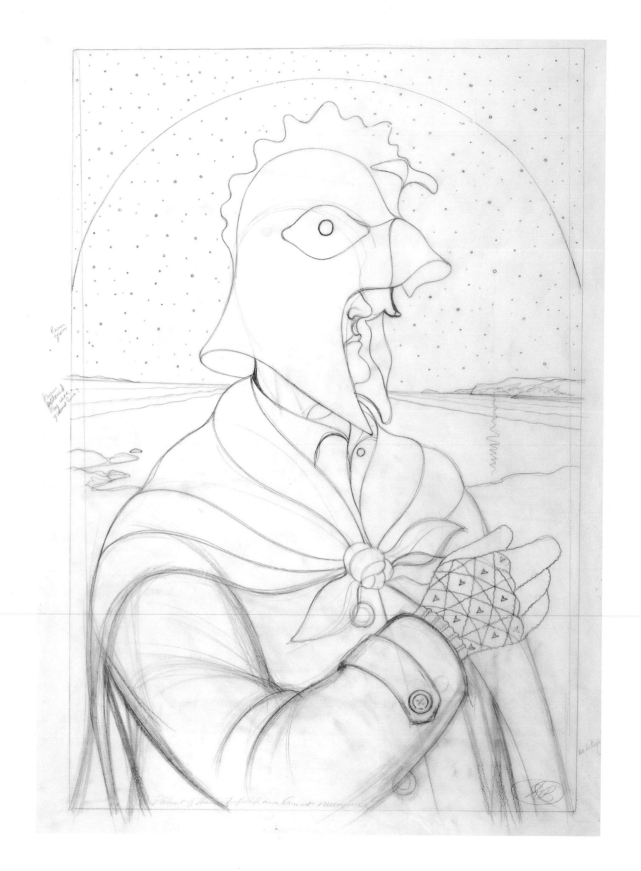

Portrait of
Heber Fifield as a
Great Mummer:
Drawing

2000 · 90 × 60 cm

Portrait of
Heber Fifield as a
Great Mummer:
Working proof 1

2000 · 90 × 60 cm

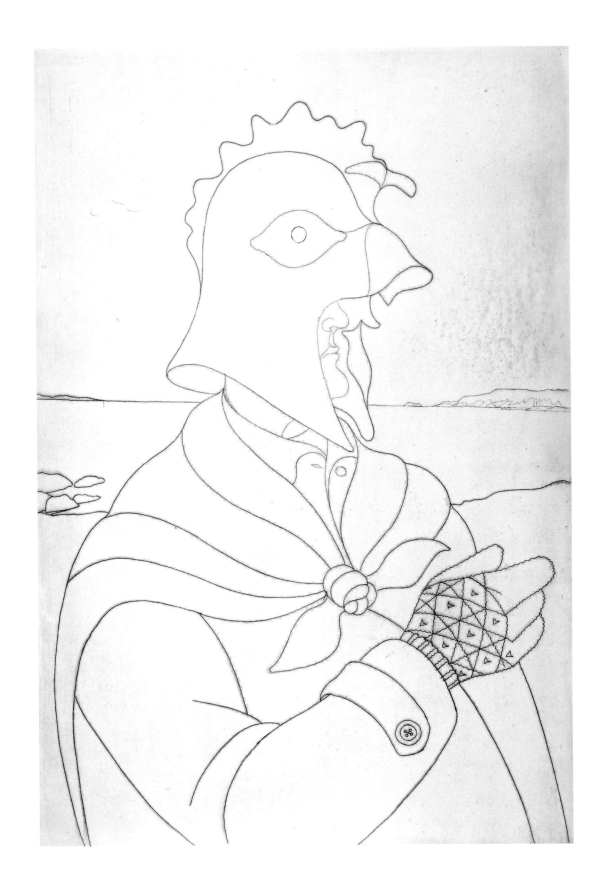

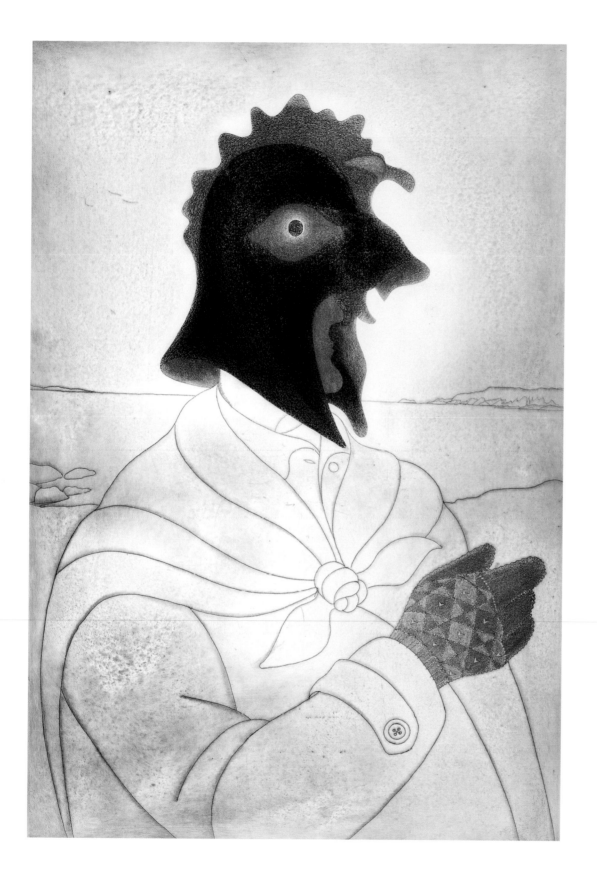

Portrait of
Heber Fifield as a
Great Mummer:
Working proof 2

2000 · 90 × 60 cm

Portrait of
Heber Fifield as a
Great Mummer:
Working proof 3
2000 · 90 × 60 cm

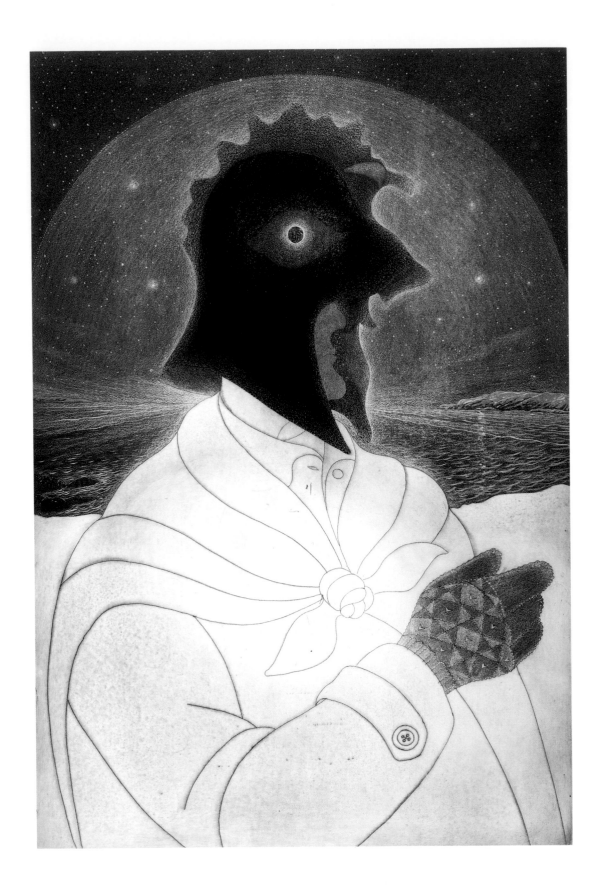

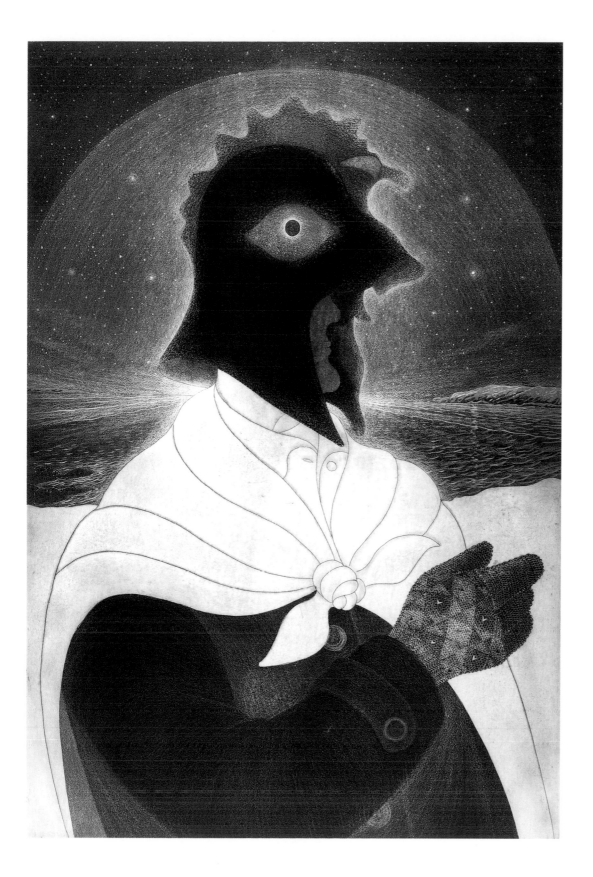

Portrait of
Heber Fifield as a
Great Mummer:
Working proof 4

2000 · 90 × 60 cm

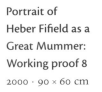

Portrait of
Heber Fifield as a
Great Mummer:
Working proof 8
2000 · 90 × 60 cm

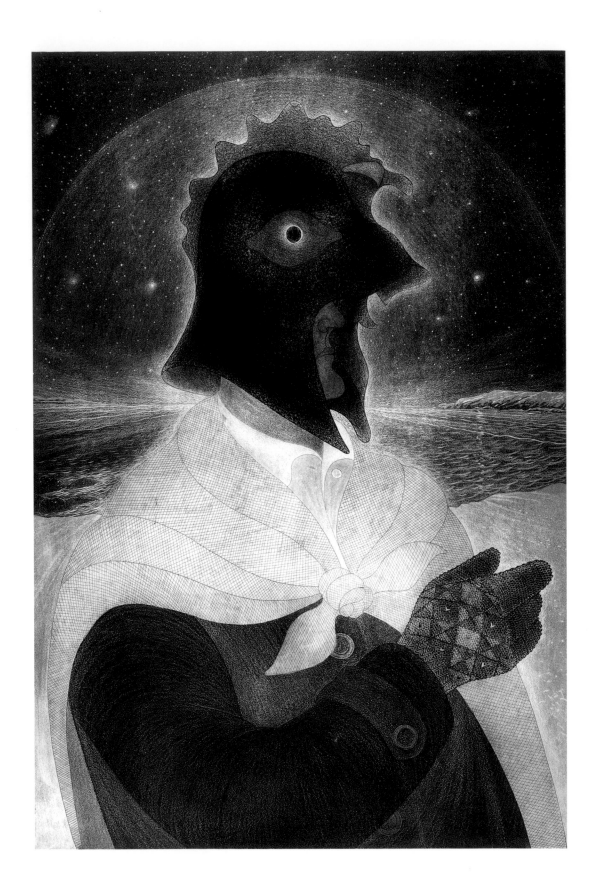

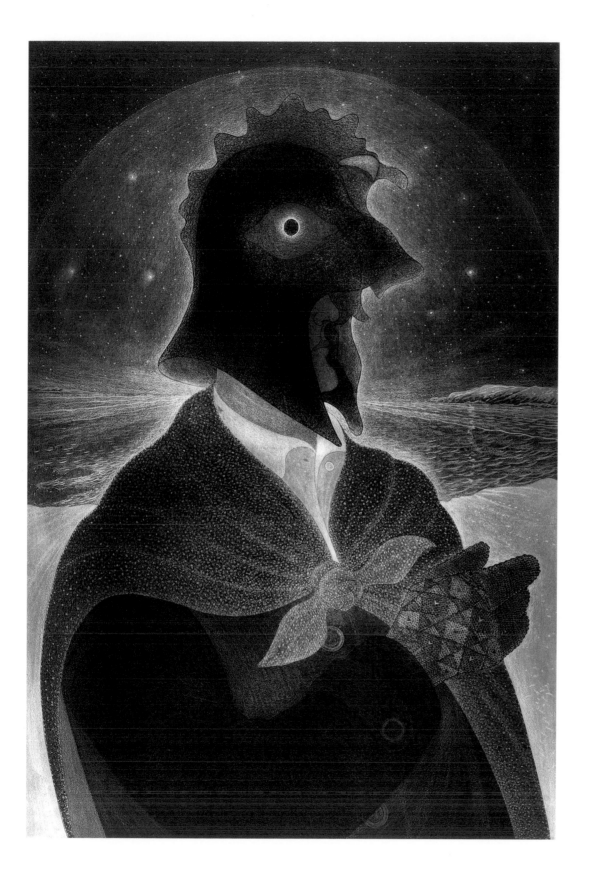

Portrait of
Heber Fifield as a
Great Mummer:
Working proof 9

2000 · 90 × 60 cm

Portrait of
Heber Fifield as a
Great Mummer:
Final working proof

2000 · 90 × 60 cm

facing page:
Portrait of
Heber Fifield as a
Great Mummer:
Completed work

2000 · 90 × 60 cm

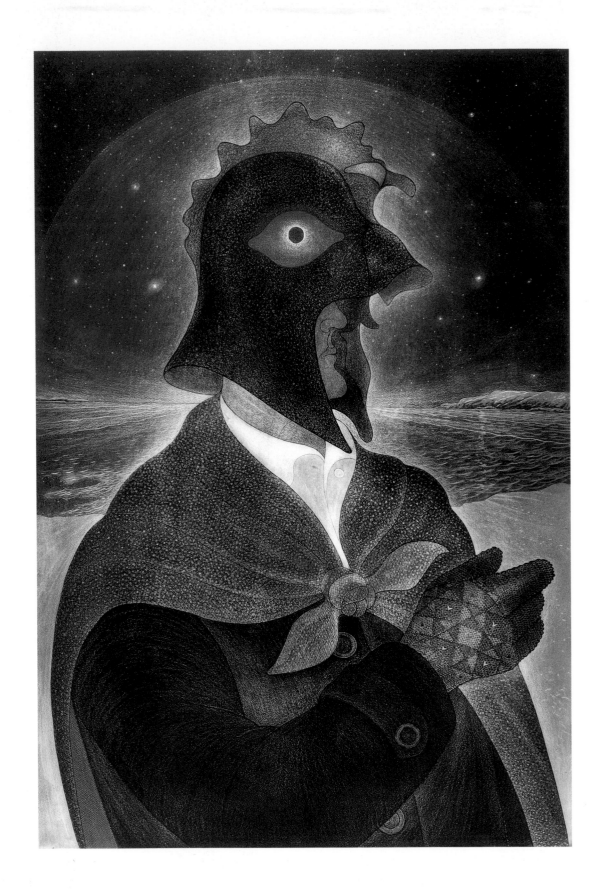

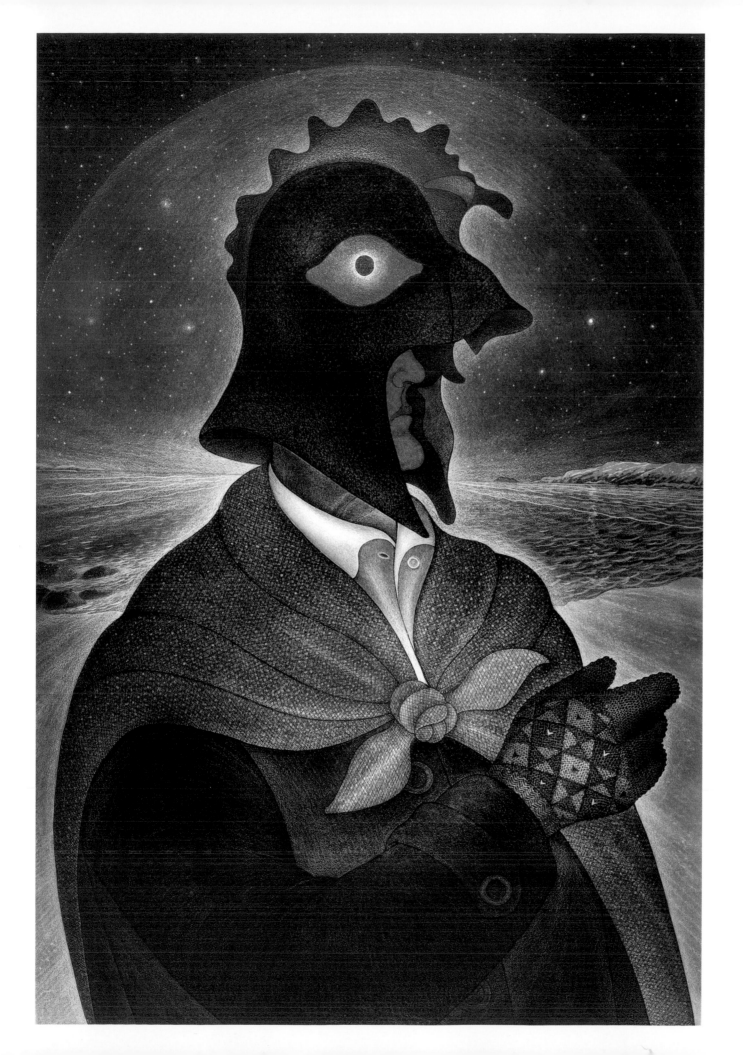

CHRONOLOGY

1941

Born David Lloyd Blackwood on November 7, 1941, in Wesleyville, Newfoundland, the first son of Captain Edward and Molly Blackwood (née Glover)

1945–53

Spends summers with his father aboard the schooner *Flora S. Nickerson,* collecting cod to be dried for the merchant firm of Mifflin's in Catalina

1957

Establishes his first studio in the loft of Captain Billy Winsor's woodshed; receives a new punt from his father for lobster fishing with Cyril Best, who will later be referred to in the print *Cyril's Kite over Blackwood's Hill*

1958

Establishes a studio in Captain Edward Bishop's shop

1959

Graduates from Wesleyville Memorial High School; receives Government of Newfoundland Centennial Scholarship; moves to Toronto, Ontario, to attend the Ontario College of Art

1962

Hired by historian A. B. Hodgetts to teach painting at Hodgetts's summer camp Hurontario in Georgian Bay, Ontario, a place he will continue to spend his summers until 1967

1963

Graduates from the Ontario College of Art with an honours diploma in Drawing and Painting; continues on at OCA as a teaching assistant in printmaking for the academic year 1963–64; receives an OCA travelling scholarship to study major art collections in the United States; receives the Government of France (Ingres) Medal; appointed as art master at Trinity College School, Port Hope, Ontario, a position he will hold until 1988, teaching one day a week

1964

The National Gallery of Canada selects and purchases Blackwood's first etching, *The Search Party,* for inclusion in its Biennial of Canadian Prints

1965

Has a solo exhibition at the Brantford Art Gallery in Brantford, Ontario; exhibits in group shows at the Royal Canadian Academy of Arts in Toronto and the Sarnia Art Gallery in Sarnia, Ontario

1966

The National Gallery of Canada selects the etching *Spring* for inclusion in its Biennial of Canadian Prints

1967

Has solo exhibitions at the Memorial University Art Gallery in St. John's, Newfoundland; the McMaster University Art Gallery in Hamilton, Ontario; and Trinity College School in Port Hope; exhibits in group shows at the Art Gallery of Ontario in Toronto, the National Gallery of Canada in Ottawa, Ontario, and Expo '67 in Montreal, Quebec

1968

Has solo exhibitions at the University of Alberta Art Gallery in Edmonton, Alberta, and the Art Gallery of the University of British Columbia in Vancouver, British Columbia; exhibits in group show, Ninth Annual Calgary Graphics, in Calgary, Alberta

1969

Becomes artist in residence at Erindale College, University of Toronto, in Mississauga, Ontario, a position he will hold until 1975; has his first commercial exhibitions at Gallery Pascal in Toronto and the Wells Gallery, Ottawa

1970

Exhibits with the Royal Canadian Academy at the National Gallery in Ottawa; marries Anita Bonar

1971

Founds Erindale College Art Gallery, University of Toronto; has solo exhibitions at Gallery Pascal in Toronto; the Damjkar Burton Gallery in Hamilton, Ontario; the Wells Gallery in Ottawa; the Confederation Art Gallery in Charlottetown, Prince Edward Island; and the Macintosh Art Gallery at the University of Western Ontario in London, Ontario; son David Bonar is born

1973

Publication of *Wake of the Great Sealers:* prints and drawings by David Blackwood, text by Farley Mowat (McClelland & Stewart); has solo exhibitions at Gallery Pascal in Toronto and the Wells Gallery in Ottawa; an exhibition entitled *David Blackwood: Prints,* organized by the Art Gallery of Memorial University,

St. John's, and the Art Gallery of Algoma in Sault Ste. Marie, Ontario, is launched and will tour to public galleries across Canada and to the University of Maine in Orono, Maine, over the next seven years; has work selected for inclusion in *Biennial International de l'Estampe,* Paris, France

1974

Release of *Blackwood,* a National Film Board documentary directed by Andy Thomson and Tony Ianuzielo that will go on to receive ten international film awards or award nominations; has solo exhibitions at the Fleet Gallery in Winnipeg, Manitoba; Gallery Pascal in Toronto; and the New Brunwick Museum in St. John, New Brunswick

1975

Has solo exhibitions at Gallery Pascal in Toronto and Gallery 1640 in Montreal; exhibits in a group show at the Art Gallery of Ontario

1976

The film *Blackwood* receives an Oscar nomination for Best Documentary from the Academy of Motion Picture Arts and Sciences

1977–80

Has solo exhibitions at Gallery 1640 in Montreal, Gallery Pascal in Toronto, Gallery Graphics in Ottawa, Gallery Royale in Vancouver, and the West End Gallery in Edmonton; has a studio built in Wesleyville

1981

Has a solo exhibition at Gallery Pascal in Toronto

1982

Has solo exhibitions at Gallery Pascal in Toronto and the Robertson Gallery in Ottawa; exhibits in a group show at the Bronx Museum, New York

1984

David Blackwood: Prints 1962–1984, a travelling exhibition organized by the Art Gallery of Algoma and Memorial University Art Gallery, is launched and will tour to public galleries in Canada, the United States, England, Holland, and France over the next six years; has a solo exhibition at Cape Freels Art Council in Wesleyville, Newfoundland

1985

Has solo exhibitions at the Madison Gallery in Toronto, the Masters Gallery in Calgary, and Gallery Guilia in Rome, Italy

1986

Has solo exhibitions at the Spurrell Gallery in St. John's, the Madison Gallery in Toronto, and Gallerie Gian Ferarri in Milan, Italy

1988

Publication of *The Art of David Blackwood,* text by William Gough (McGraw-Hill Ryerson); has a solo exhibition of monotypes at Gallery One in Toronto

1989

Has solo exhibitions at the Heffel Gallery in Vancouver, and the West End Gallery in Edmonton

1990

Has solo exhibitions at the Emma Butler Gallery in St. John's, Gallery One in Toronto, the Heffel Gallery in Vancouver, and the West End Gallery in Edmonton

1991

Has a solo exhibition of paintings at Gallery One in Toronto

1992

The Blackwood Gallery at Erindale College, University of Toronto, is officially opened; receives an Honorary LL.D. from the University of Calgary; receives an Honorary Litt.D. from Memorial University in St. John's

1993

Is appointed to the Order of Canada in recognition of his outstanding contribution to the artistic and cultural life of Canada; receives a Heritage Award from the Canadian Parks Service; *David Blackwood Survey Exhibition 1980–1990,* a travelling exhibition organized by the Blackwood Gallery at Erindale College, University of Toronto, is launched and will tour to public galleries all across Canada and to the Canadian embassy in Tokyo over the next seven years

1995

Has solo exhibitions at the West End Gallery in Edmonton and the Emma Butler Gallery in St John's; has solo exhibitions of oil tempera paintings at the Heffel Gallery in Vancouver and Gallery One in Toronto

1996

Has a solo exhibition of oil tempera paintings at Gallery One in Toronto; *Blackwood in Calgary: A Broader View,* a selection of work from private collections, is mounted at the Nickel Arts Museum in Calgary

1997

Has a solo exhibition of paintings at the Emma Butler Gallery in St. John's

1998

Has solo exhibitions of paintings at the Heffel Gallery in Vancouver and the West End Gallery in Edmonton and Victoria, British Columbia; has a solo exhibition of monotypes at Gallery One in Toronto

2000

The Art Gallery of Ontario announces a major gift of prints from David and Anita Blackwood, which gives the AGO the collection of record for Blackwood's work and will allow the creation of a centre for the study of his prints; has solo exhibitions at the Abbozzo Gallery in Oakville, the Edward Day Gallery in Kingston, and the Heffel Gallery in Vancouver, as well as an exhibition of paintings, prints, and related artifacts at the Marine Museum of the Great Lakes in Kingston

2001

Has a solo exhibition of paintings at the Edward Day Gallery in Toronto; has an exhibition of monotypes at the Emma Butler Gallery in St. John's